DESTINATIONS OF A
LIFETIME
FROM LANDMARKS TO NATURAL WONDERS

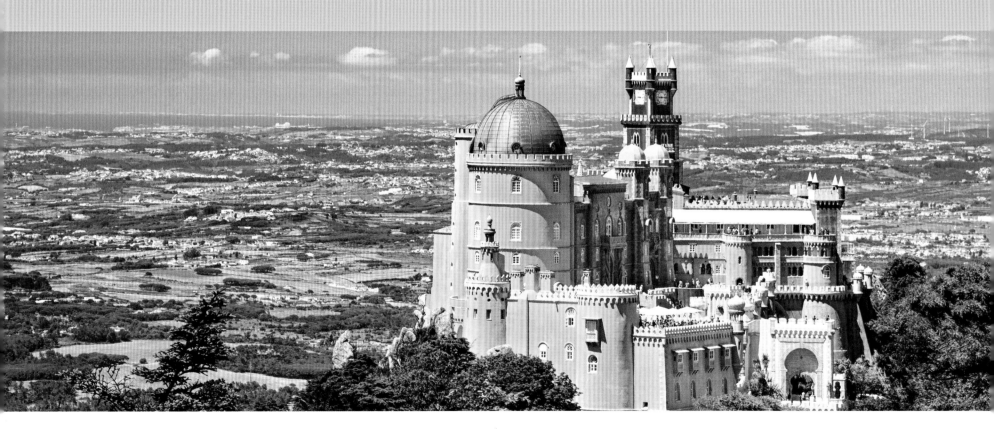

pil

Publications International, Ltd.

Written by Judson Picco

Images from Shutterstock.com

Louis Weber, CEO
Publications International, Ltd.
8140 Lehigh Avenue
Morton Grove, IL 60053

Permission is never granted for commercial purposes.

ISBN: 978-1-64030-878-7

Manufactured in China.

8 7 6 5 4 3 2 1

Table of Contents

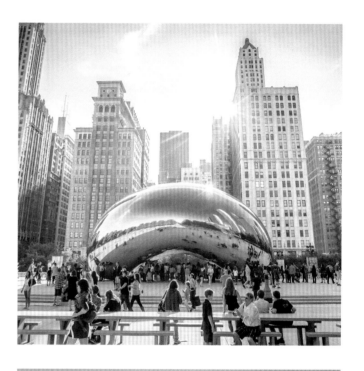

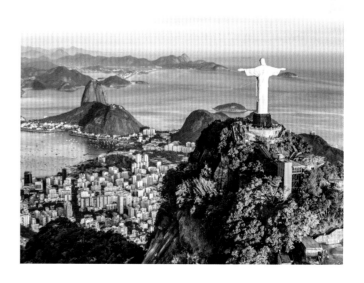

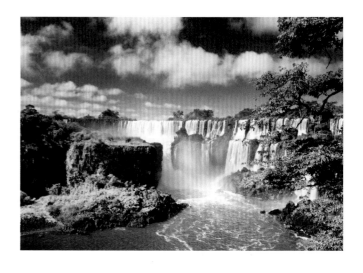

EUROPE

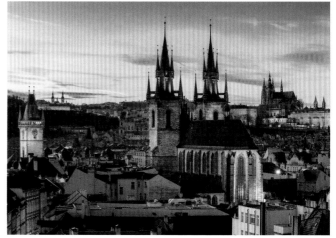

AFRICA AND THE MIDDLE EAST

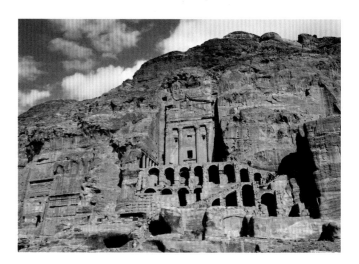

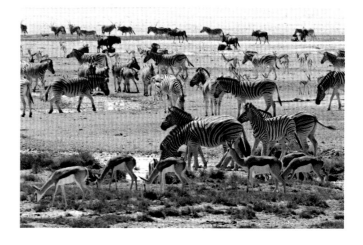

ASIA

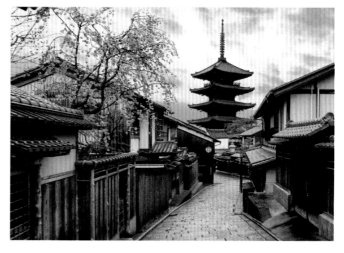

ANTARCTICA AND OCEANIA

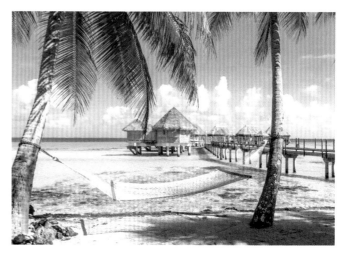

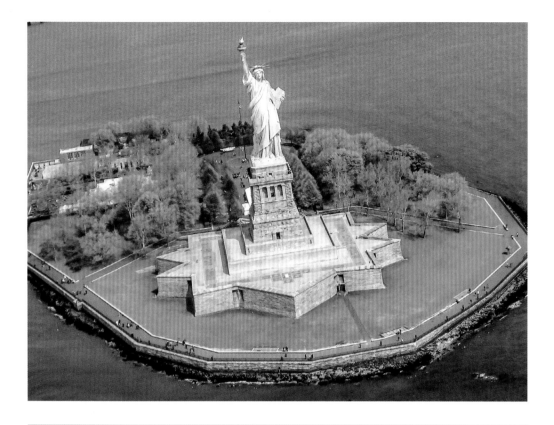

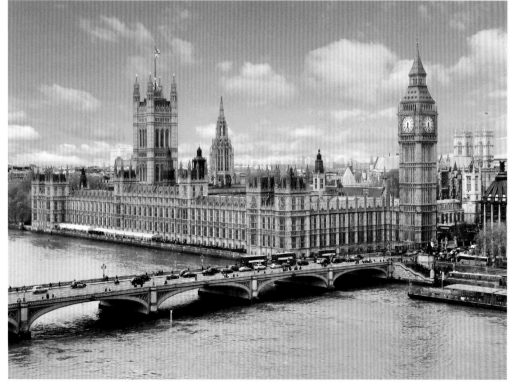

Introduction

Why do we travel? Is it to experience new cultures? Learn a new language? Push ourselves out of our comfort zones? People travel for many reasons, and luckily, traveling the world has never been easier. International and domestic flights are getting cheaper and more frequent, and thanks to the internet, researching hotels, restaurants, and tourist attractions is a breeze. So whether you're hoping to broaden your perspective on the world, or you're just trying to find something new and exciting to do, travel is the answer.

In this book, you'll find the travel inspiration you're looking for. Some places may seem familiar—like world-famous New York City, home to millions of people and dozens of the country's most celebrated sights like the Statue of Liberty and the Empire State Building. Or London, full of centuries worth of history, literature, and iconic architecture that has influenced countless other cities around the world.

And some locations are a bit more eccentric, like Cappadocia, Turkey, where you can enjoy a hot air balloon ride overlooking the region's otherworldly geologic landforms. Or the Dalmatian Coast of Croatia, full of some of the country's most dramatic and breathtaking natural wonders and medieval architecture.

From lively cities like New Orleans and Amsterdam that are known for energetic nightlife scenes and vibrant atmospheres, to pristine island paradises like Tahiti or The Maldives, where you can escape the stressors of urban life, this book has it all. Each destination is completely different from the last, with new wonders to behold on every page.

With 52 destinations on all seven continents, *Destinations of a Lifetime* hopes to inspire your next trip around the world. This book is just the start though—once you start traveling you'll have a hard time stopping! With limitless new places to discover, the possibilities are endless!

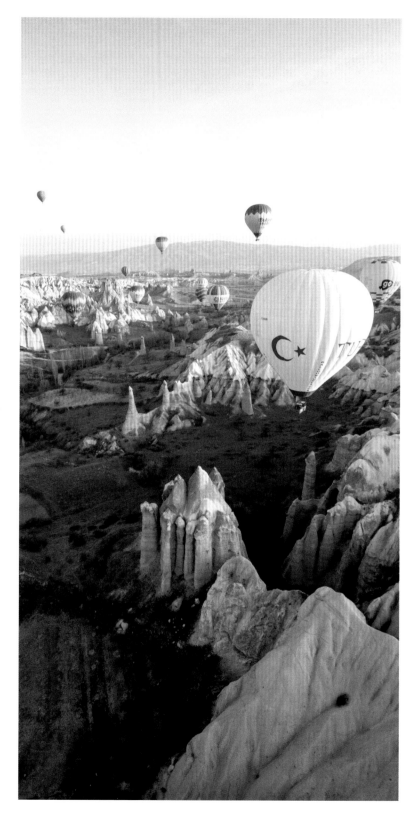

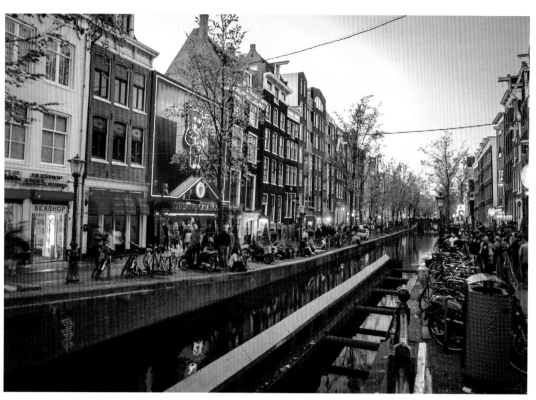

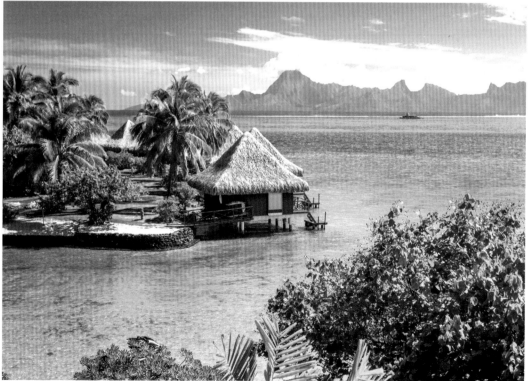

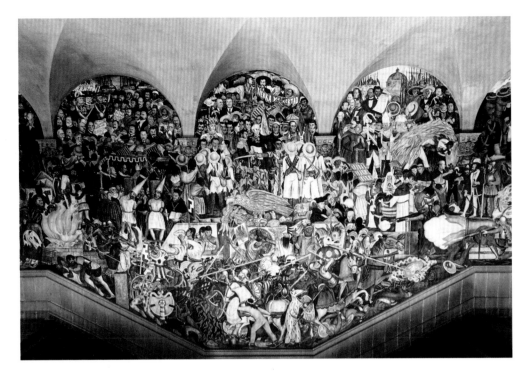

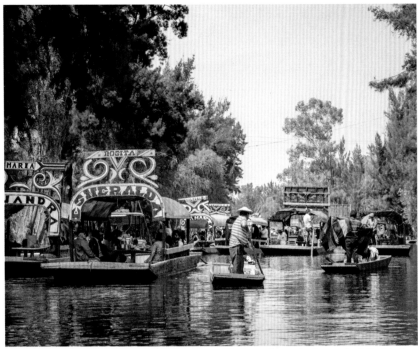

Trajineras barges in the canals of Xochimilco

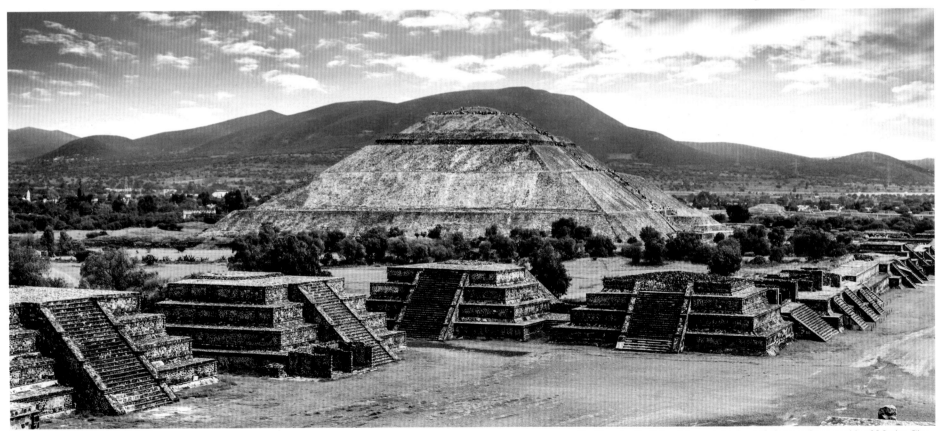

Teotihuacán, the "city of the gods," is located about an hour outside of Mexico City.

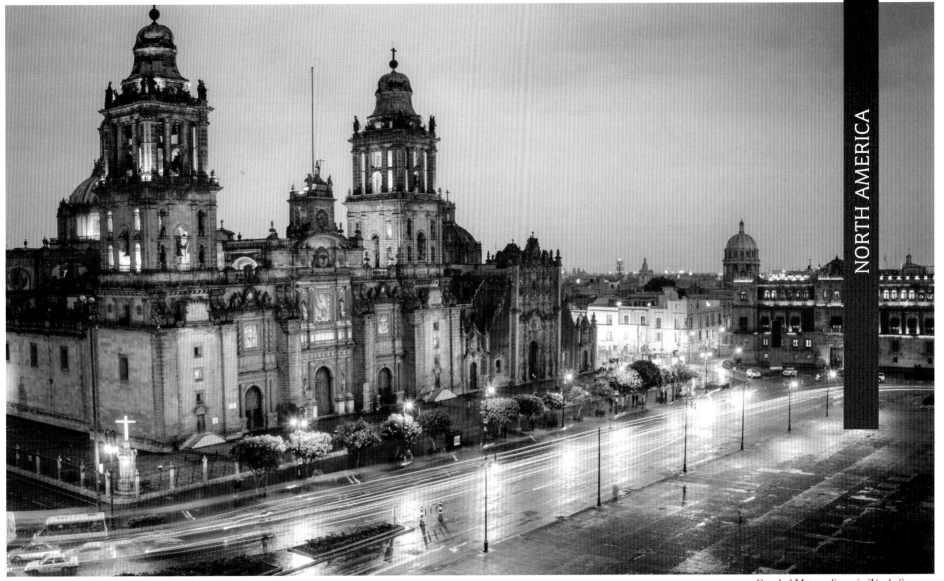

Catedral Metropolitana in Zócalo Square

Mexico City, Mexico

One of the world's largest cities, teeming Mexico City can take several days to really explore fully. Most visitors begin at the Zócalo—a massive public square that's anchored by the Palacio Nacional, featuring murals by Diego Rivera—and Catedral Metropolitana, which is among the great religious buildings in the Latin world. In the canals of Xochimilco, fun seekers can ride the flowery and colorful trajineras barges, complete with mariachi bands of their own. For a daytrip into Mexican history, head out to Teotihuacán, the sacred "city of the gods," where Aztec pyramids of the Sun and Moon have stood for thousands of years.

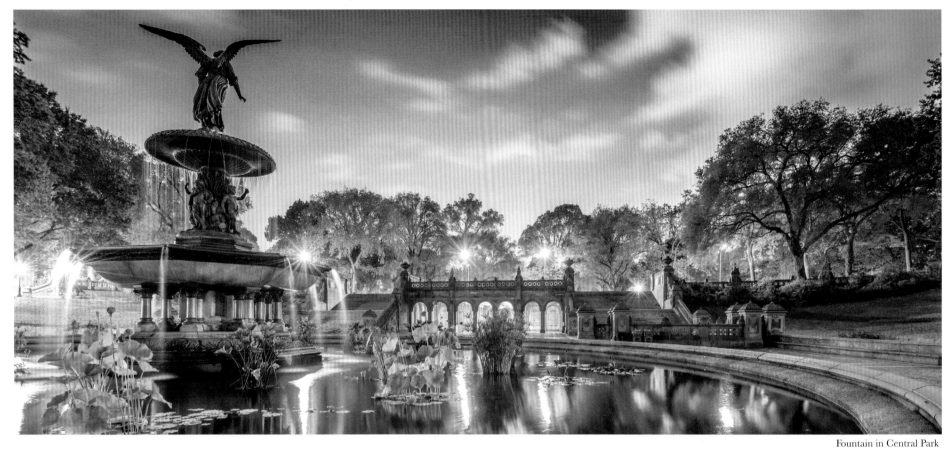

Fountain in Central Park

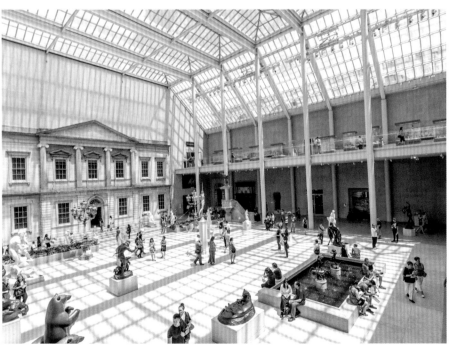

The Metropolitan Museum of Art, also known as "The Met,"
is one of the most-visited art museums in the world.

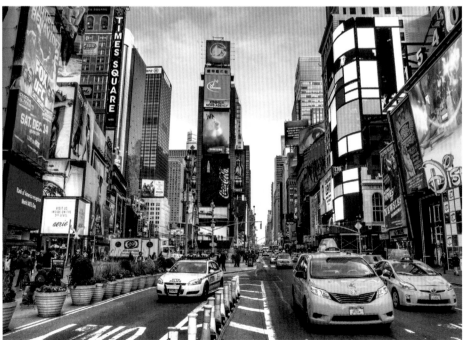

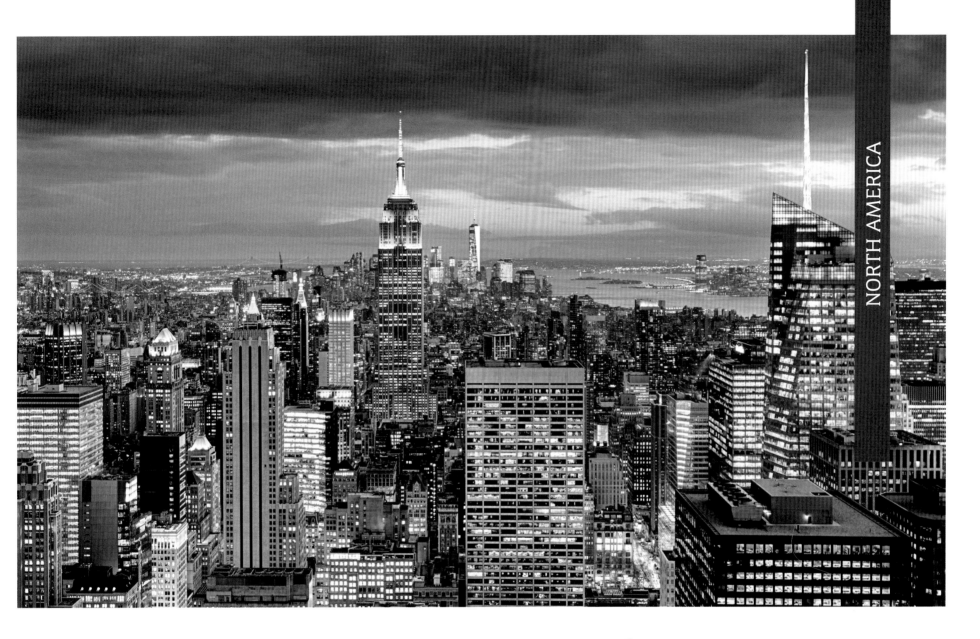

New York, New York

Frenetic and fascinating, New York City has been called The Capital of the World...and for good reason. Though it is priccy and can be overcrowded in spots, the Big Apple is among the planet's most culturally diverse cities, it's one of the most walkable, and it boasts the biggest subway system anywhere, ready to get you wherever you need to be, 24/7. There's the largest art museum in the western hemisphere, the Metropolitan Museum of Art. There's bustling Times Square, where bright lights, Broadway shows, and sundry street performers beckon. There's massive Central Park and the iconic Empire State Building—and we haven't even left the island of Manhattan yet!

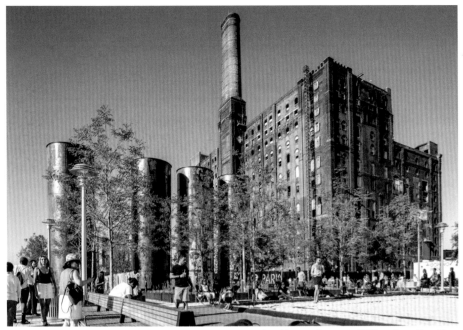

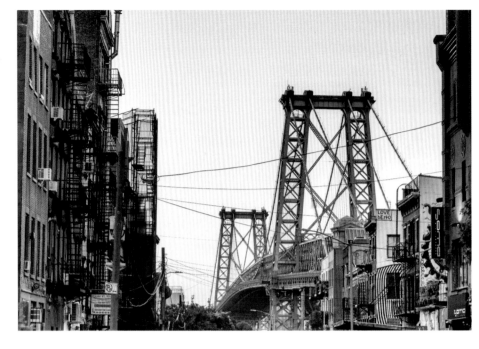

An old sugar factory in Williamsburg, Brooklyn

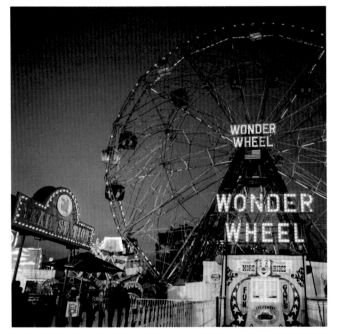

Coney island is known for its theme parks.

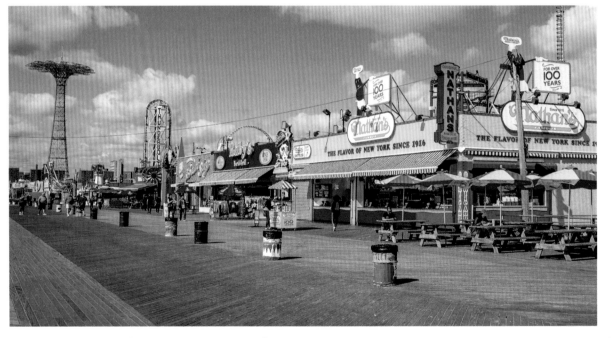

The city's other four boroughs are no less noteworthy. Brooklyn is buzzing in recent years, with trendy neighborhoods like Williamsburg and Park Slope, plus the classic eats and entertainments of Coney Island. Queens is a mecca for Greek and Mediterranean cuisine, and it showcases Hollywood and TV treasures at the Museum of the Moving Image. In the Bronx, pay a visit to the more than 10,000 animals at the Bronx Zoo, the largest metro zoo in the US. For skyline views and a top-notch look at the Statue of Liberty, take a free voyage by ferry to Staten Island.

Queens is known for its wide selection of Greek and Mediterranean foods.

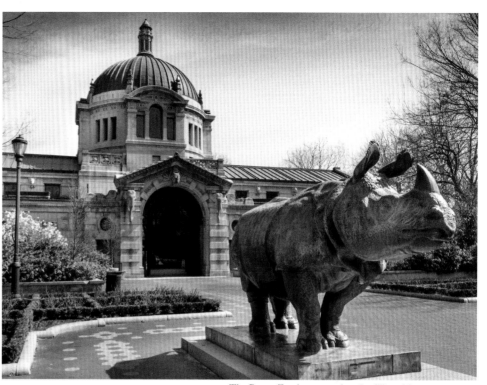

The Bronx Zoo has more than 2 million visitors every year.

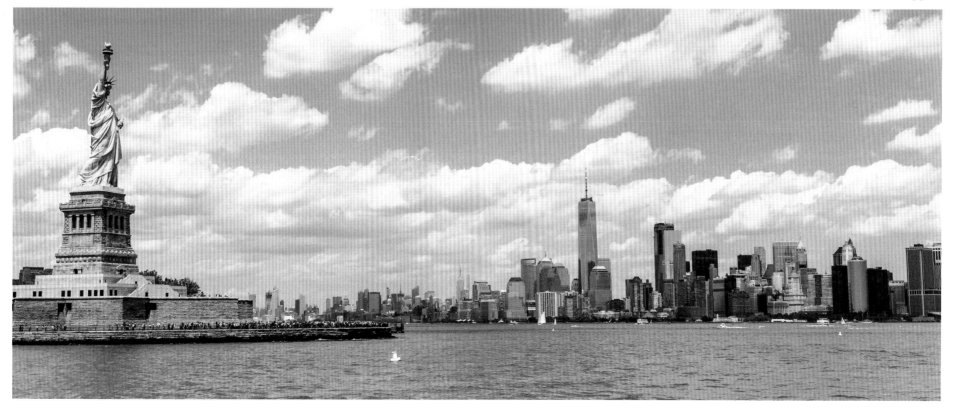

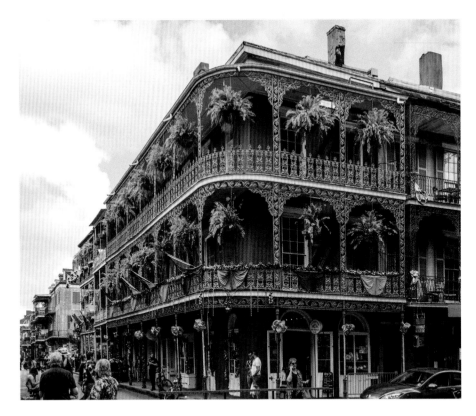

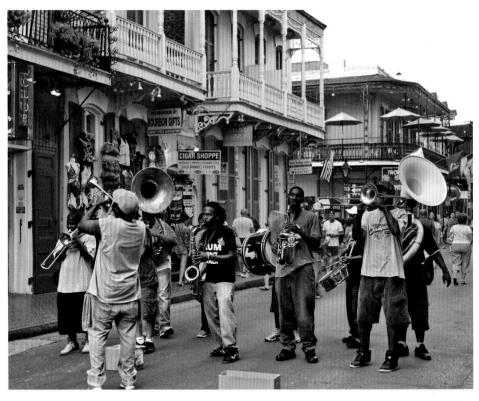

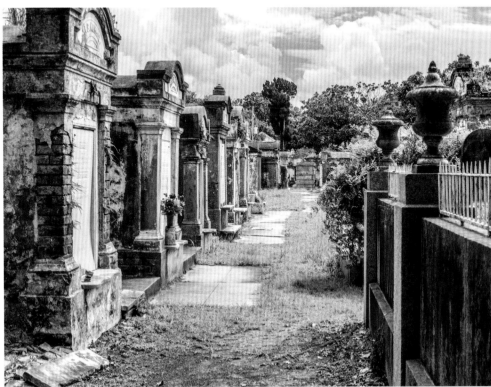

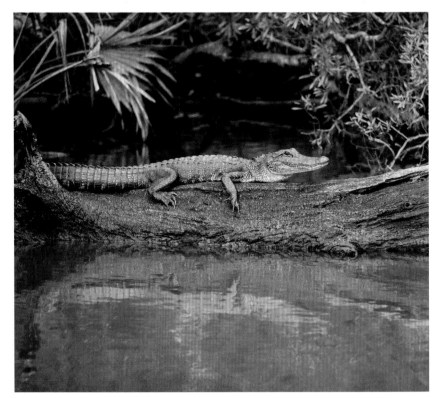

Lafayette Cemetery, founded in 1833, is the first planned cemetery in New Orleans.

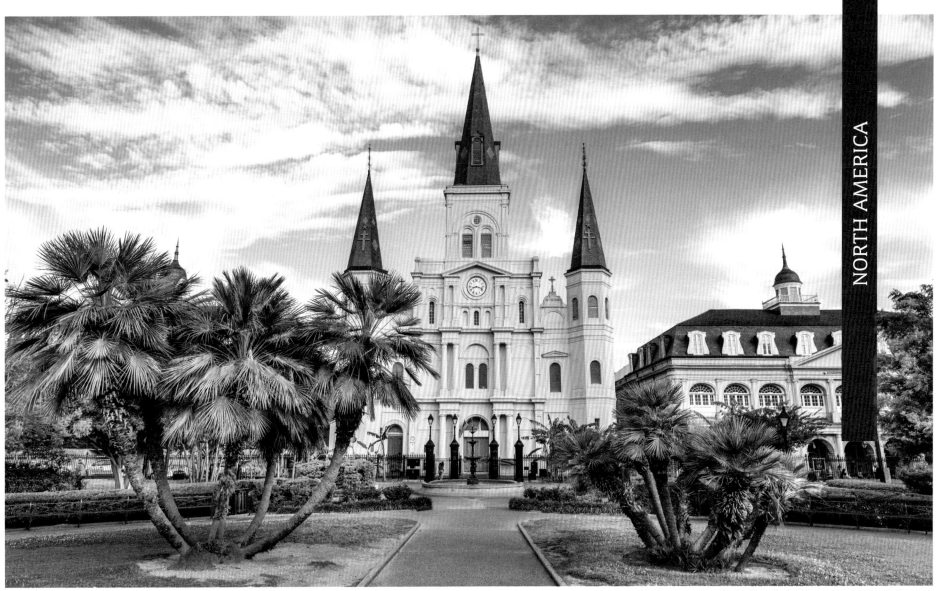

St. Louis Cathedral, located in the French Quarter

New Orleans, Louisiana

Distinctive and exuberant, New Orleans seduces many first-timers with the carousing crowds of Mardi Gras or the tacky, sinful Bourbon Street. But it's the historical homes, museums, and funky tours of areas like the French Quarter that really win visitors' hearts in the end. Or the Garden District, famed for its lush greenery, magical mansions, and moody spots like Lafayette Cemetery. Just west of the Quarter, in Mid-City, City Park is bigger than New York's Central Park, and it offers botanical gardens, an art museum, kid attractions like Carousel Gardens and Storyland, and even waterways that might conceal an alligator or two.

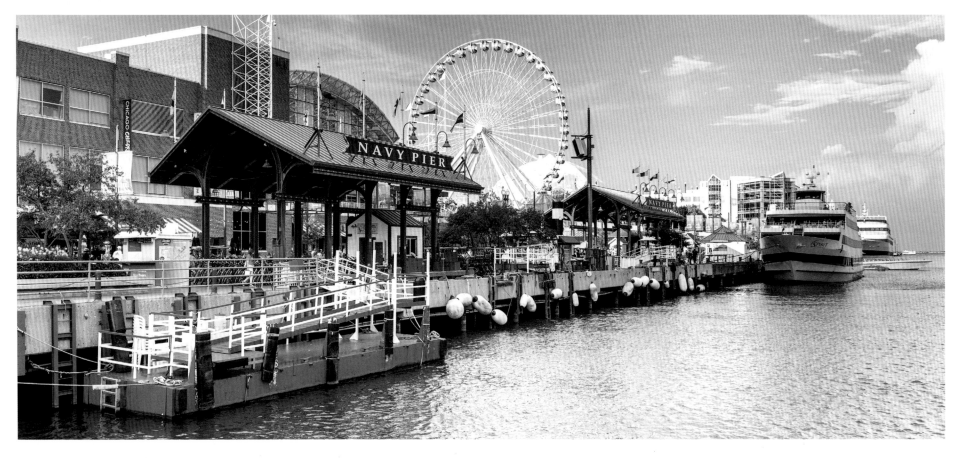

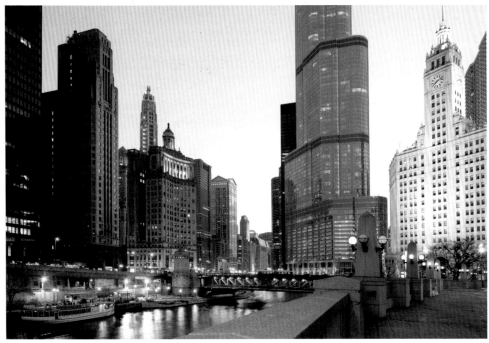

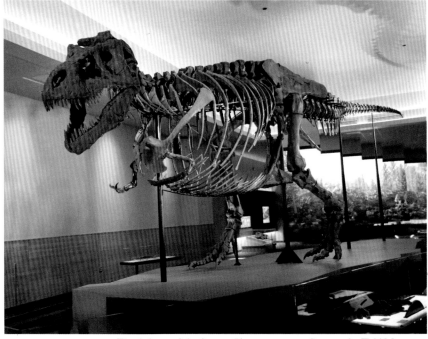

The skeleton of the famous *Tyrannosaurus rex*—Sue—at the Field Museum.
Sue is the most complete *T. rex* skeleton discovered.

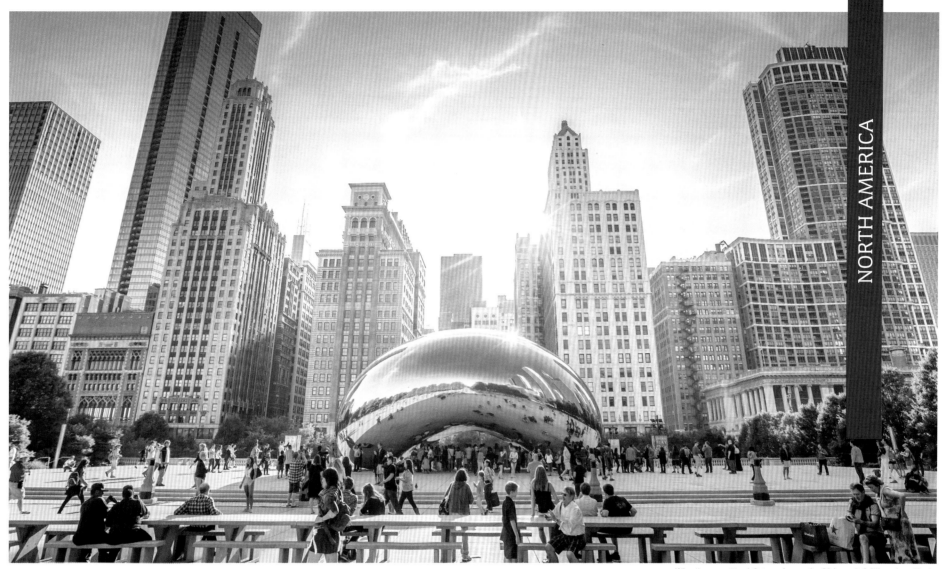

The famous *Cloud Gate* sculpture in Chicago's Millennium Park

Chicago, Illinois

Whether you know it as the Second City, the Windy City, the Jewel of the Midwest, or the City of Big Shoulders, Chicago is second to none among American tourist destinations. When the weather's nice, Chicago's world-class lakefront along Lake Michigan offers family fun at Navy Pier, the breathtaking public art and playscapes of Millennium Park, and strolls up and down the Magnificent Mile—one of the nation's premiere shopping districts. Along the Chicago River, within the city's bustling core, you can take in Chicago's iconic architecture by riverboat or on foot, along the ever-expanding Riverwalk. Downtown Chicago's not too shabby indoors, either: the world-famous museum campus offers thrilling exhibits at the Field Museum, Shedd Aquarium, and Adler Planetarium.

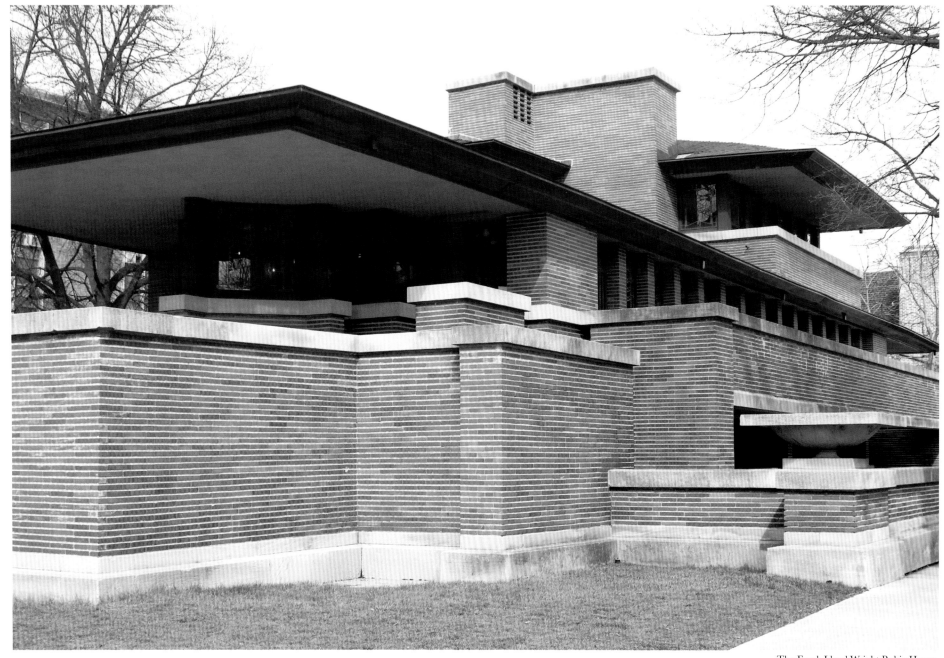

The Frank Lloyd Wright Robie House

But Chicago is home to much more than just downtown skyscrapers. A visit to Frank Lloyd Wright's Robie House of 1909 is a stunning introduction to the influential Prairie School of homebuilding. To the west, Garfield Park Conservatory provides shelter from Chicago's notorious cold snaps as well as an up-close experience with primitive ferns, more than 70 palm trees, and thousands more flowers, cacti, lilies, and other botanical attractions. Signature pizza offerings and upscale eateries across the city's neighborhoods mean no one ever travels hungry in Chicago. And there's no better place on Earth for baseball than Wrigley Field.

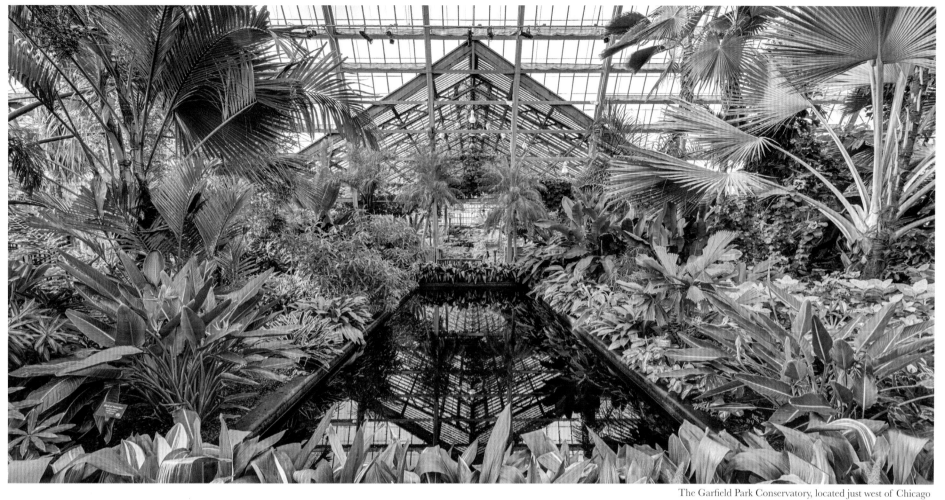

The Garfield Park Conservatory, located just west of Chicago

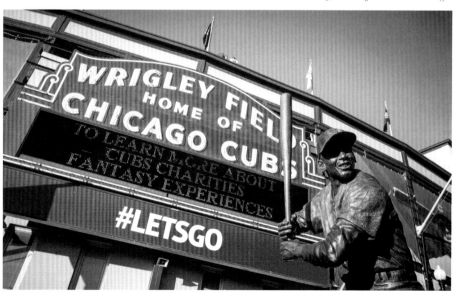

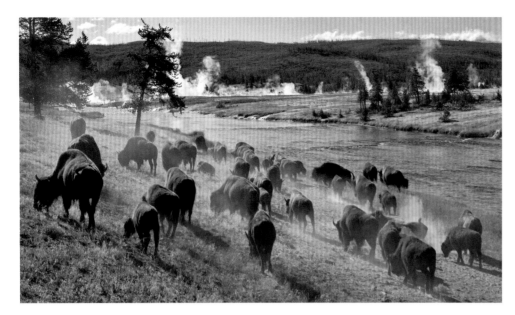

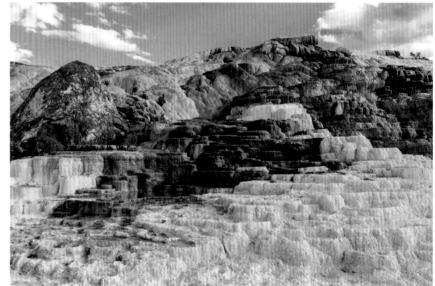

Mammoth Hot Springs

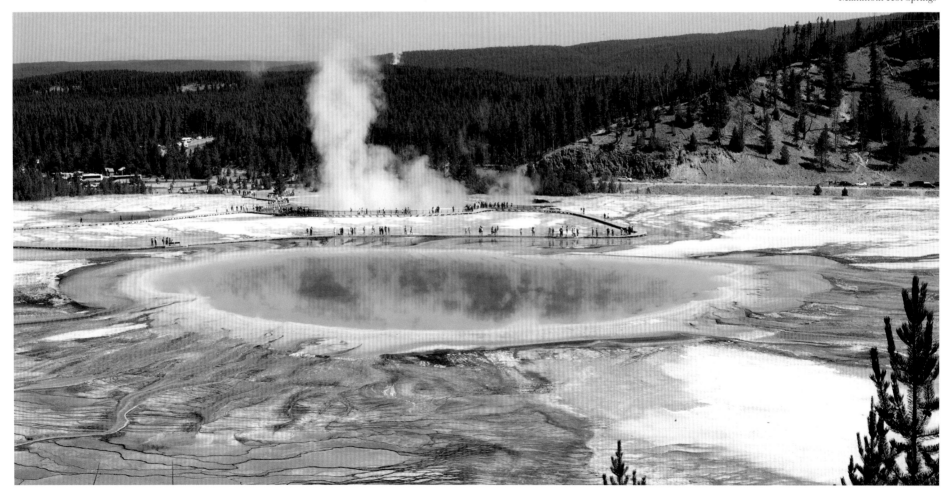

The Grand Prismatic Spring in Yellowstone is the largest hot spring in the United States.

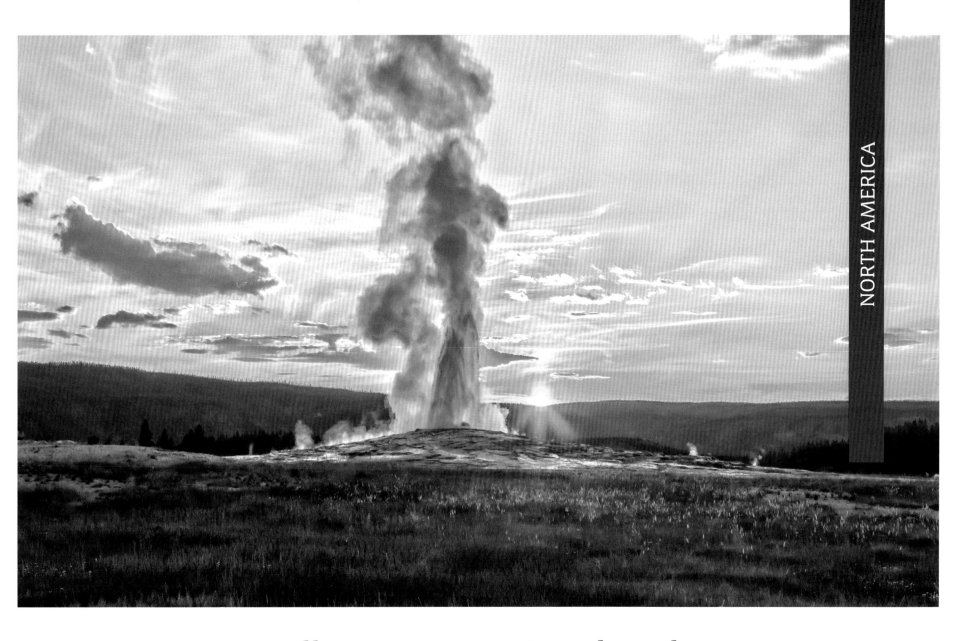

Yellowstone National Park

Yellowstone is both the United States' and the world's first national park. Established in 1872, Yellowstone boasts more than 2 million acres and an awe-inspiring collection of lakes, canyons, river, mountains, and geysers. The Grand Canyon of Yellowstone, the terraces of Mammoth Hot Springs, the Mud Volcano, and Upper Geyser Basin—home to both Old Faithful and Chromatic Spring—are just a few of the park's most recognizable features. Biologists consider Yellowstone one of the planet's most important wildlife habitats, with both Lamar and Hayden Valley ranked among the best places to spot bison, bears, elk, moose, coyote, and gray wolves.

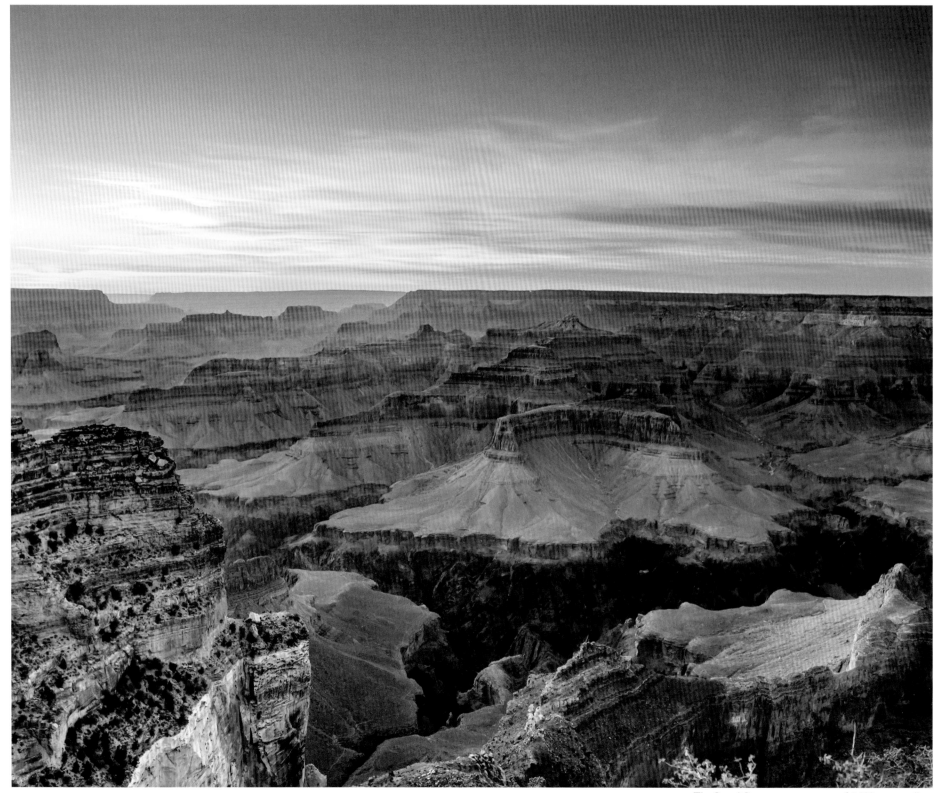

The Grand Canyon covers an area of 1,900 square miles.

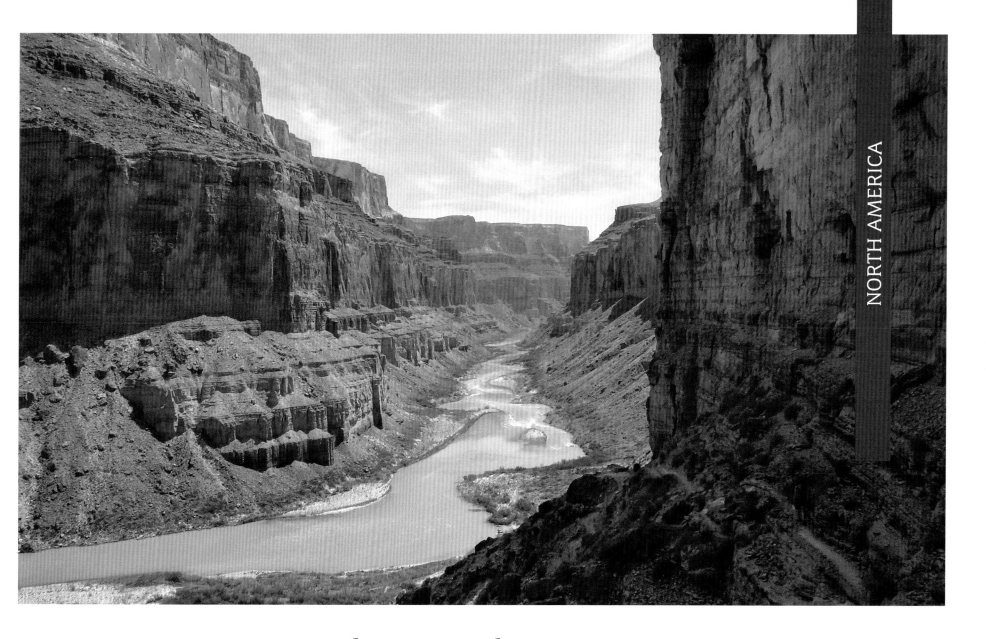

The Grand Canyon

The Grand Canyon, a mile-deep gorge in northern Arizona, might just be the most breathtaking natural attraction in the United States. Formed more than 5 million years ago by the erosive effects of the Colorado River, the Grand Canyon has been a national park for just over 100 years. The canyon's wide vistas of Redwall Limestone are marveled at by nearly 6 million visitors every year. Tourists have long enjoyed the chance to take a steep, slow journey down to the riverbed on horse- or muleback—or even by hiking on foot. While the South Rim of the canyon boasts some of the most iconic views, a trip to the North Rim offers a quieter, calmer visit with more forested surroundings and cooler temperatures on average.

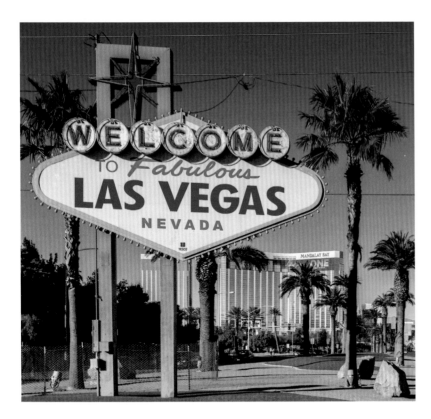

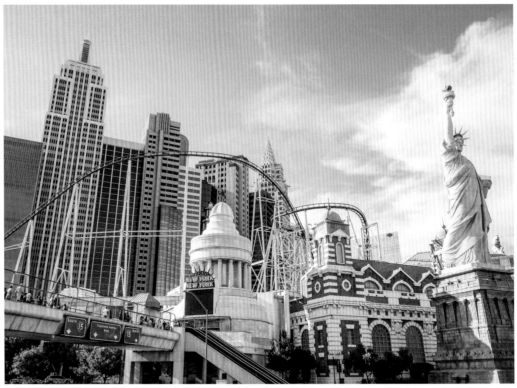

The New York-New York Hotel and Casino was designed to evoke the architecture and ambience of New York City.

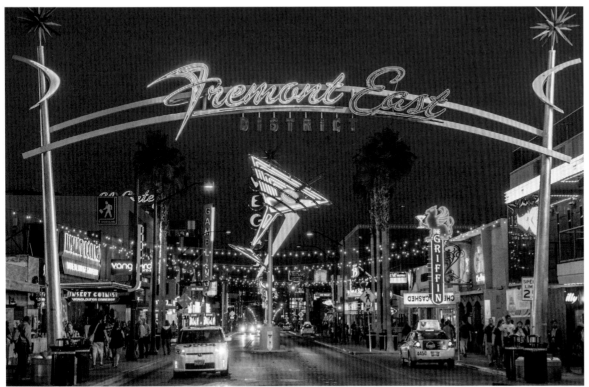

Fremont Street is known for its many famous casinos.

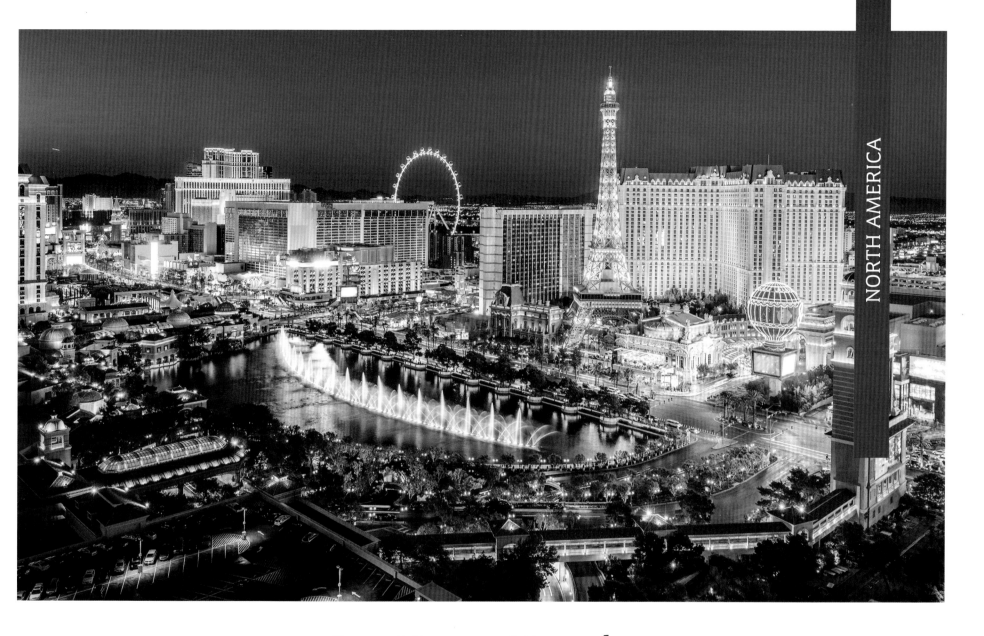

Las Vegas, Nevada

They don't call it Glitter City for nothing. A mecca for dice-rollers, wheel-spinners, and slot-stuffers, Las Vegas is also an oasis for entertainment of every kind: from live concerts and fashion shows to a roller coaster that speeds through a replica New York skyline. The Strip is where you'll find America's premiere casino resorts, the gargantuan, glitzy showbiz palaces with recognizable names like Bellagio, MGM Grand, and Excalibur. In downtown Las Vegas, Fremont Street offers the classic Vegas experience with toned-down touristic frills. On your way back to the Strip, check out the 18b Arts District or the Mob Museum, where the history of American organized crime is brought to life by interactive exhibits.

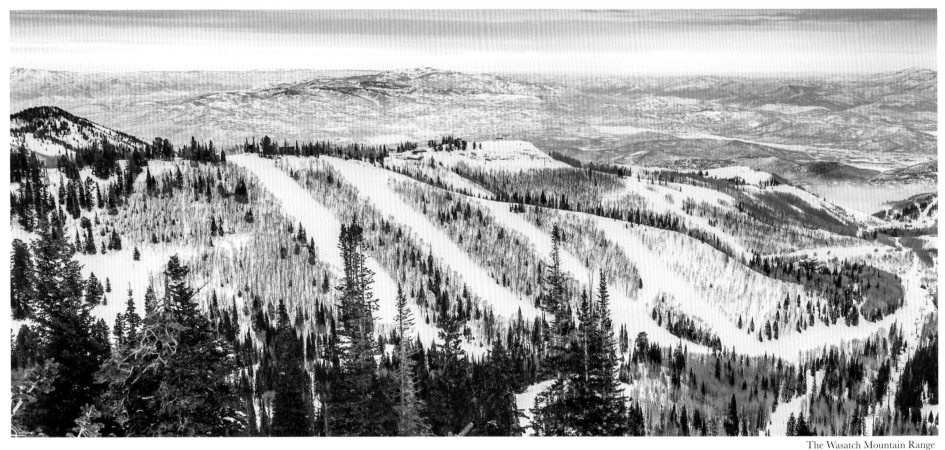

The Wasatch Mountain Range

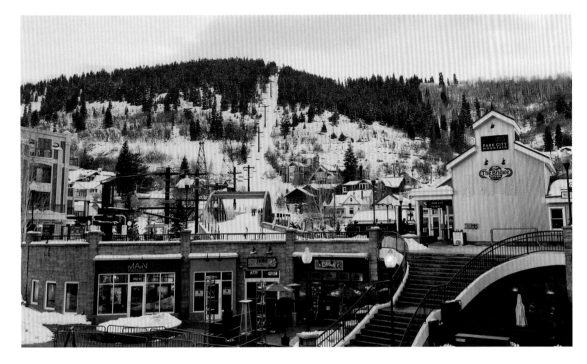

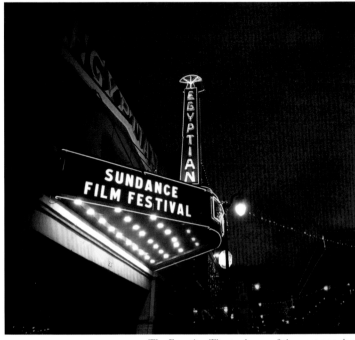

The Egyptian Theater is one of the most popular theaters during the Sundance Film Festival.

Park City, Utah

Park City, nestled about 7,000 feet above sea level in the Wasatch Back region of the Rocky Mountains, has long been a legendary destination for winter skiing. In fact, the Park City Mountain Resort alone features 324 powdery runs and 41 lifts that can elevate more than 30,000 skiers every hour. Since 1978, Robert Redford's Sundance Film Festival, held in Park City each winter, has been gaining influence. It's now the largest and most prestigious film festival in the U.S., one that launches ambitious indie movies into the mainstream every year. And at the Utah Olympic Park, built for the 2002 Winter Games, you can zip down the track at 80 mph in a real bobsled—with help from a professional driver, of course.

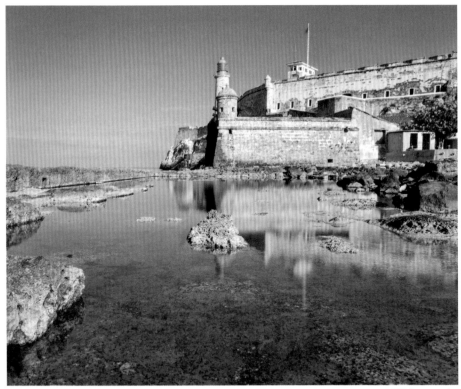

El Morro castle

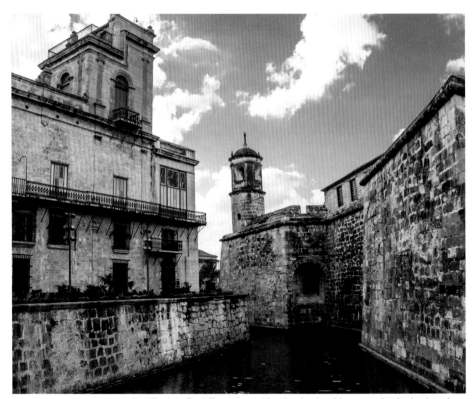

Castilla de la Real Fuerza, considered to be the oldest stone fort in the Americas

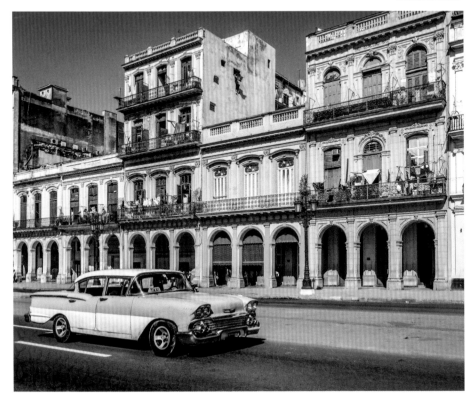

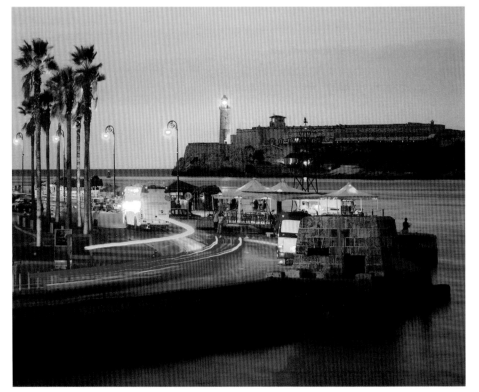

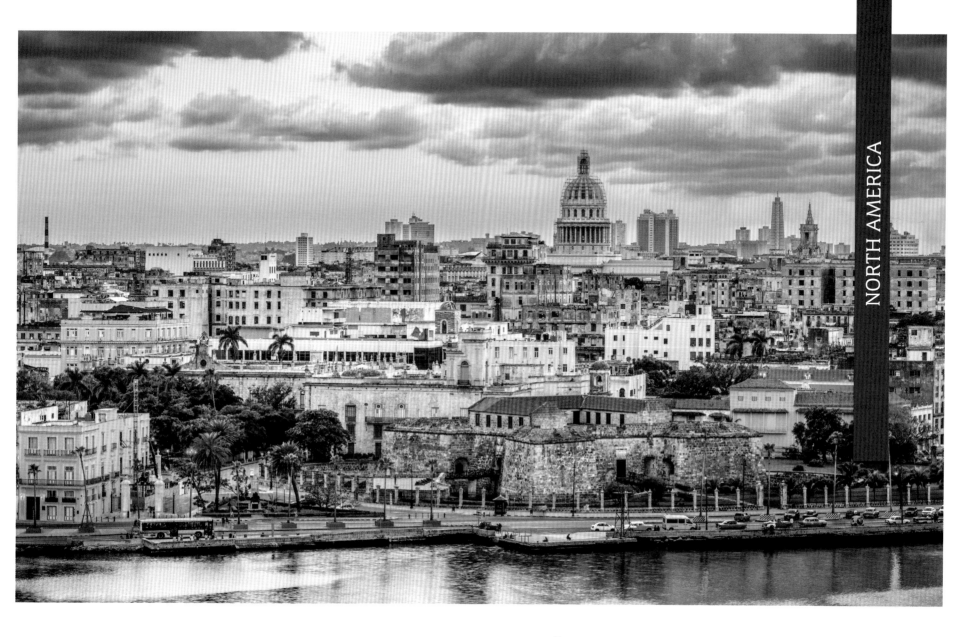

Havana, Cuba

Havana, the capital of Cuba, was once the most popular tourist destination in the Caribbean. Even today, it's perhaps the Western Hemisphere's best example of a Spanish colonial city. Dilapidated and currently undergoing major renovations, La Habana Vieja (or "Old Havana") has been a UNESCO World Heritage site since 1982. The harbor here has long been defended by several castles, including El Morro and San Salvador de la Punta, both of which are open to tourists. And Havana's romantic oceanfront esplanade, the Malecón, connects the old city to Vedado, a residential area. It's picturesque at sunset, busy with crashing waves, local fisherman, and some of the area's most ornate and rundown buildings.

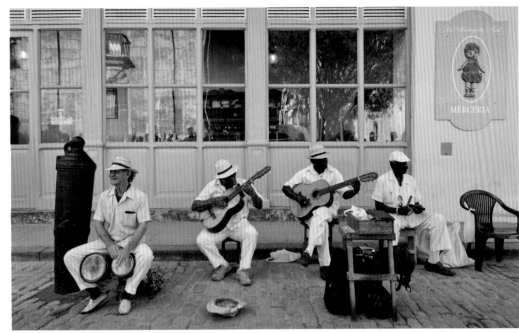
Street musicians in La Habana Vieja

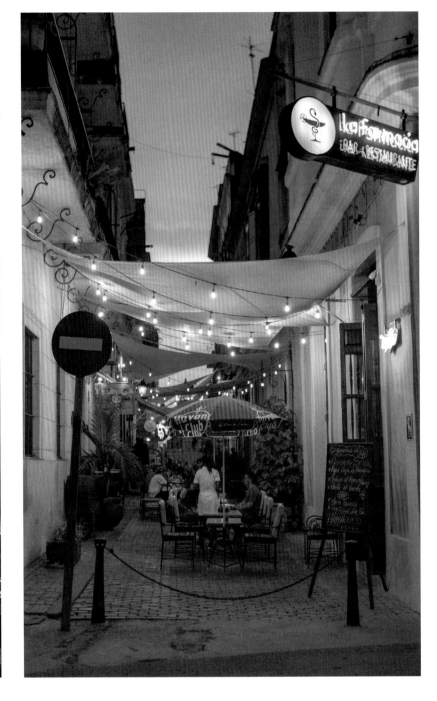

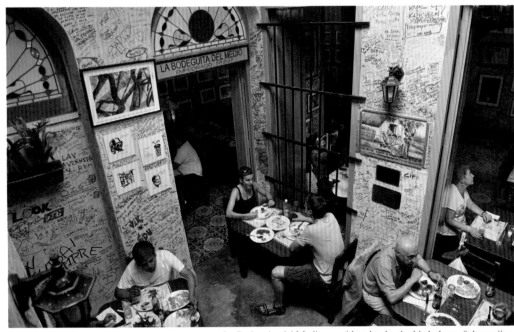
La Bodeguita del Medio, considered to be the birthplace of the mojito

In Vedado, the once-grand houses and hotels may be crumbling, but nightlife is alive and well. It's the best area in Havana for restaurants and bars filled with jazz and salsa music, and it's also the place to be for theatres, cinemas, and even classical concerts. Vedado is home to the Plaza de la Revolución, where so much of recent Cuban history unfolded. For a break from Havana's urban richness, take the short trip to Playas del Este, a string of tropical beaches that's both a bit ramshackle and a popular retreat for locals.

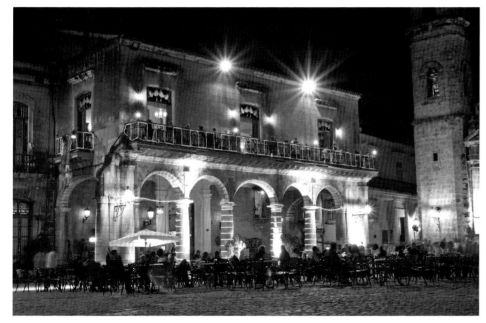

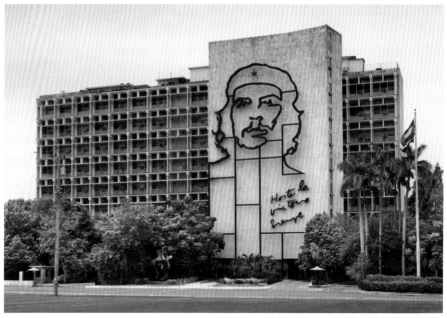

An image of Che Guevara in Plaza de la Revolución

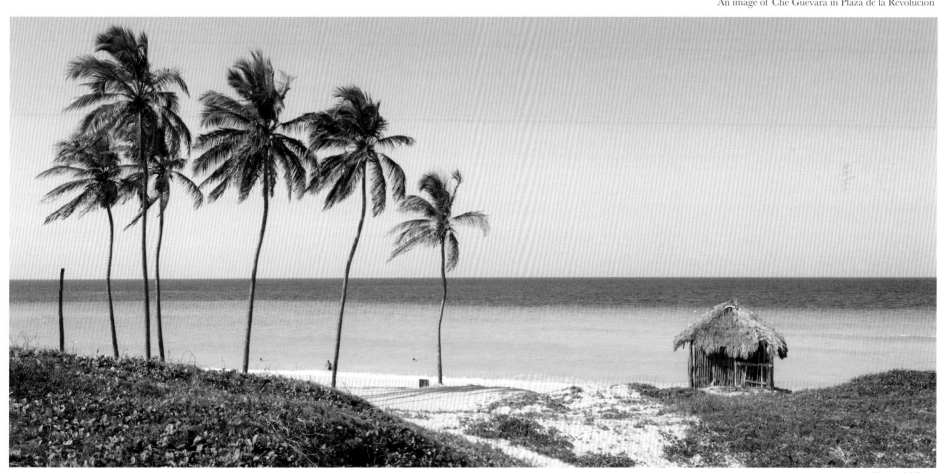

Playas del Este

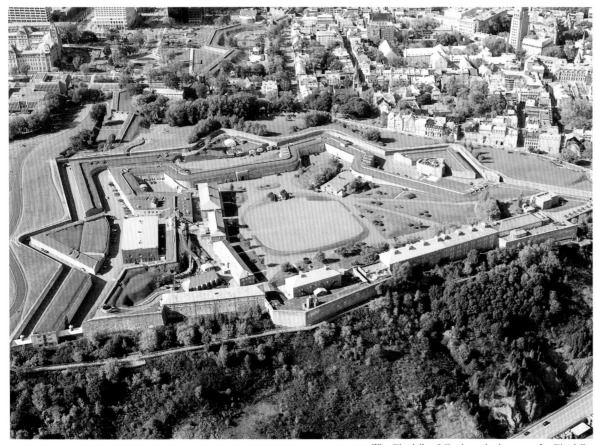
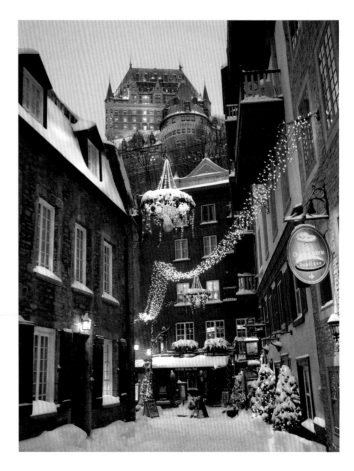

The Citadelle of Quebec, also known as La Citadelle

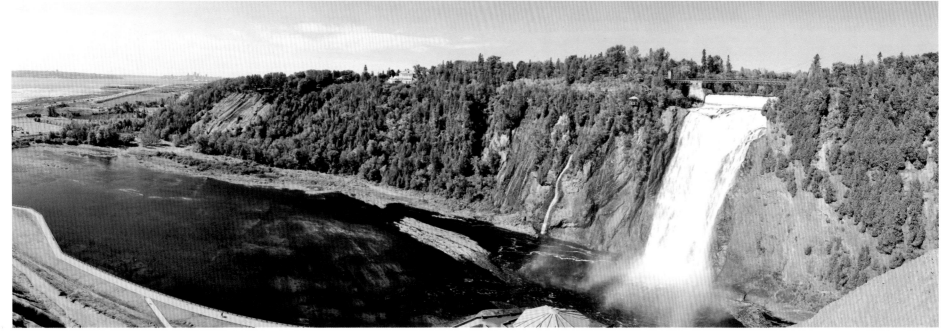

Montmorency Falls, located about 8 miles outside Quebec City

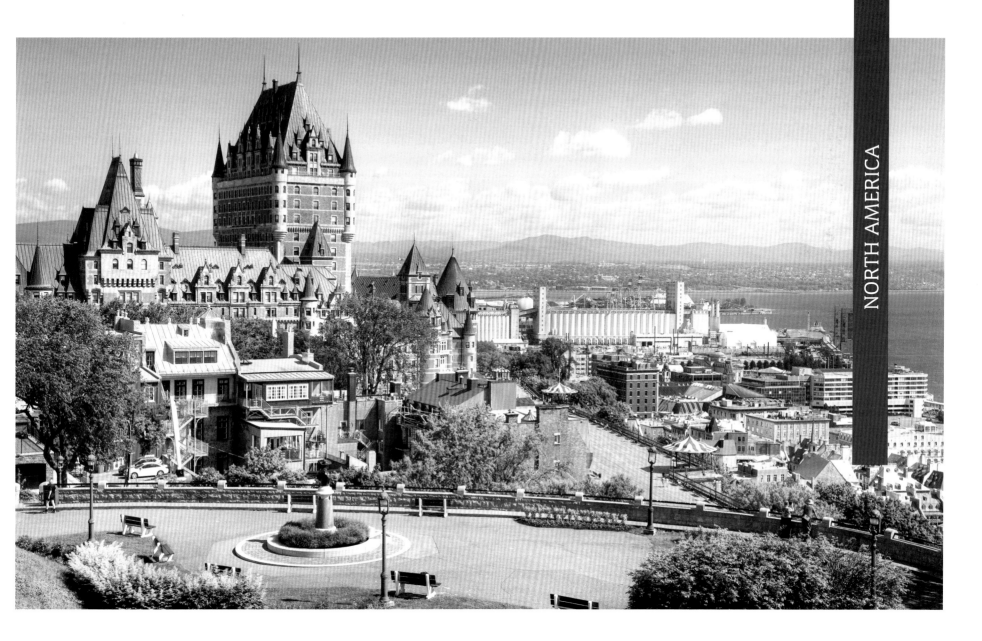

Quebec City, Quebec

The capital city of Quebec, Canada's largest province, was originally founded in 1608 by Samuel de Champlain. The historic district of Quebec City known as Old Quebec is the only remaining fortified city in North America, with stone ramparts and gates that date back as far as 1694. An architectural time capsule of French-Canadian history—whose highlights include the fort La Citadelle and the famed 1890s hotel Le Château Frontenac—Old Quebec was designated a UNESCO World Heritage site in 1985. Not far from Quebec City is gorgeous Montmorency Falls, a river cataract that falls about 30 meters farther than Niagara Falls and features a scenic boardwalk and surrounding parkland.

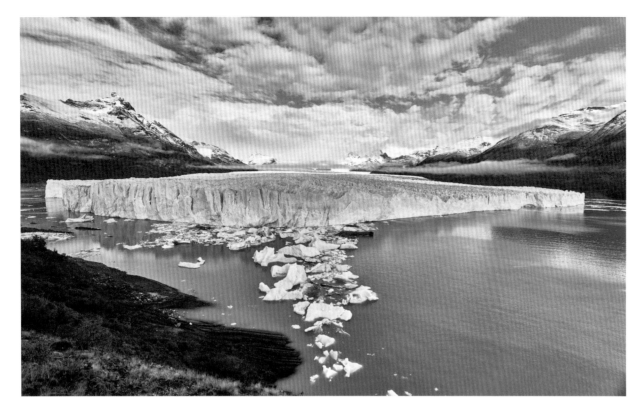

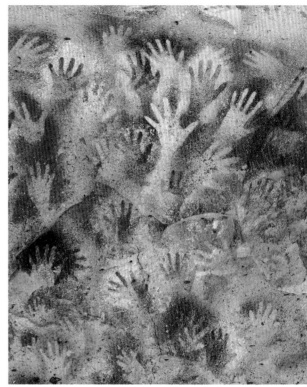

A prehistoric cave painting found in Patagonia, Argentina

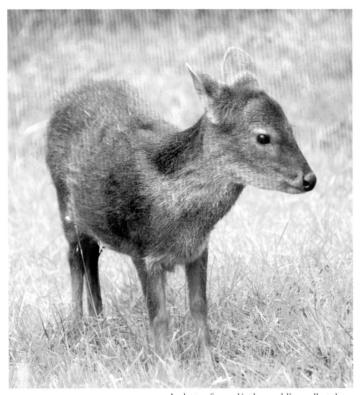

A photo of a pudú, the world's smallest deer

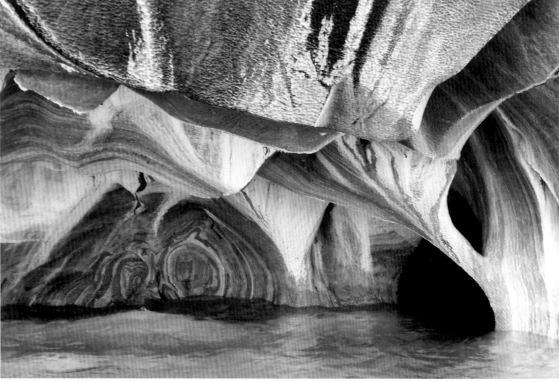

A marble cave in Patagonia, Chile

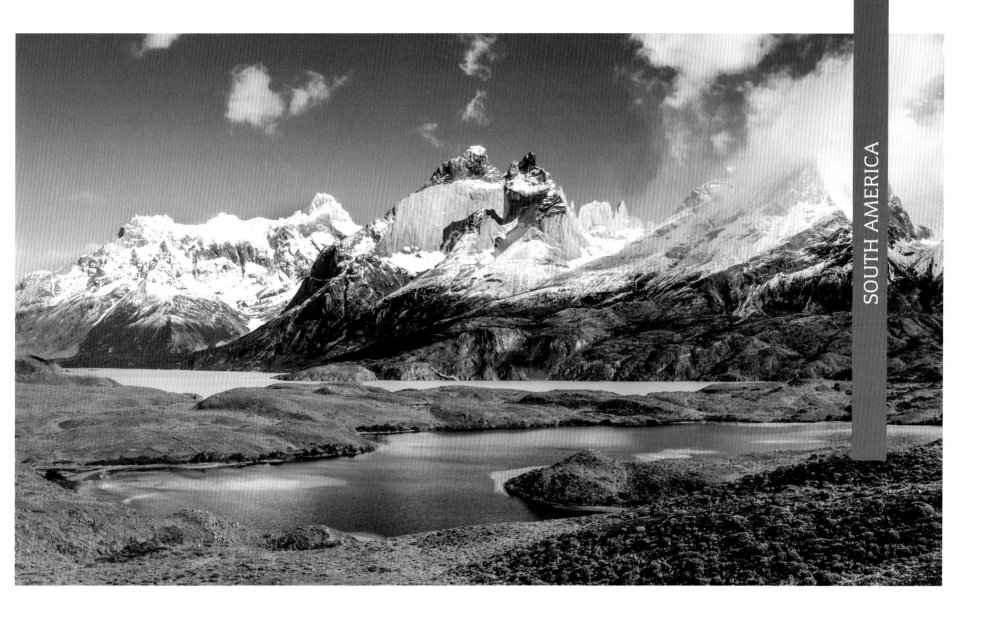

Patagonia

Patagonia is a vast and sparsely populated southernmost region of South America, stretching west from the Atlantic Ocean to the Patagonian Andes mountains. About three quarters of Patagonia is Argentinian territory, while the rest belongs to Chile. Tierra del Fuego is often included as part of the region as well. Patagonia is known best for its stunning mountain summits, its many glaciers, and its distinctive flora and fauna. This endless natural wonder and the emptiness of the region is what draws most visitors. Inside the enormous national parks of Patagonia, you can watch huge icebergs calve away from their glaciers, hike to hidden lakes, or explore a UNESCO World Heritage site that's also the forest home of the world's smallest deer, the pudú.

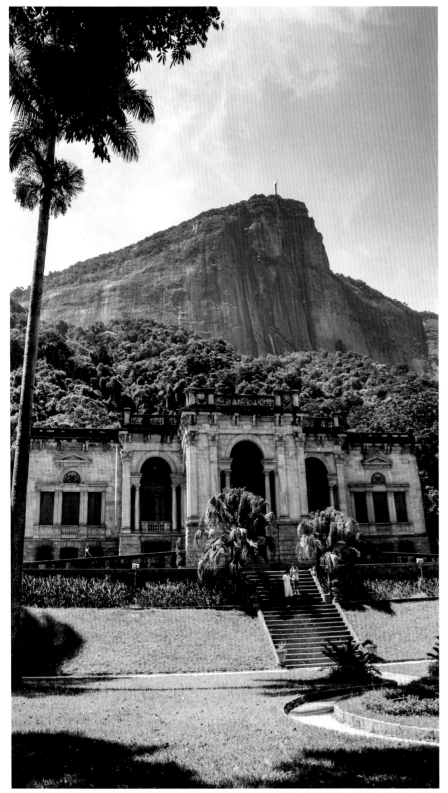

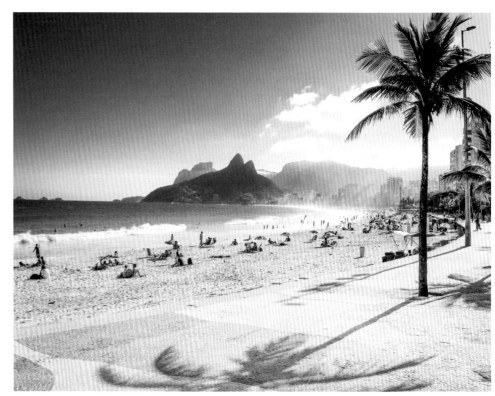

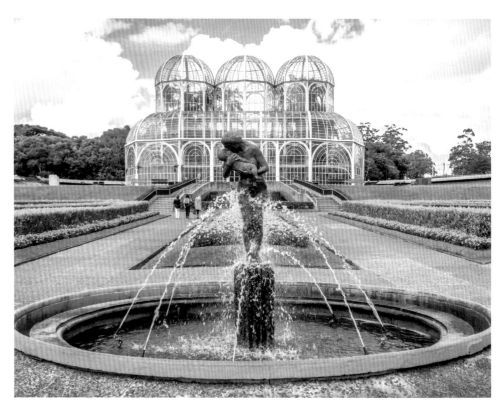

The Rio de Janeiro botanical garden

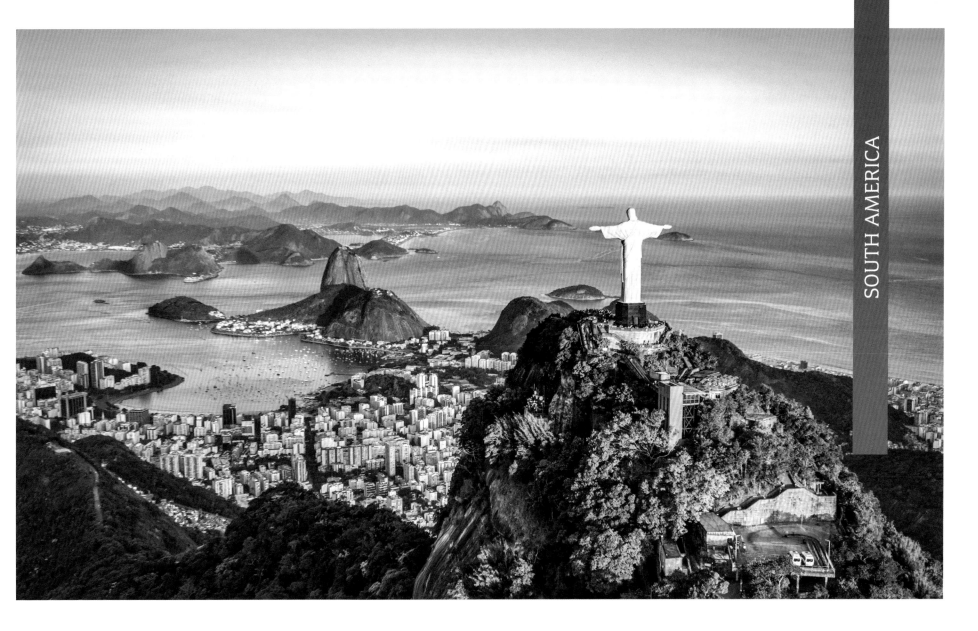

Rio de Janeiro, Brazil

Known to world travelers as Cidade Maravilhosa, or Marvelous City, Rio de Janeiro is the most popular tourist destination in the Southern Hemisphere. It's a complex playground metropolis, brimming with music and culture, so distinctive that it has an adjective of its own: "carioca" which implies anything related to Rio. The city's signature seaside landscapes became a UNESCO World Heritage site in 2012 in recognition of their natural splendor, including the peaks of Tijuca National Park, Corcovado Mountain and its iconic Christ the Redeemer sculpture, the world-famous beaches of Copacabana and Ipanema, and Jardim Botânico, a botanical garden established more than 200 years ago.

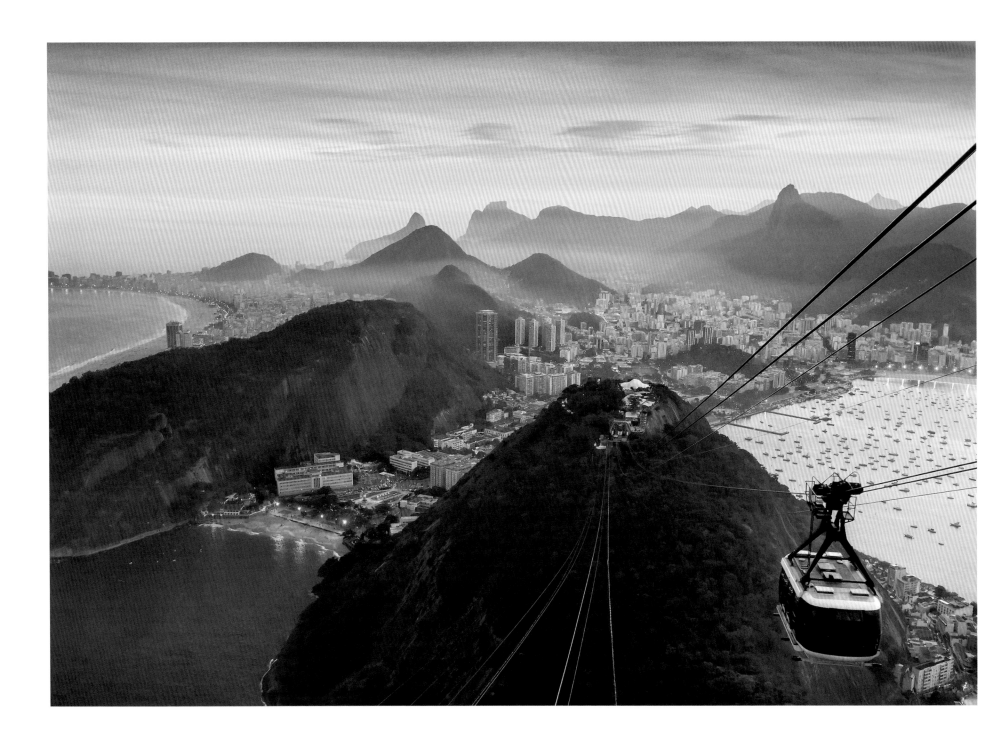

With a population of around 6.5 million, Rio de Janeiro offers more than enough to explore across an entire lifetime. One can't-miss attraction is the cable car ride to the 1,300-ft. peak of Sugarloaf Mountain, with spectacular sunset views of the city and beaches below. Closer to sea level, you can soak up South American culture at Museu Histórico Nacional or Museu de Arte do Rio, which focus on Brazilian and Cariocan exhibitions, respectively. Or explore the hundreds of ocean dwellers at AquaRio, the new downtown aquarium that's the largest in all of South America.

The Niterói Contemporary Art Museum

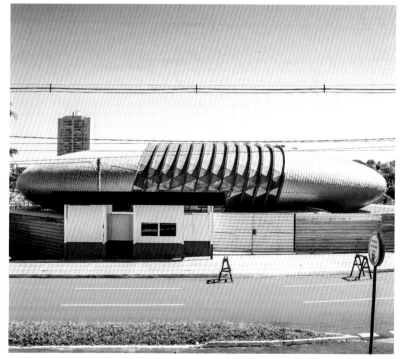

Construction of the Pantanal Aquarium

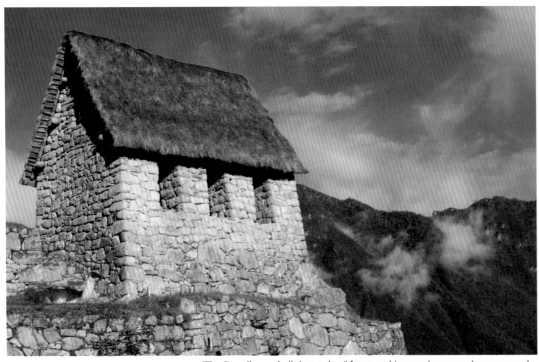

The Guardhouse, built in a style of Incan architecture known as the *wayrona* style

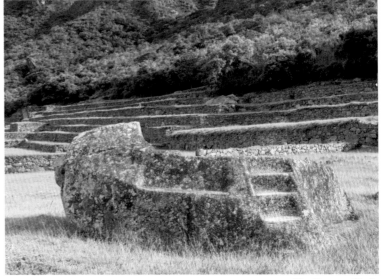

The Funerary Rock

The Temple of the Sun

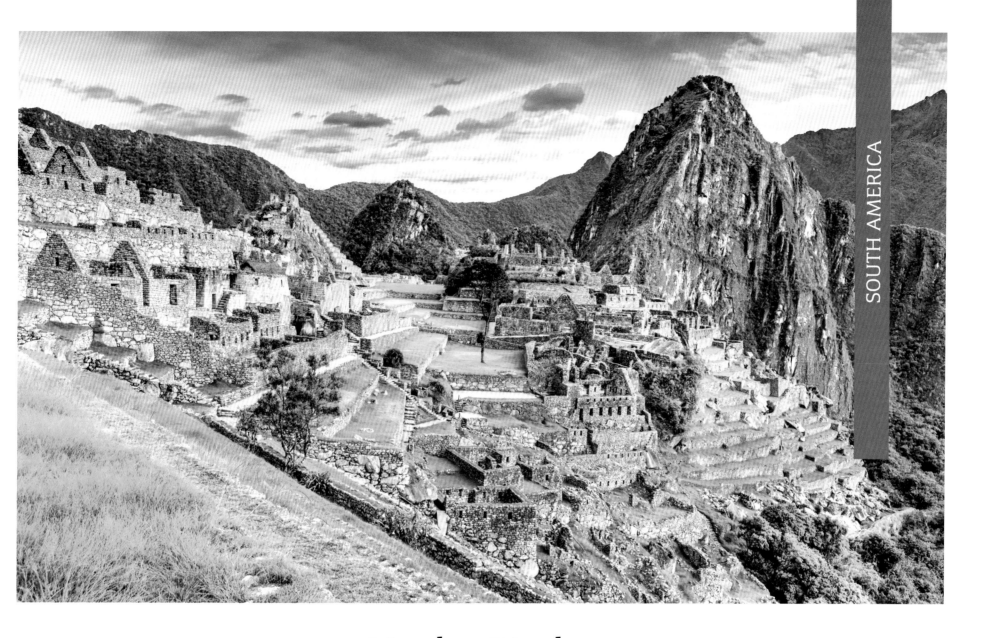

Machu Picchu

Machu Picchu, also known as the Lost City of the Inca, is an iconic symbol of Peru and the most important archeological site in all of South America. Discovered in 1911, the immense stone structures of the Incas, probably built around 1450 AD, have been a UNESCO World Heritage site since 1983, as well as being counted among the New Seven Wonders of the World since 2007. Once you've made it to the site above the valley at some 8,000 feet of altitude, you can visit the Guardhouse and Funerary Rock for mind-blowing views, see an Incan astrological wonder called the Temple of the Sun, or take a challenging hike up the Huayna Picchu trail.

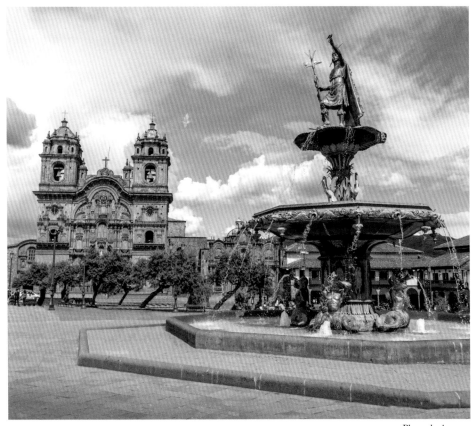
Plaza de Armas

The Santo Domingo Convent uses a blend of colonial and Incan architecture.

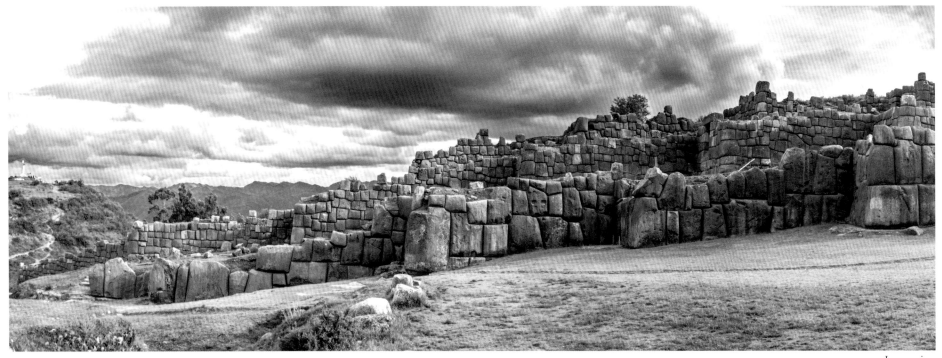
Incan ruins

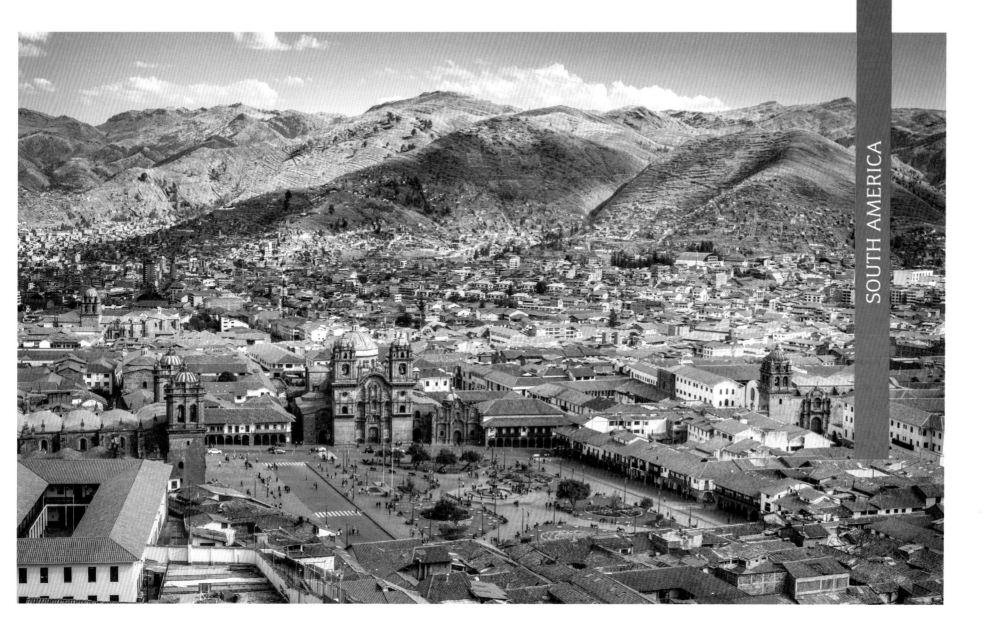

Cusco, Peru

Cusco, perched high in the Andes Mountains at around 11,000 feet above sea level, is both a gateway for many a tourist's trip to Machu Picchu or the Sacred Valley of the Inca. It's also a showcase for ancient and colonial architecture alike. In Cusco, massive walls built by the Incas share space with Catholic cathedrals completed almost 500 years ago. There's an Incan temple called Qorikancha that once featured gold-plated walls. And you can take a tough 40-minute walk to Sacsayhuaman—an Incan fortress that rivals Machu Picchu's marvels—right from the centrally located colonial main square known as Plaza de Armas.

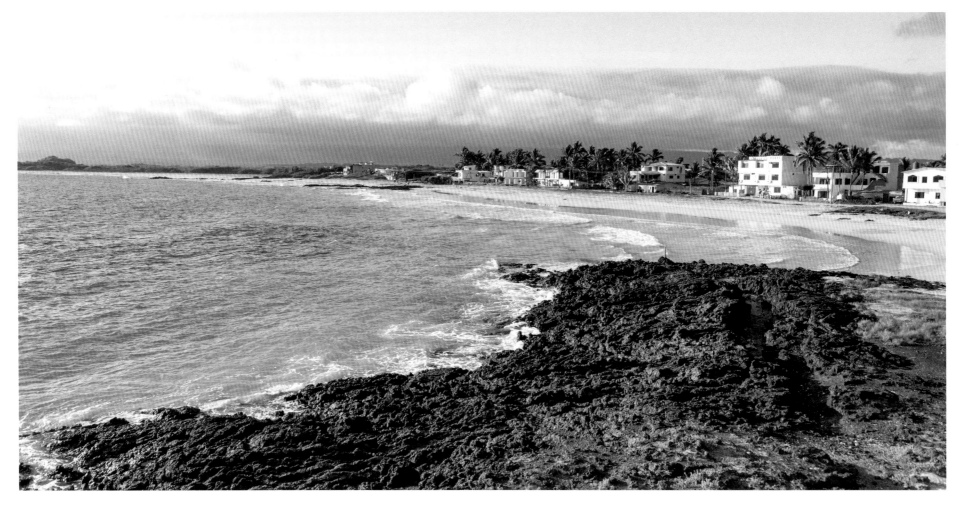

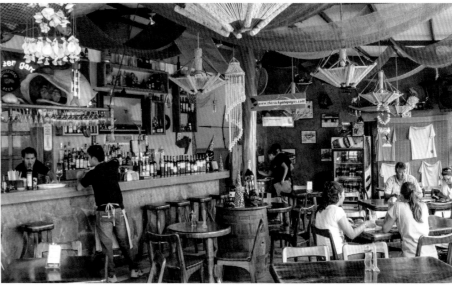

The Galápagos Islands have numerous restaurants and hotels
to serve the growing number of tourists who visit.

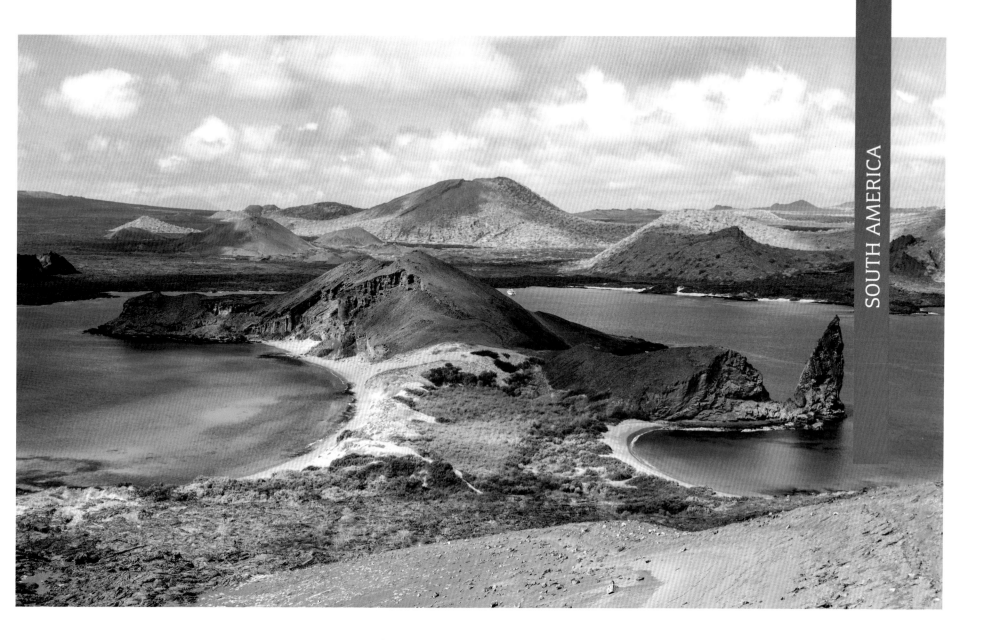

Galápagos Islands

Most people know Galápagos as the isolated, biodiverse island chain that helped inform Charles Darwin's ideas about natural selection. But did you know that today the volcanic archipelago about 600 miles west of Ecuador is home to more than 35,000 people? Of the 19 total islands, only a handful are inhabited by humans. Tourists began exploring the Galápagos in the 1930s, and today the islands receive around 150,000 visitors every year. Although most sightseers stay on cruise ships that dock at various ports around the archipelago, Galápagos has a growing number of hotels and eateries where one can rest and refuel between outings into an unspoiled natural habitat.

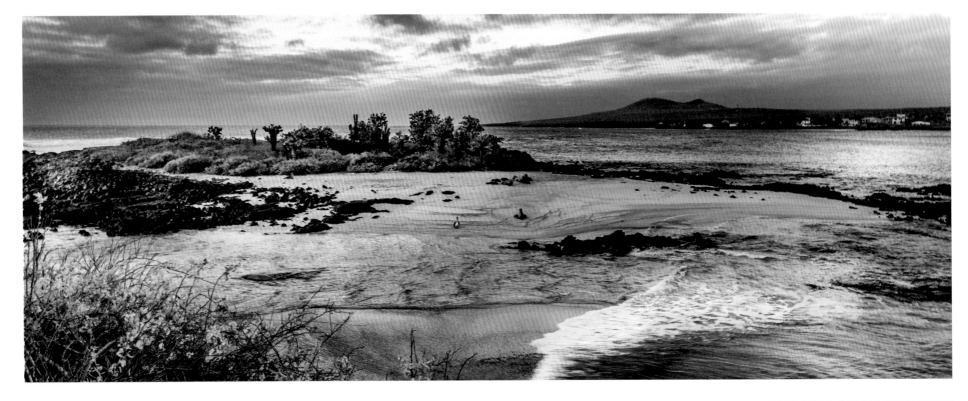

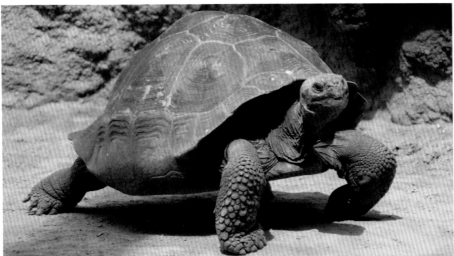

The Galápagos giant tortoise

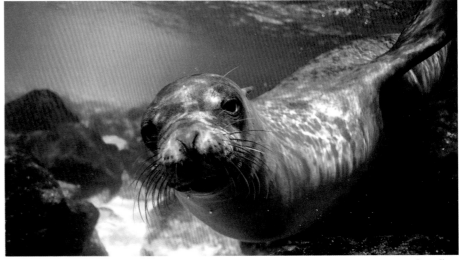

A sea lion

On the Galápagos Islands, most of the mammals, reptiles, and land birds you encounter can be found nowhere else on Earth. The Galápagos giant tortoises might be the most famous animal ambassadors, but there are also the endemic sea lions who'll swim right up to divers, sea-going lizards like the marine iguanas, and distinctive feathered fauna including the blue-footed booby and the waved albatross. Quick-footed and colorful, Sally Lightfoot crabs patrol the black volcanic rocks of Galápagos coastlines. And lucky snorkelers can catch a glimpse of Galápagos, hammerhead, and whale sharks, that—while not unique to the islands—are a thrilling feature of the surrounding waters.

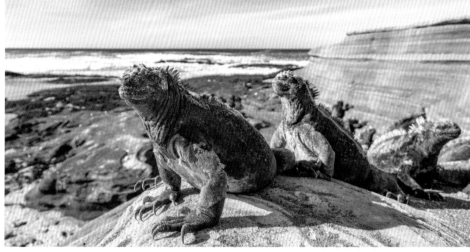
Marine iguanas

The blue-footed booby's characteristic blue feet come from pigments obtained through its diet.

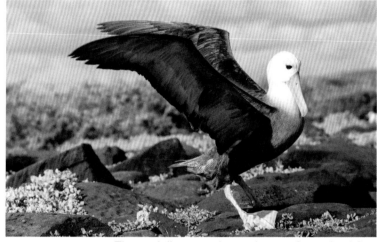
The waved albatross can have a wingspan of more than 8 feet.

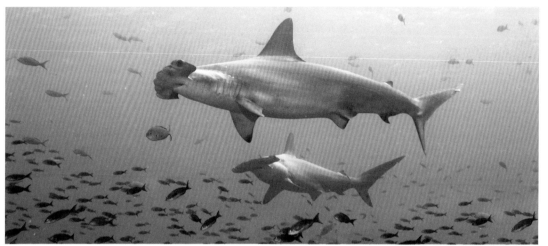
A hammerhead shark

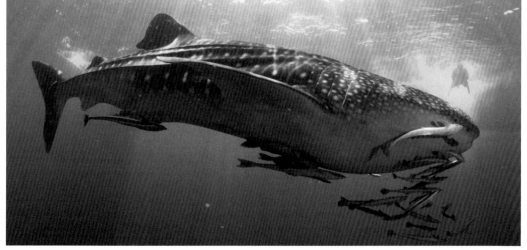
A whale shark

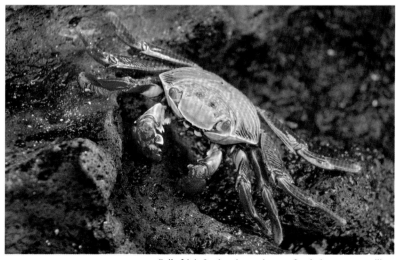
Sally Lightfood crabs are known for their extreme agility.

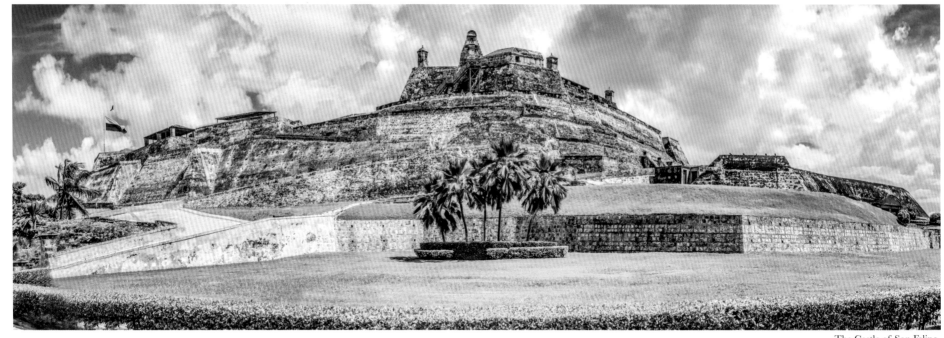

The Castle of San Felipe

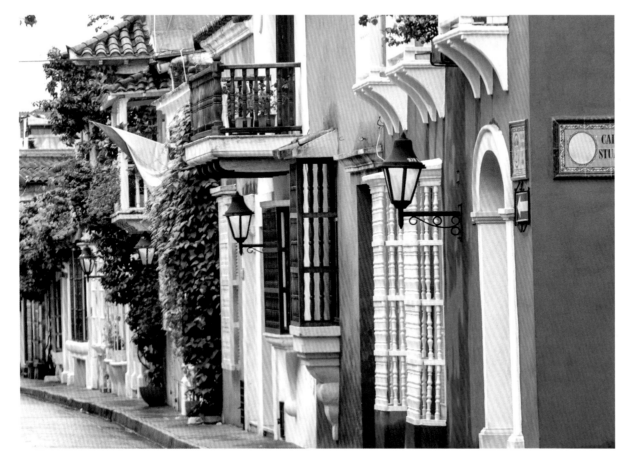

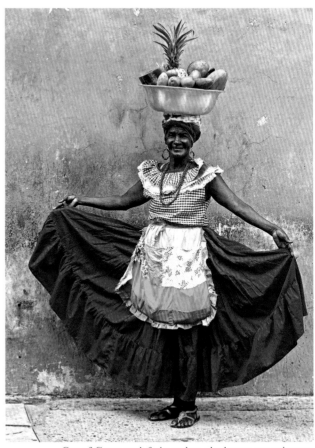

One of Cartagena's fruit vendors, also known as a *palenquera*

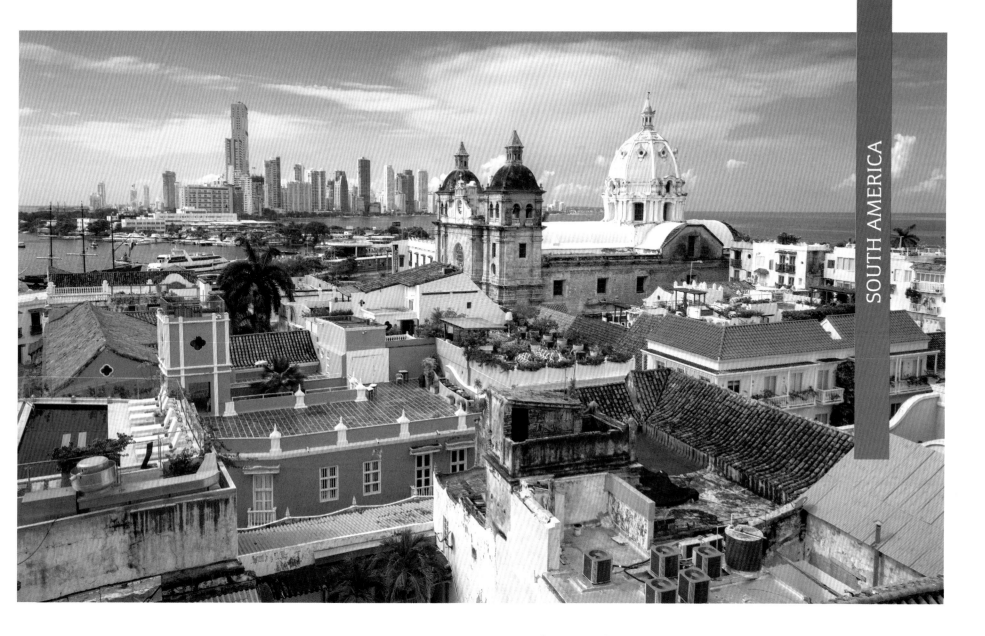

Cartagena, Colombia

Founded in 1533, Cartagena is now Colombia's fifth largest city. Independence from Spain came to Cartagena in 1811, after which the city's Old Town slowly came to represent one of the Western Hemisphere's great collections of colonial architecture. In fact, Cartagena's colonial walled city and fortress were designated a UNESCO World Heritage site in 1984. In Old Town, some of the historic structures have been carefully restored, while others have been left to deteriorate. Colors abound on the streets of the city, not only on the facades of homes that are many centuries old, but also on roadside souvenir stands and in the traditional clothing of Cartagena's fruit vendors.

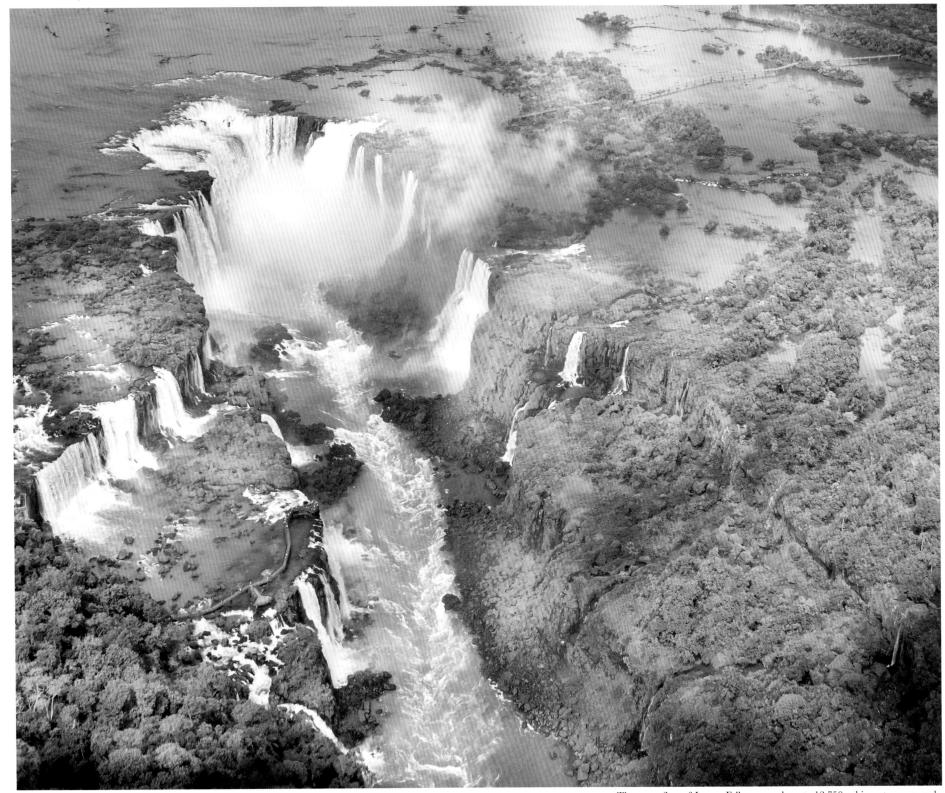

The water flow of Iguazu Falls can reach up to 12,750 cubic meters a second.

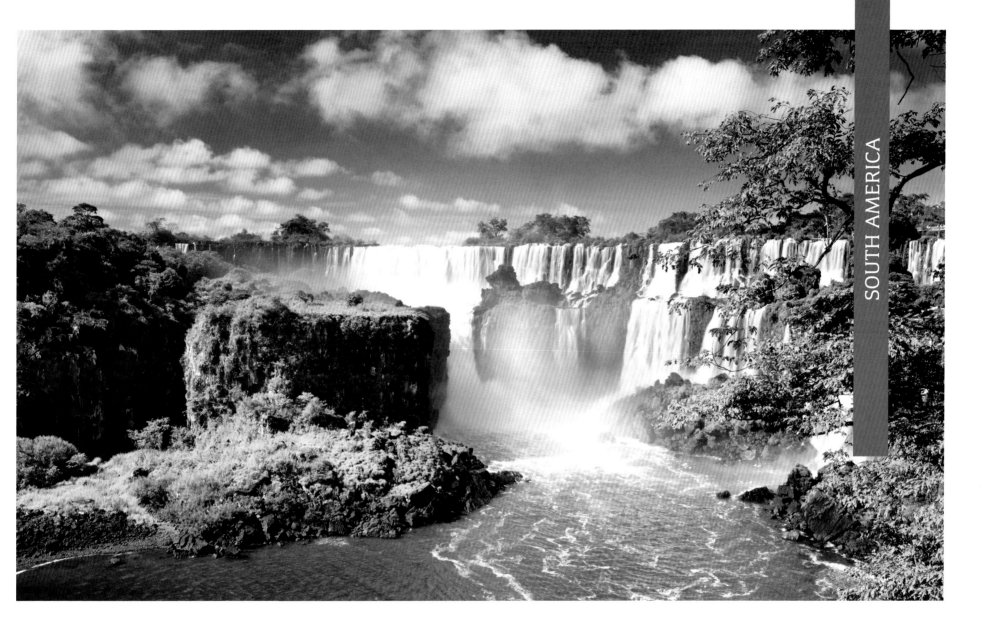

Iguazu Falls

Located on the Iguazu River at the border between Brazil and Argentina, the Iguazu Falls are probably the world's most magnificent waterfalls. Amazingly, Iguazu is actually a collection of 275 total falls along about 1.7 miles of the river. The main attraction at Iguazu is Devil's Throat, a horse-shoe-shaped set of 14 falls that descend around 80 meters, sending up enormous plumes of mist. The bravest souls who come to Iguazu can even take a thrilling boat ride directly into the plummeting cascades of river water. Away from the water, the surrounding inland rainforest is home to thousands of species of plants, birds, mammals, and insects.

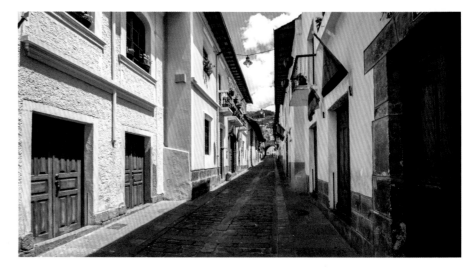

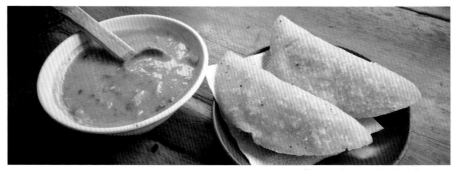

The Basilica of the National Vow—the largest neo-Gothic basilica in the Americas

Empanadas served with chili sauce

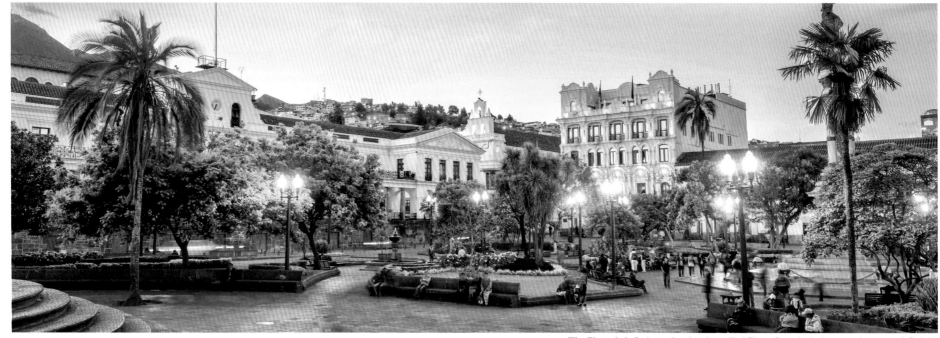

The Plaza de la Independencia, also called Plaza Grande, is the central square of Quito.

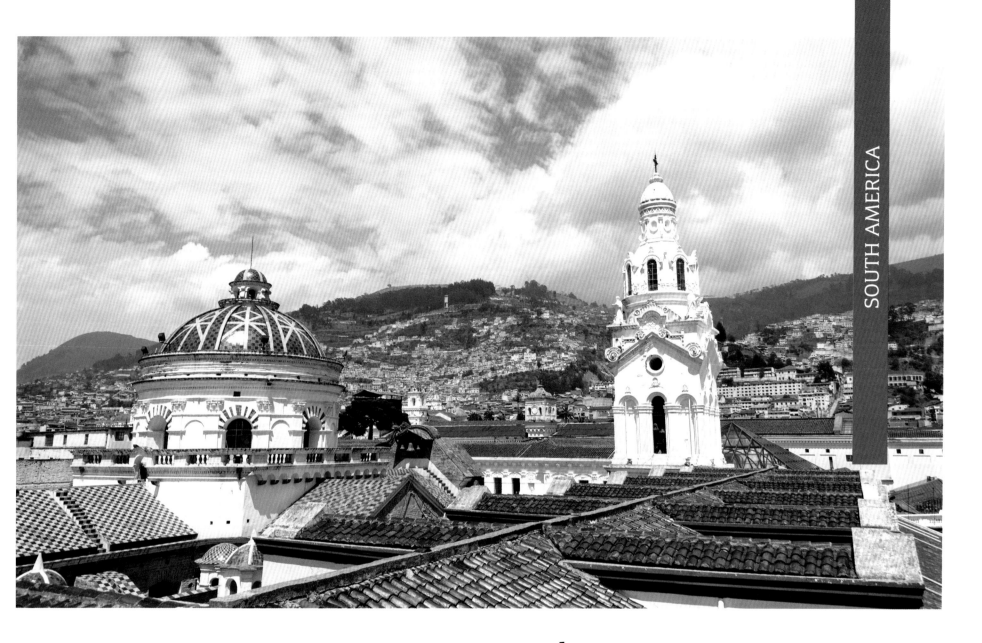

Quito, Ecuador

Quito, the capital city of Ecuador, is the nation's largest city, perched high in the Andes Mountains at more than 9,000 feet of elevation. It was founded in 1534 and was previously the site of an important Incan city. Quito's Old Town is a UNESCO World Heritage site that features cobblestone streets, Colonial squares, and many historic churches and chapels, including Iglesia de la Compañia de Jesús, an ornately gilded Jesuit church completed in the 1760s. Other Old Town highlights include La Ronda, a picturesque pedestrian way that offers chocolate makers, silversmiths, traditional foods, and more, before becoming lively with music by night.

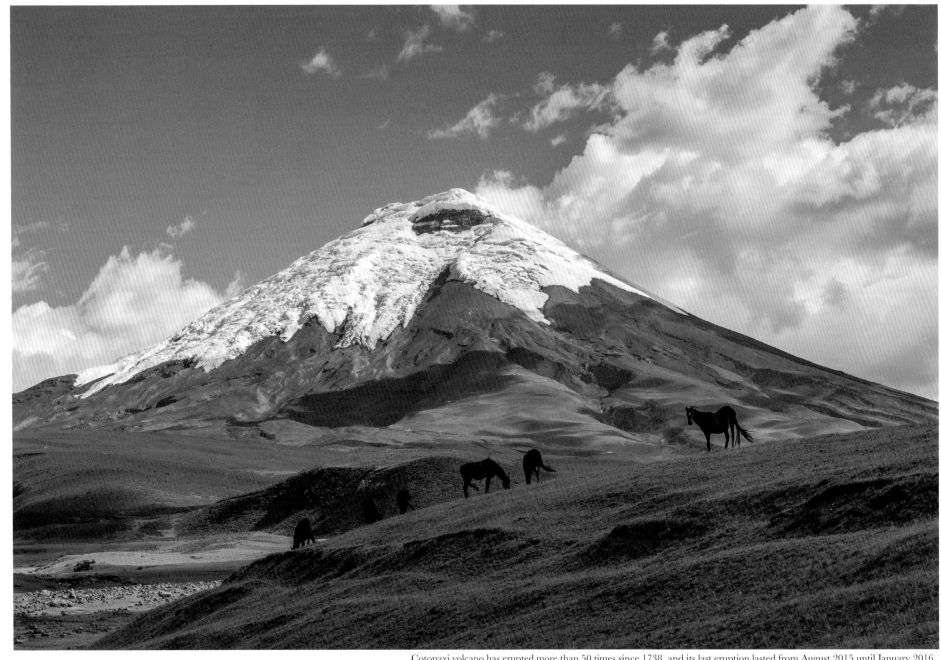

Cotopaxi volcano has erupted more than 50 times since 1738, and its last eruption lasted from August 2015 until January 2016.

Given Quito's place in the Andean heights, it's no wonder that visitors go to great lengths to take in its spectacular views. There's an aerial tram known as the TeleferiQo, which can get you to the 12,000-foot top of a dormant volcano in 20 minutes—and provides breathtaking looks at Cotopaxi, one of South America's most active volcanoes. Overlooking the city, La Capilla del Hombre is a recreation of a pre-Columbian temple, designed by perhaps Ecuador's most important artist, Oswaldo Guayasamín. You can even gaze at cloud-covered mountains while lounging in a hot-springs bath at Termas de Papallacta.

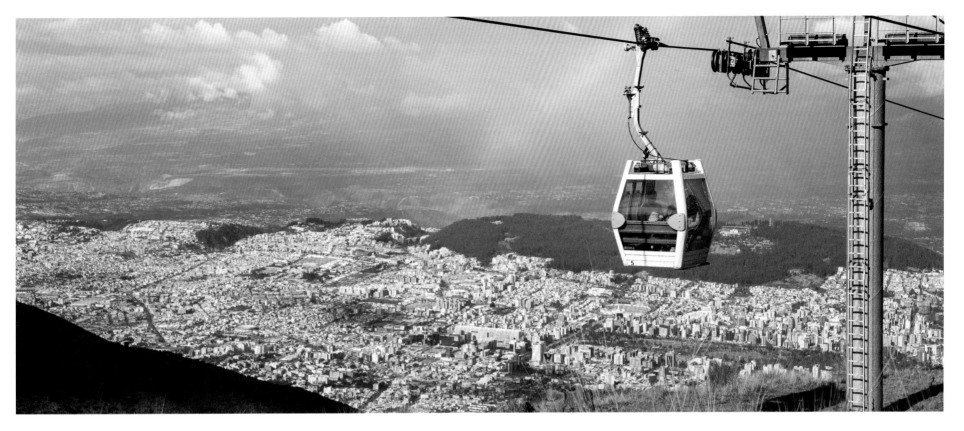

Termas de Papallacta hot springs

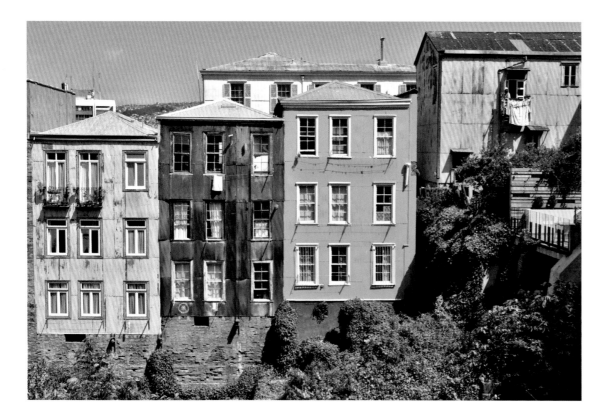

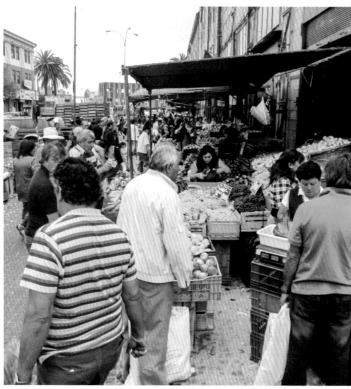

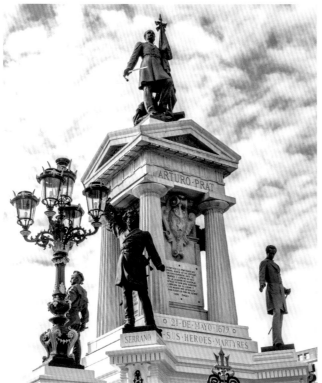

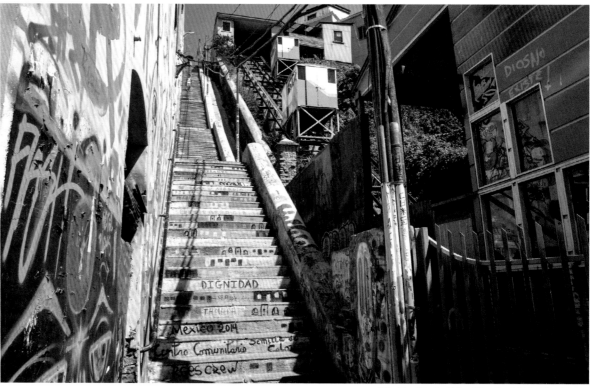

A statue dedicated to Chilean war hero Arturo Prat

The Semilla de Color ("Seeds of Color") staircase

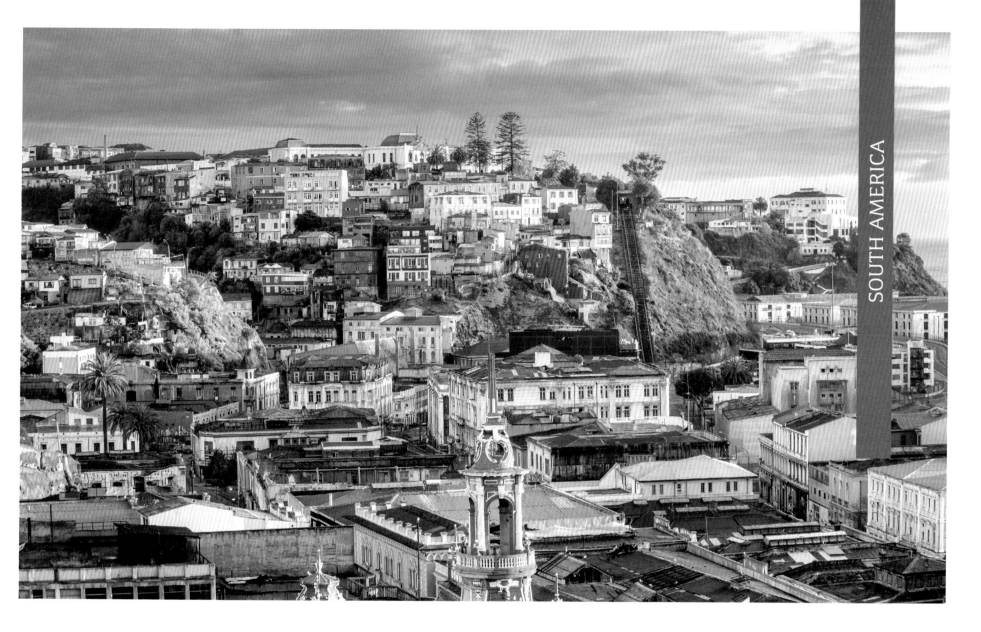

Valparaiso, Chile

Valparaiso is a seaport city that's centrally located on Chile's long Pacific coast, about 84 miles west of the capital city of Santiago. With a population of nearly 300,000 people, Valparaiso features a historic quarter that's comprised of five fused neighborhoods. Santo Domingo Square preserves important 19-century seaport architecture, while Echaurren Square consists mostly of markets and street traders. In Prat Pier, sizable public spaces characterize the area, and the Prat Street neighborhood features a monument to a Chilean war hero. Finally, there are the promenades and views of the Cerro Alegre and Cerro Concepción hills, which visitors can traverse using the city's famed funicular elevators.

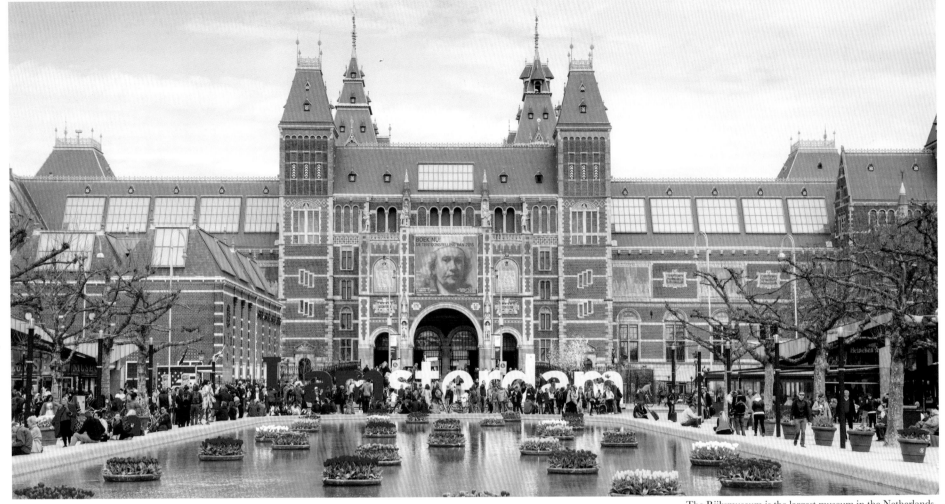
The Rijksmuseum is the largest museum in the Netherlands.

The entrance to the Artis Zoo

A stroopwafel

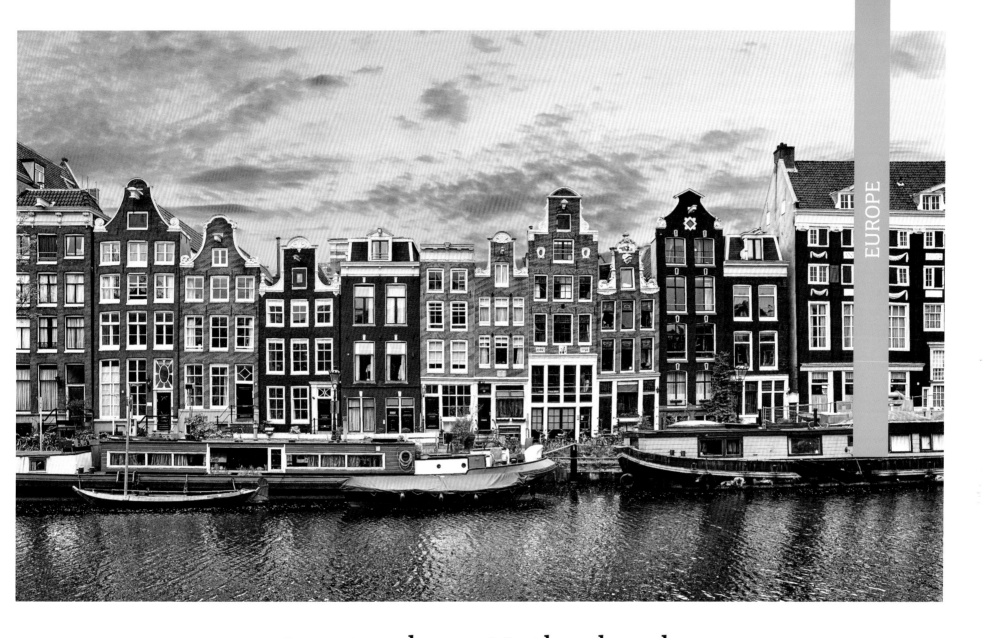

Amsterdam, Netherlands

Amsterdam, the capital city of the Netherlands, is home to around 850,000 permanent residents, but the city's characteristic canals and houseboats attract more than 20 times that number of visitors every single year. Beyond Amsterdam's charming waterways, there's no shortage of cultural attractions, including the Rijksmuseum and its collection of over 1 million works of art, including priceless pieces by Rembrandt, Vermeer, Hals, and others. Whatever your speed, you'll find a suitable brewery, coffeeshop, public park, or zoo—like Artis Zoo, one of the world's oldest. And don't forget to treat your tummy to a stroopwafel, a sort of wafer-like waffle with a delectable syrupy caramel middle.

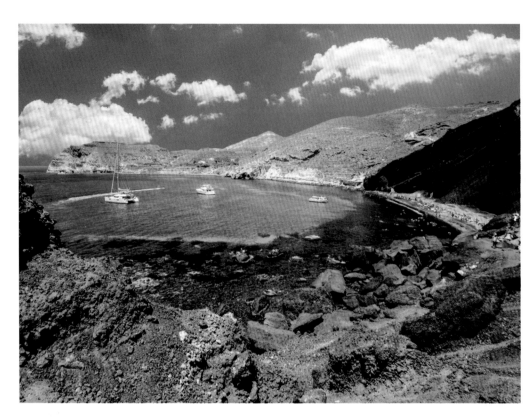

Ruins at Akrotiri

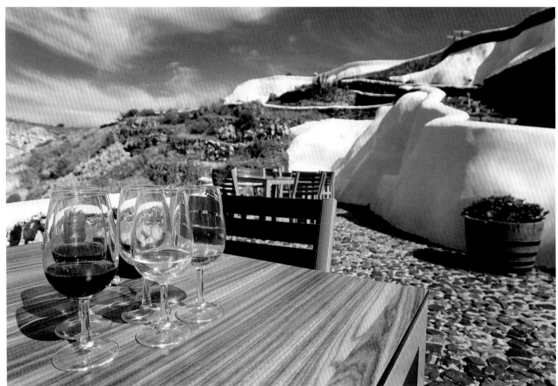

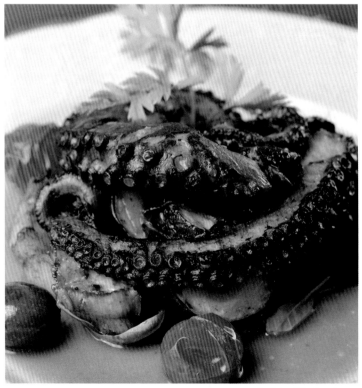

A plate of fresh octopus

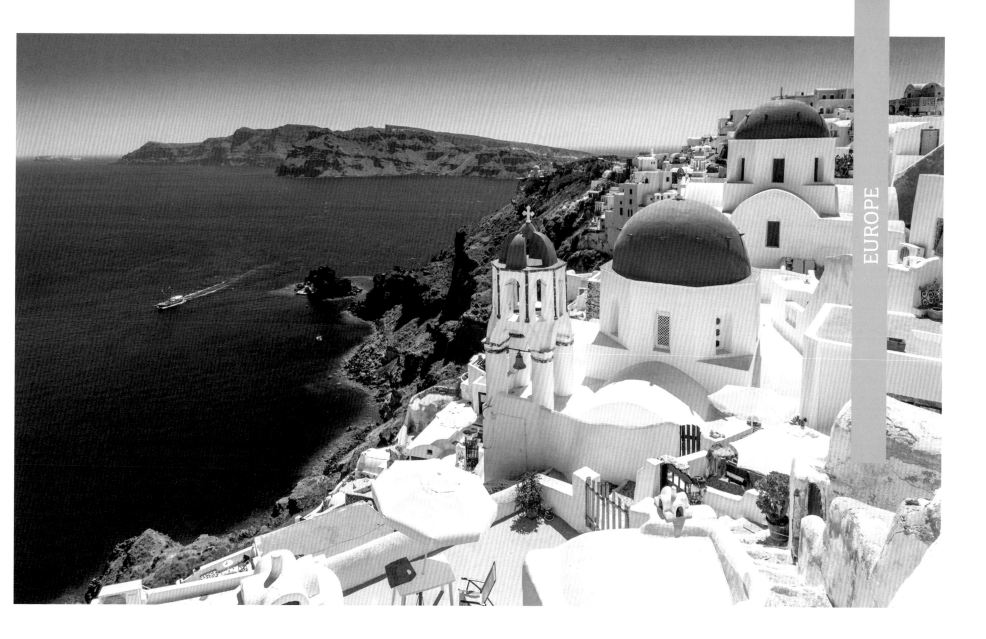

Santorini, Greece

Santorini is what most people probably picture when they think of the Greek Isles. The volcanic caldera island in the southern Aegean Sea is famed for its starkly hued white-and-blue towns, like Oia, poised high on a cliff about 300 feet above the ocean. Near Akrotiri, on the southern end of the island, visitors can explore the ruins of a Bronze Age Minoan town wiped out long ago by a volcanic eruption. It may even have inspired Plato's tales of Atlantis. After taking in your fill of ancient history, you can soak up Mediterranean rays on black or red sand beaches, tour noted Grecian wineries, or dine on fresh octopus while enjoying a sunset on Amoudi Bay.

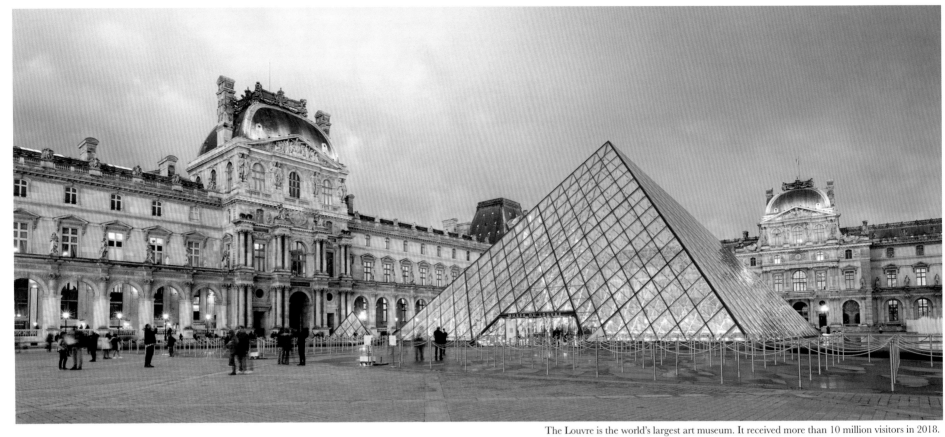

The Louvre is the world's largest art museum. It received more than 10 million visitors in 2018.

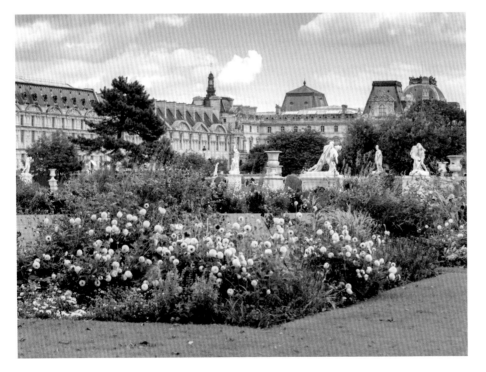

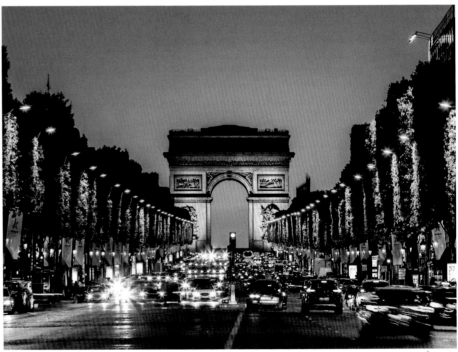

The world-famous Champs-Élysées

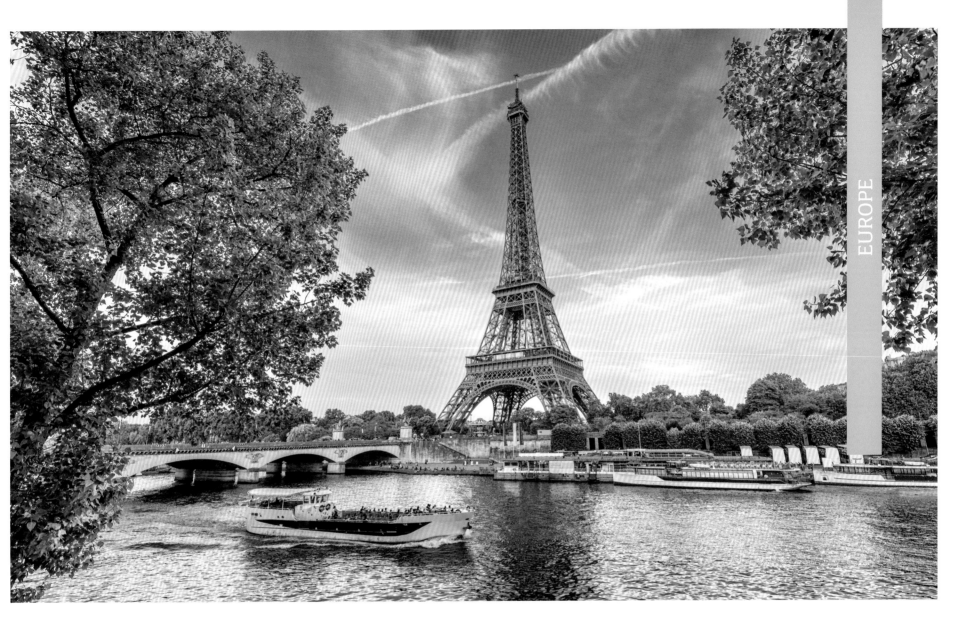

Paris, France

Paris has been known as the City of Lights since 1878, when it led Europe in its use of electric street lighting. Today, it's known as the center of world fashion and as a captivating metropolis filled with iconic structures including the Eiffel Tower, the Palace of Versailles, and Sacré-Cœur Basilica. Almost everyone takes a stroll down the famed Champs-Elysées, past the monumental Arc de Triomphe or through the manicured and sculpture-dotted Tuileries Gardens. Just east of the Gardens is the Louvre Museum, the world's largest art museum and an absorbing way for connoisseurs and novices alike to spend a day—or more—in Paris.

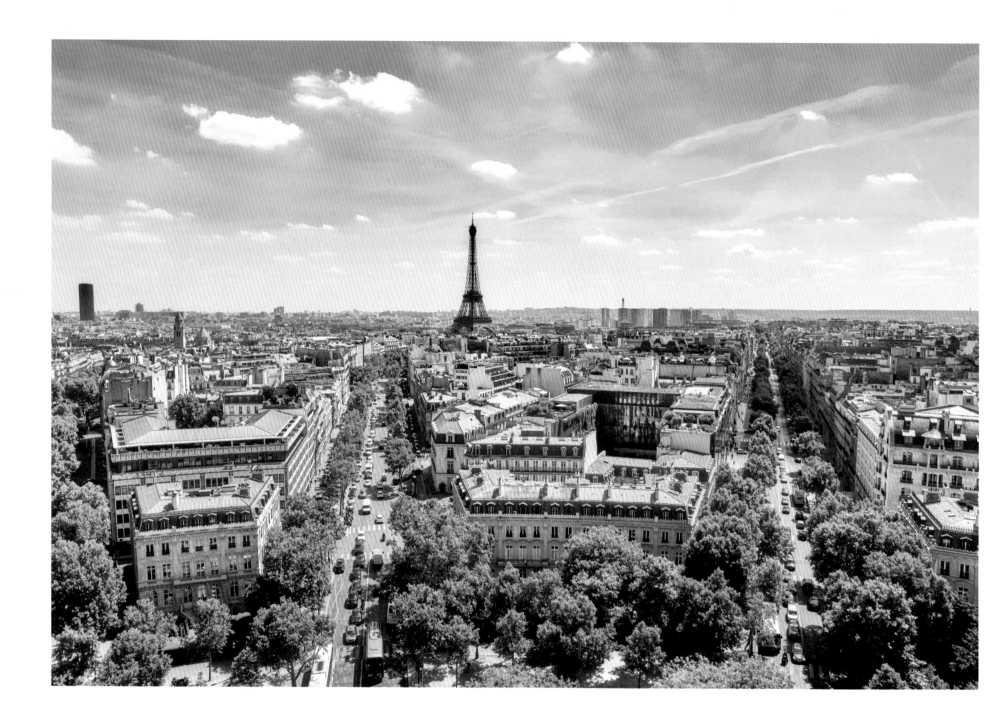

As the capital of France, Paris is home to more than 2 million residents in the city proper and more than 10 million in the surrounding area. For decades, it has held its place as a European and world hub of the arts, finance, and cuisine. Perhaps the most famous food offerings in Paris are simple everyday pastries, including baguettes and croissants. But thinking of the culture that invented restaurants also brings to mind such French delicacies as steak frites and duck confit. There are countless shops and vendors offering world-class examples of wines and cheeses. And don't forget dessert: macarons are small, sweet sandwiches of meringue and tasty fillings, and Paris does them better than anywhere else.

Steak frites

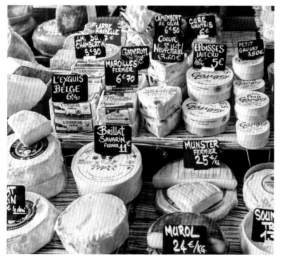

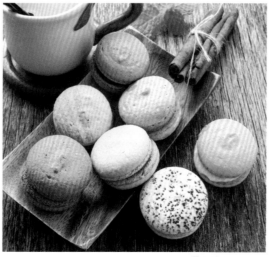

French macarons

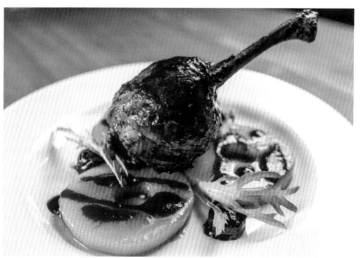

Duck confit

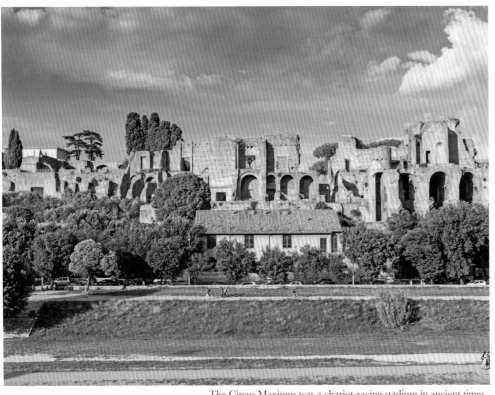
The Circus Maximus was a chariot-racing stadium in ancient times.

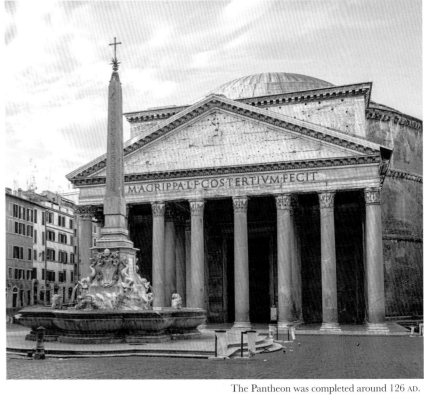
The Pantheon was completed around 126 AD.

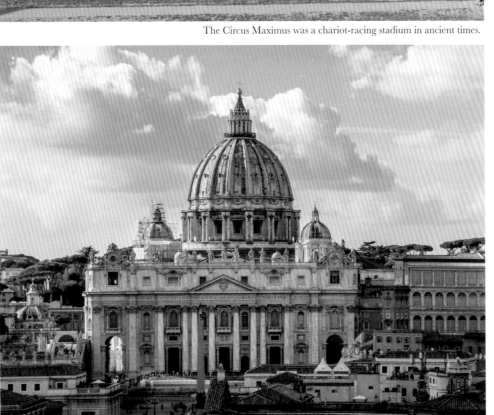
St. Peter's Basilica

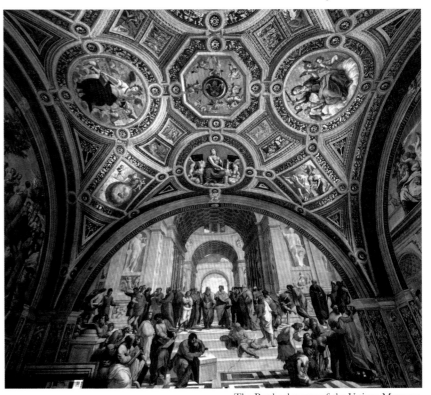
The Raphael rooms of the Vatican Museum

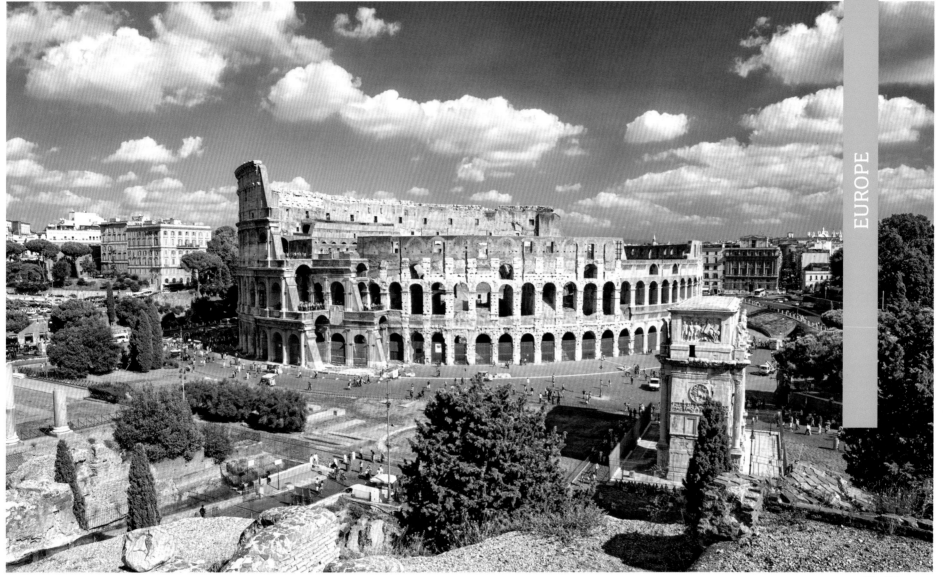

The Colosseum

Rome, Italy

For hundreds of years, Rome stood at the center of perhaps the most famous empire in human history, the Roman Empire. Today, the masterworks of Roman antiquity, the Renaissance, and other eras bring nearly 10 million tourists to the Eternal City every year. At the top of the must-see list are some of the most extraordinary and influential structures in Europe, including the Colosseum, the Roman Forum, the Pantheon, and the Circus Maximus. Several of the most exalted works of Renaissance art are inside Vatican City—St. Peter's Basilica, the Sistine Chapel, and the Raphael rooms inside the Vatican Museum, to name just a few.

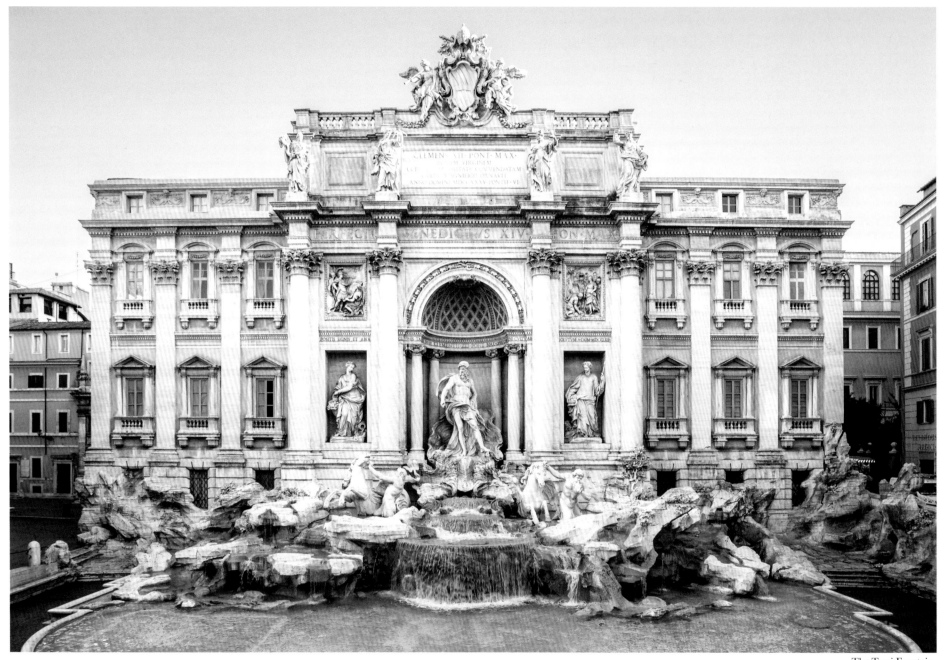

The Trevi Fountain

Today, however, Rome is much more than just a city-sized museum of masterpiece antiquities. Still on its way to 300 years old, the gorgeous Trevi Fountain is a stunning example of Baroque public art that's also a wonderful place to cool your heels or catch that perfect group photograph. Steps away from Trevi, you can find the hidden Galleria Sciarra, an opulent Art Nouveau courtyard. For lovers of street life, there's the market at Campo de' Fiori. And film buffs can feast their eyes on a tour of the famed Cinecitta movie studios, where classics from *Ben-Hur* to *La Dolce Vita* to *Gangs of New York* were shot.

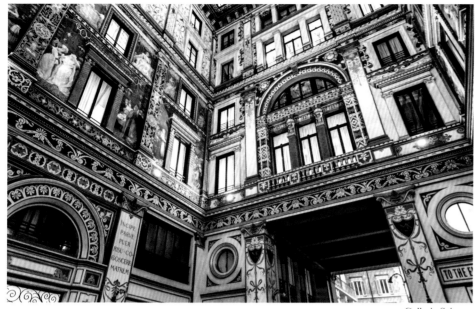

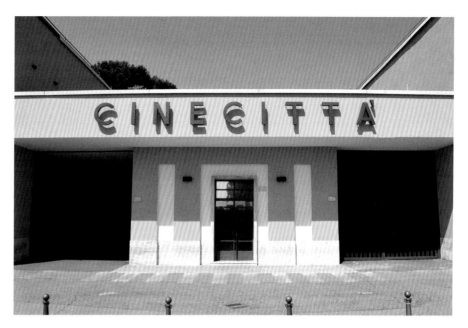

Galleria Sciarra

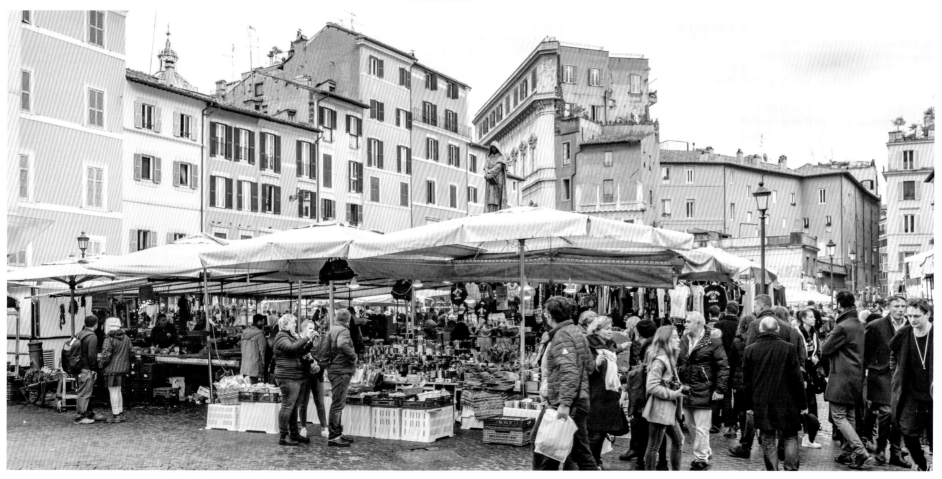

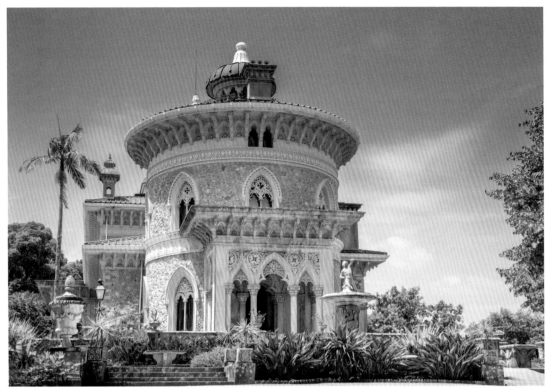

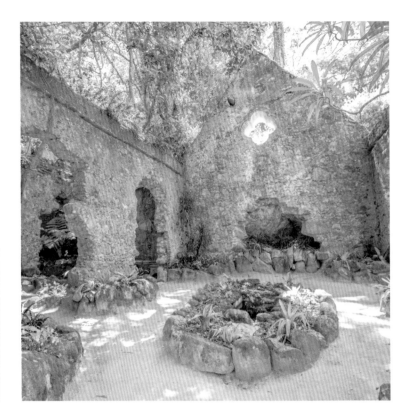

The Monserrate Palace

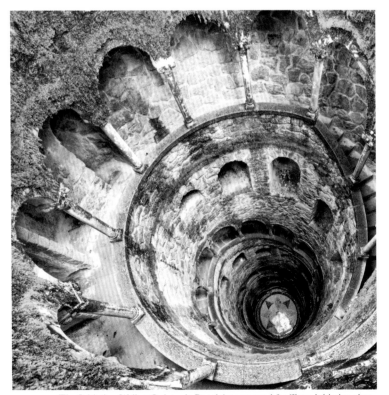

The Initiation Well at Quinta de Regaleira was used for Tarot initiation rites.

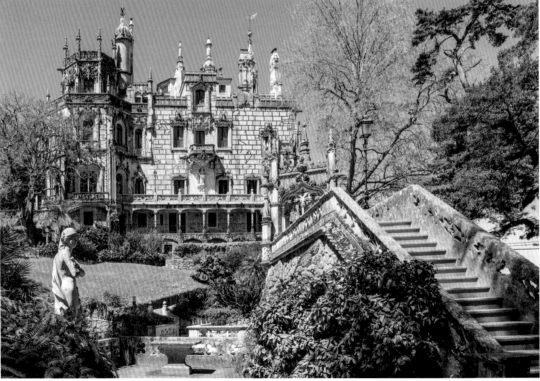

The palace at Quinta de Regaleira

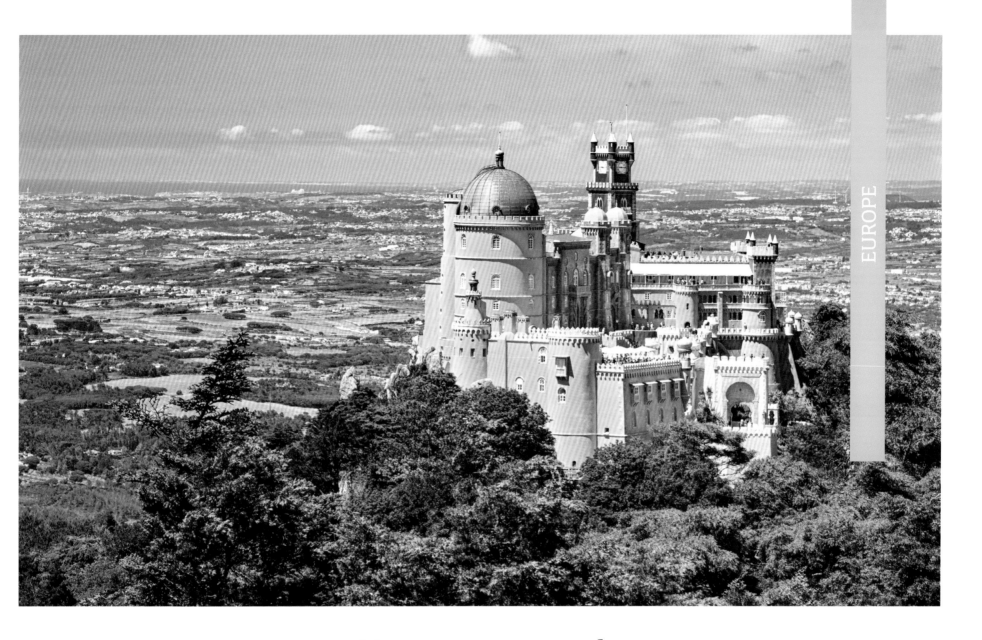

Sintra, Portugal

Just a 30-minute drive from Portugal's capital city of Lisbon, the fanciful town of Sintra is like a picture-book collection of architectural miracles in a myriad of styles. The Islamic Castle there is a 1,300-year-old stone fortress that climbs and descends the hilly green landscape. Overlooking the town is Sintra's crown jewel, the Pena National Palace, which showcases a collection of Gothic, Islamic, and Renaissance elements done up in vibrant reds, purples, and yellows. Still another facet of Sintra's magic is the UNESCO-listed Monserrate palace and gardens, which combines Indian and North African building traditions. Last, but not least, there are the fairy tale grottos, dramatic spires, and enchanting green spaces of the Quinta da Regaleira estate.

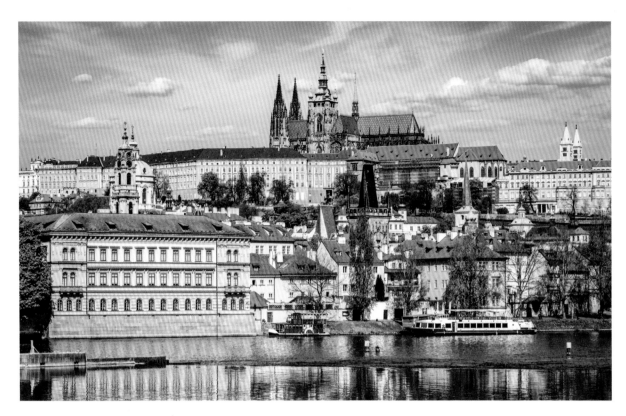

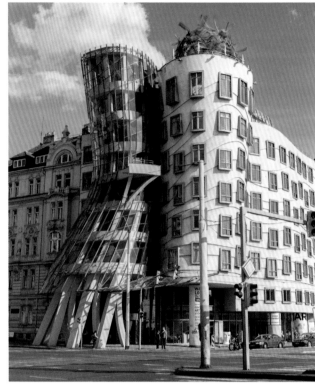

The unusual shape of the Dancing House was created with 99 concrete panels.

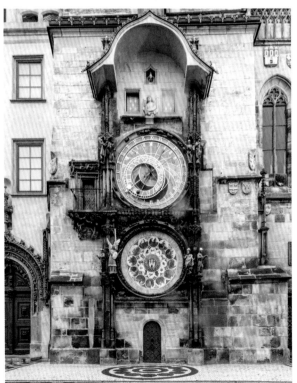

The Prague Astronomical Clock. It is said that if upkeep of the clock is neglected, the city of Prague will suffer.

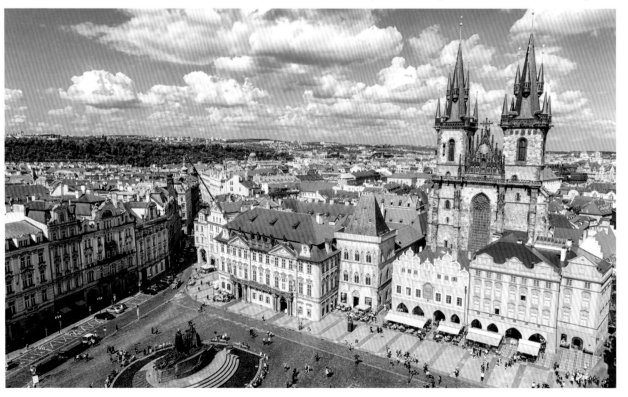

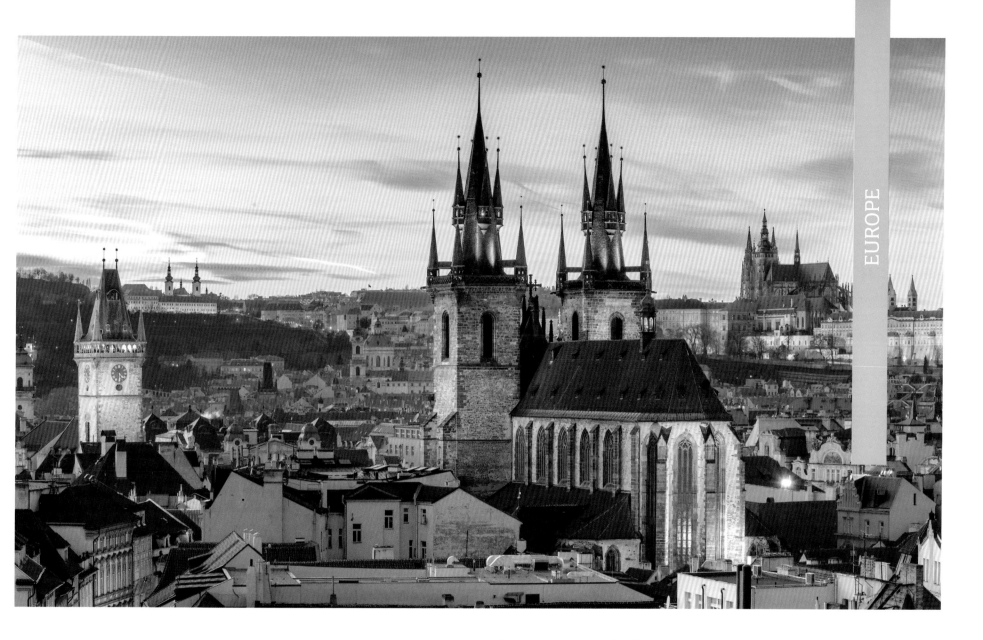

Prague, Czech Republic

Prague's nickname, the City of a Hundred Spires, needs little explanation, although some of the Czech capital city's most prominent Gothic spires belong to the Church of Our Lady before Týn, completed in 1450 in an area now known as the Old Town of Prague. An even older fixture of Old Town is the Astronomical Clock, an intricate scientific machine that features apostles and skeletons that mark the passing hours. Prague's attractions get even more diverse from there: Prague Castle, currently boasting more than 1,100 years of history, is the world's largest castle complex; and the Dancing House, built by Vlado Milunic and Frank Gehry in the 1990s, just might be one of the world's most whimsical postmodern buildings.

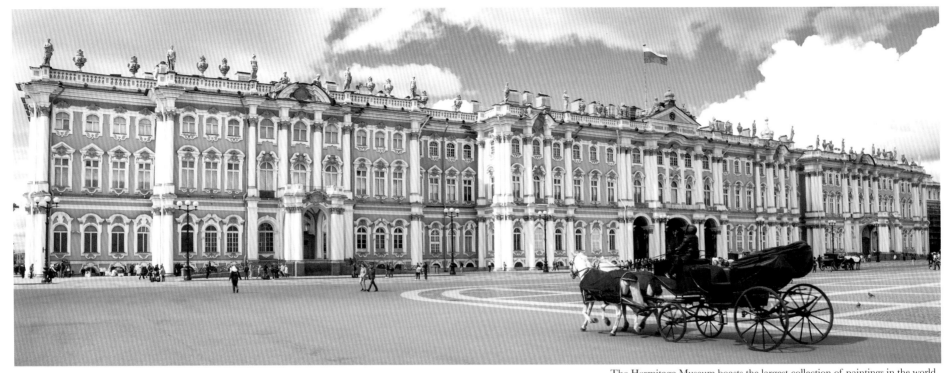

The Hermitage Museum boasts the largest collection of paintings in the world.

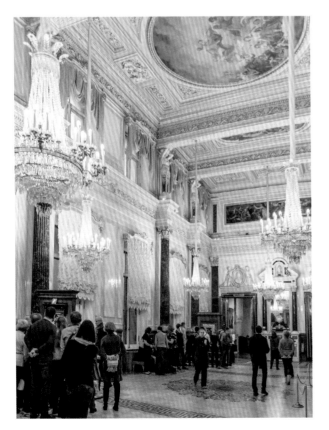

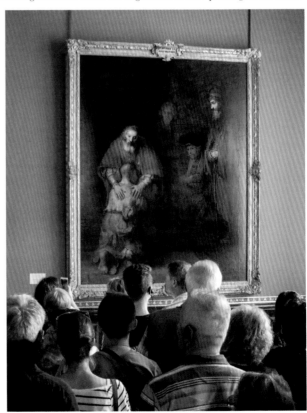

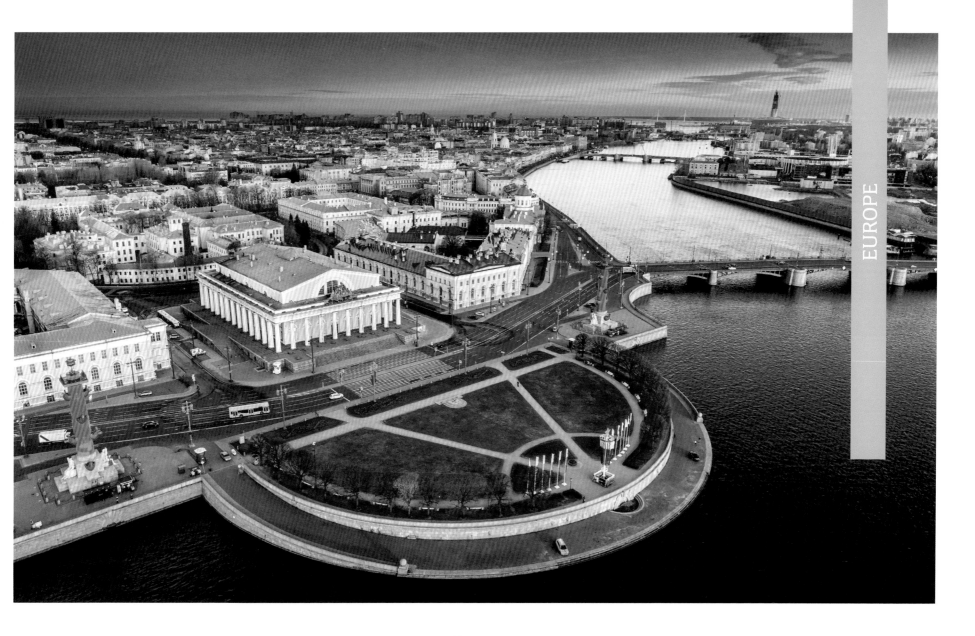

St. Petersburg, Russia

St. Petersburg, Russia, is a port city on the Baltic Sea, about 200 miles from the border between Russia and southern Finland. Founded in 1702 atop a previously uninhabitable marsh, it reigned as the country's capital for the next 200 years. Today, it's considered among the cultural centers of modern Russia. Part of the reason for this is the State Hermitage Museum, a top-shelf St. Petersburg destination that houses more than 3 million works of art and cultural artifacts in its exhibition spaces, which measure more than 700,000 square feet altogether. The Hermitage features famous paintings by Da Vinci, Raphael, Rembrandt, and many, many more, making it an essential for any first-timer in St. Petersburg.

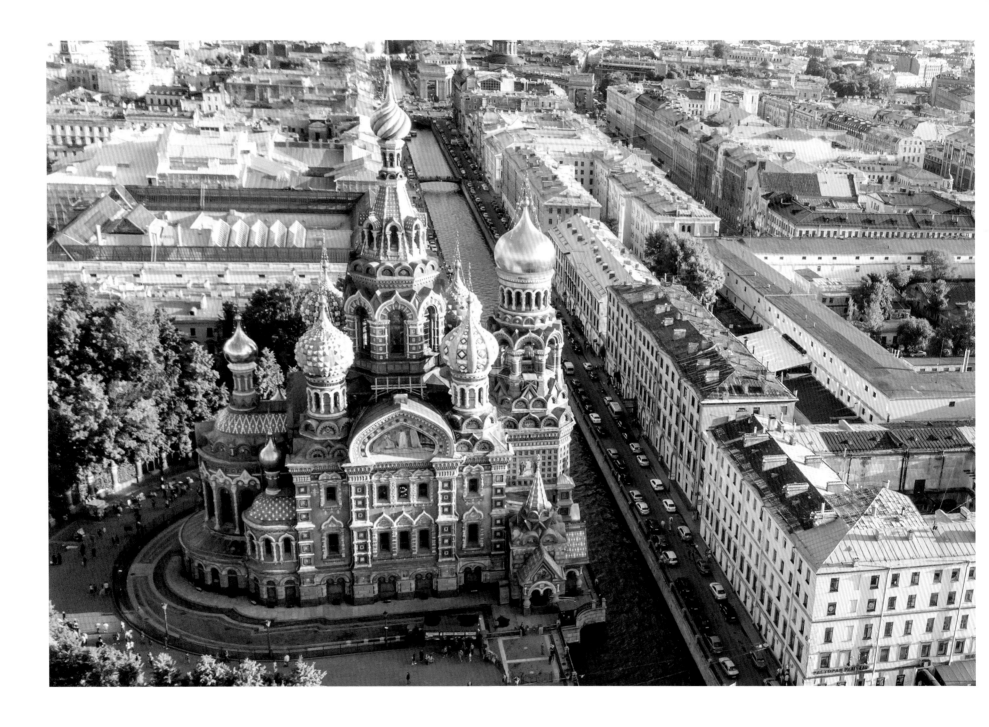

Palaces and churches also dot the St. Petersburg itinerary for most tourists, including the dazzling Church of the Savior on Spilled Blood, Peterhof Palace, and Catherine Palace and Park. In June and July, the sun never really sets in St. Petersburg—a phenomenon known as White Nights. Every year, the city takes this opportunity to host festivals and concerts through midnight until morning. After staying up all night, hungry tourists load up on delicious calories by trying the local savory pancakes, filled with meat, cabbage, or cottage cheese. Still famished? Try the beef stroganoff in the nation that gave the noodle dish its name.

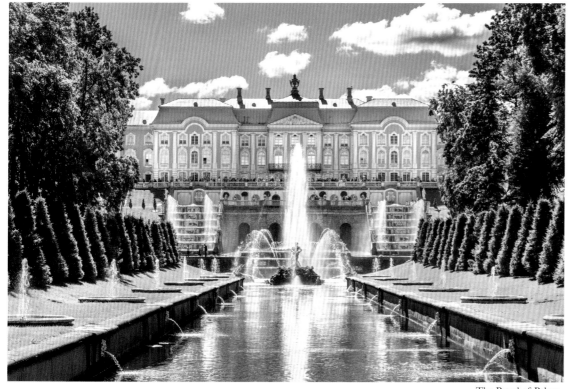

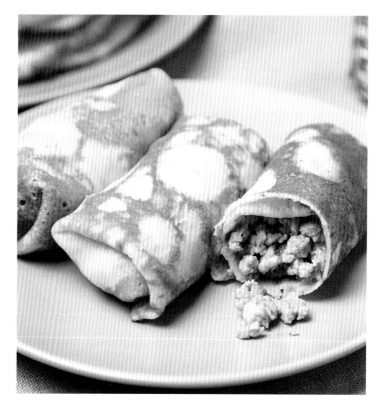

The Peterhof Palace

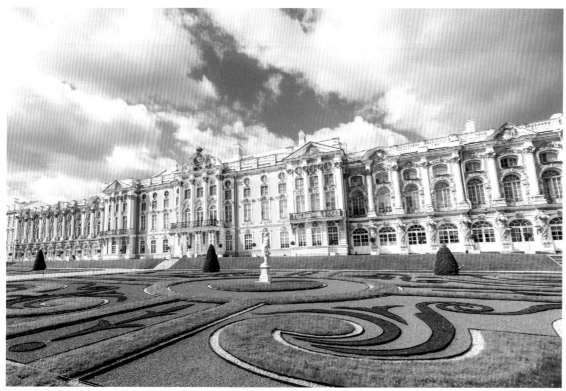

Beef stroganoff is made from sautéed beef and sour cream.

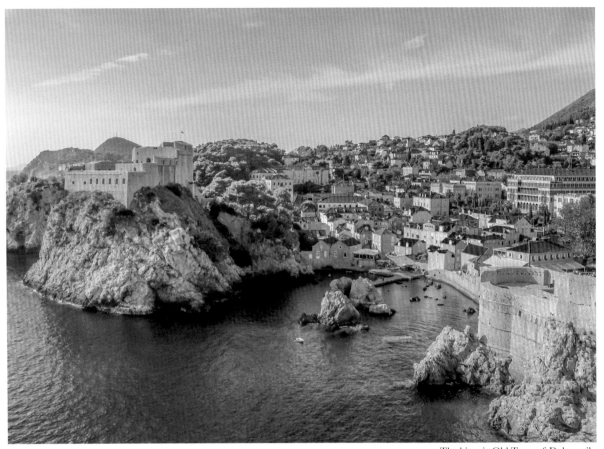

The historic Old Town of Dubrovnik

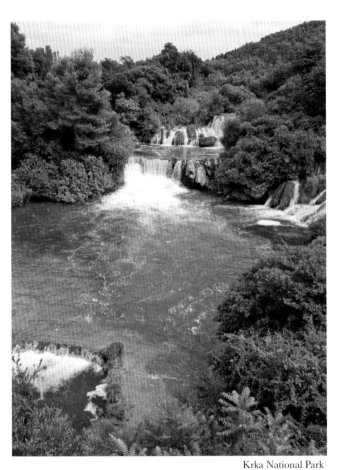

Krka National Park

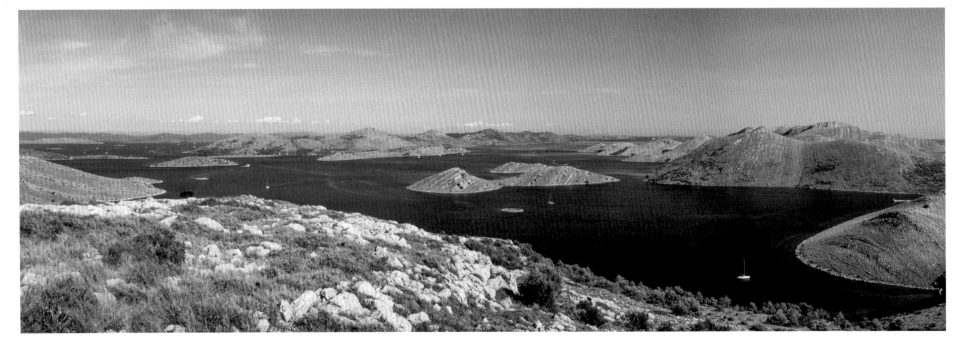

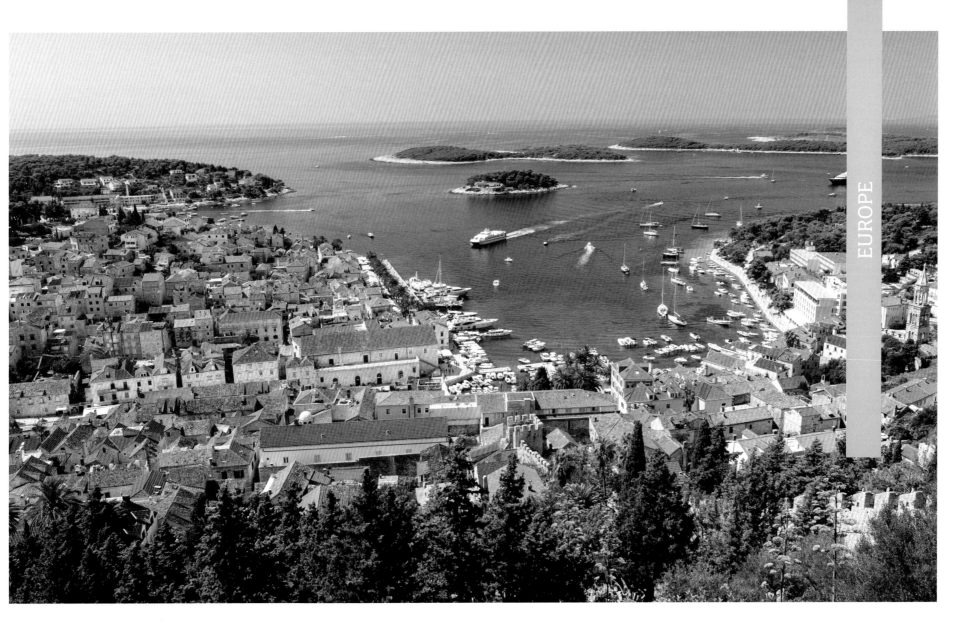

Dalmatian Coast, Croatia

The Dalmatian Coast is a dreamlike strip of southern Croatia on the Adriatic Sea. From the unusual seaside installations of Zadar, to waterfall wading in Krka National Park, to the spectacular city walls and palaces of Dubrovnik, Dalmatia really has it all. The region also includes about 1,000 islands, of which Hvar might be most famous, thanks to its reputation for glitzy revelry as well as its own medieval Old Town, Venetian Renaissance architecture, and diverse beaches. For a serious change of pace, spend some time in the tranquil Kornati National Park, an uninhabited 140-island archipelago that's ideal for boating, snorkeling, and generally escaping from the fast-paced Dalmatian mainland.

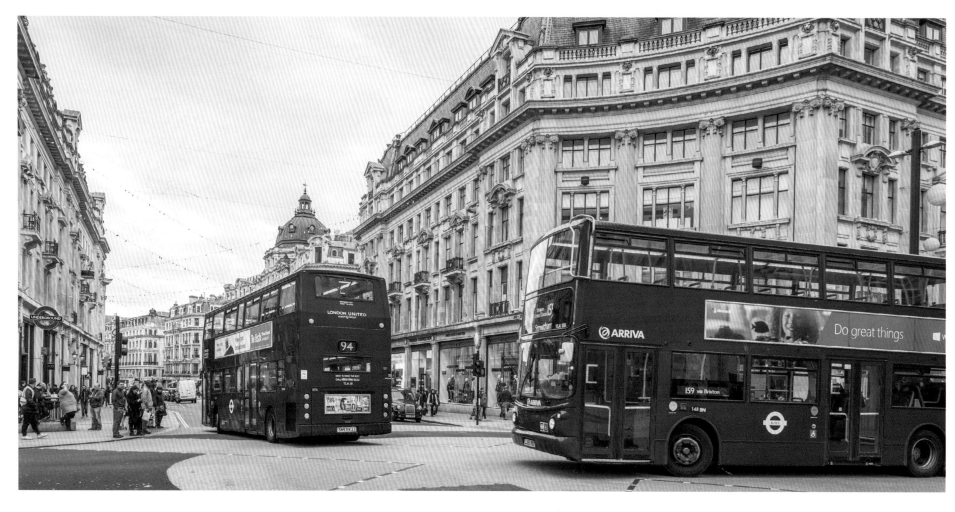

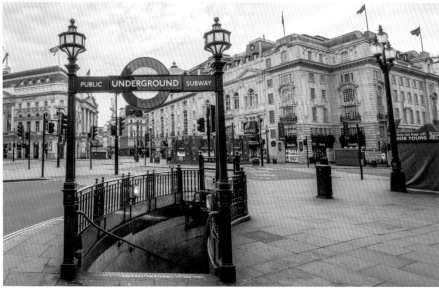

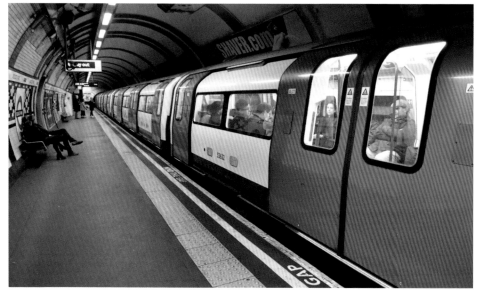

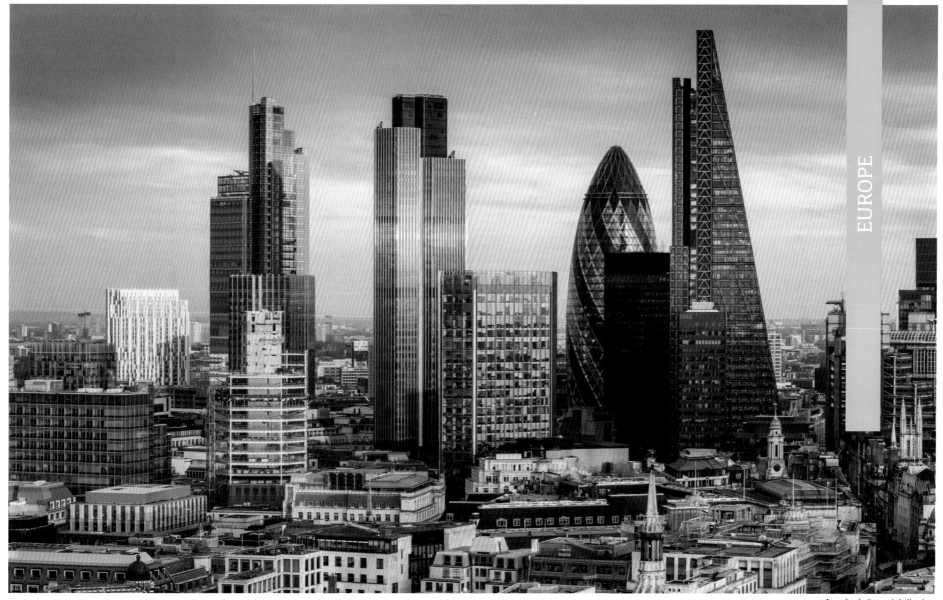

London's financial district

London, England

With a legacy that stretches as far back as the 1st century AD, London today is a modern metropolis with a population of more than 8 million people speaking 300 different languages. London tourism has really boomed in recent years, and the city can now expect more than 40 million visitors annually. Most of them hitch a ride atop one of London's handsome red double-decker buses or zip to one of the 270 stations that are connected by the London Underground—the world's oldest metro transit system, known informally as The Tube.

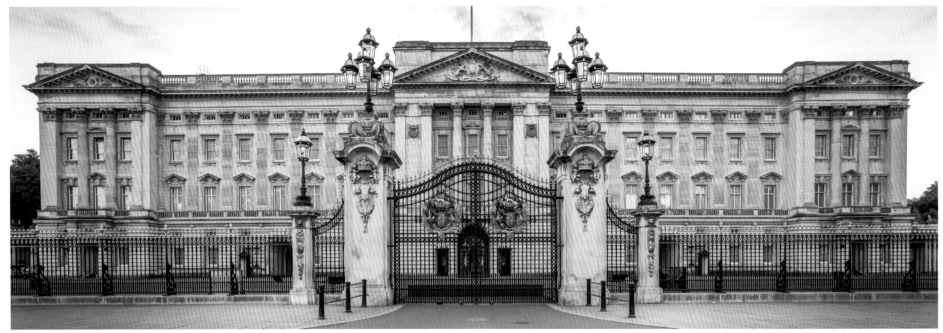
Buckingham Palace, the residence of the British monarchy

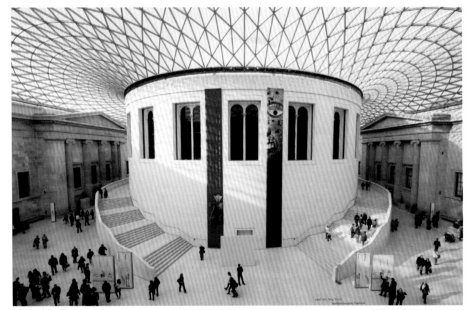
The British Museum

The prominent and stately architecture of London defines the city, with names that ring regal including Buckingham Palace, Westminster Abbey, Parliament and its mighty clock tower. Sharp tourists will refer to that famed spire as Elizabeth Tower and smartly point out that Big Ben is actually a nickname for the 13-ton bell inside. Beyond the most traditional sites, London features a host of free museums, art galleries, and markets, a vibrant Chinatown, the churches and monuments of Trafalgar Square, and much more. Not to be missed: the dramatic skyline views from the top of the London Eye, a cantilevered observation wheel that's nearly 450 feet tall at its apex.

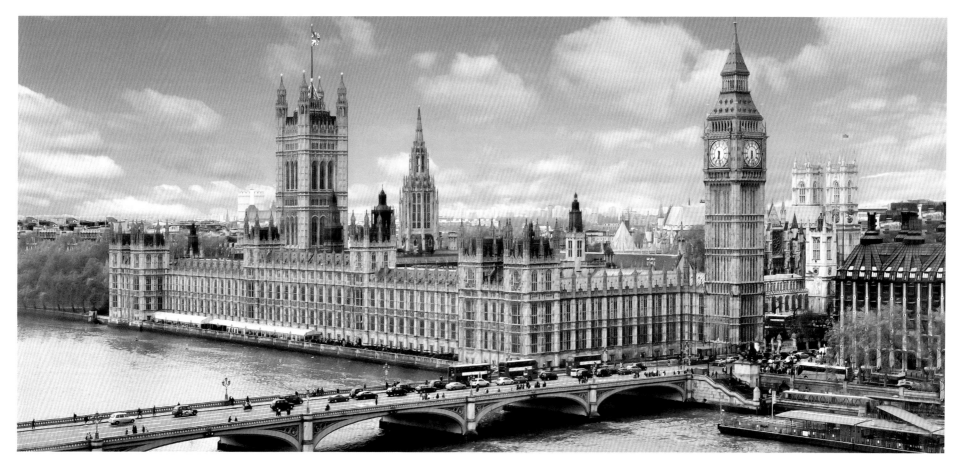

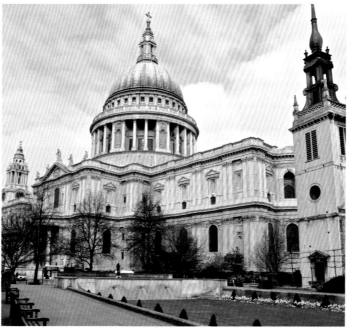

St. Paul's Cathedral

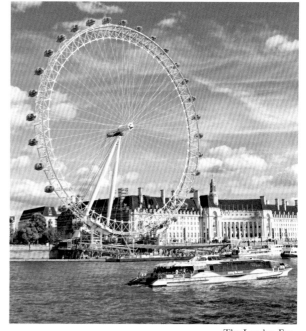

The London Eye

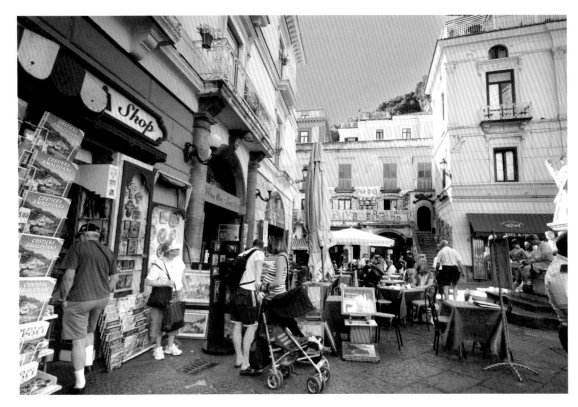

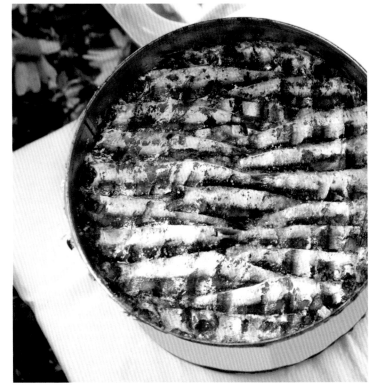

A tin of anchovies

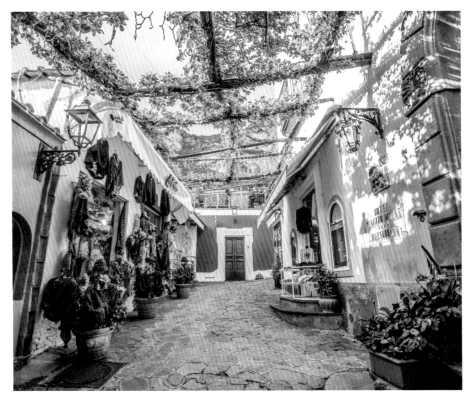

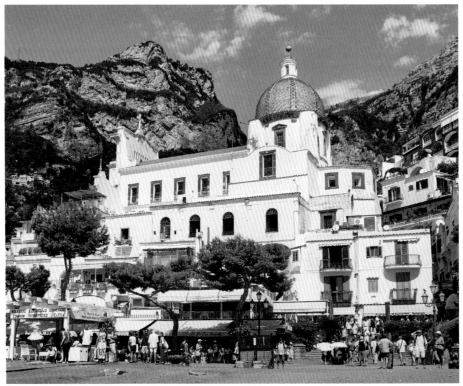

The Church of Santa Maria Assunta

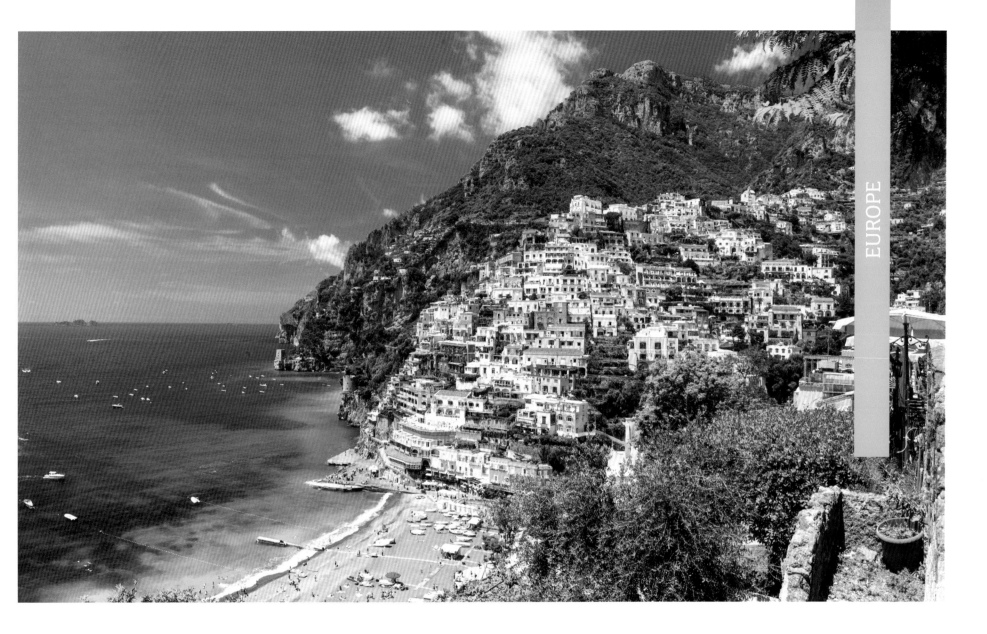

Positano, Italy

Romantic and almost impossibly picturesque, Positano is the jewel of Italy's Amalfi Coast. This small town's winding streets are lined with colorful terracotta houses that tumble down the green and hilly seaside toward some of the most glamourous beaches in Europe. Packed with charming boutiques, local and international art galleries, and shops offering linens, ceramics, and highly-regarded tinned anchovies, Positano entices visitors to walk, explore, discover—even get a little bit lost. Just a short walk from the Spiaggia Grande beach is perhaps the town's most iconic structure, the Church of Santa Maria Assunta with its much-photographed majolica-tiled dome.

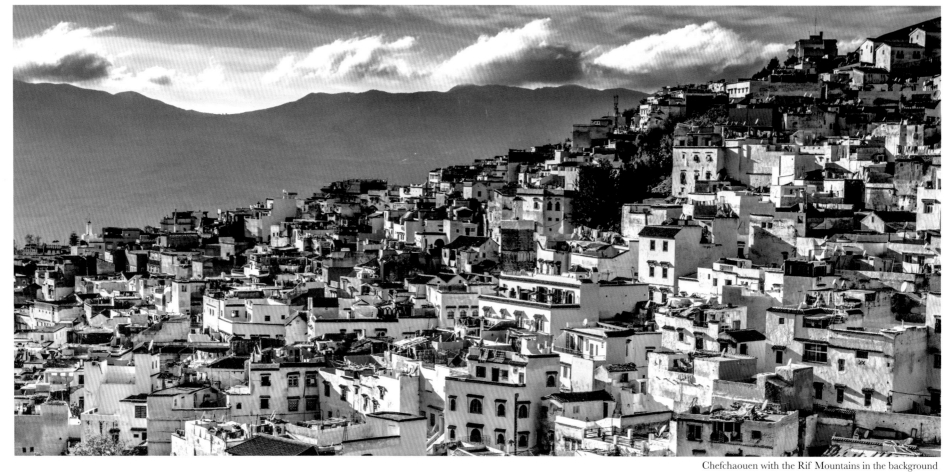

Chefchaouen with the Rif Mountains in the background

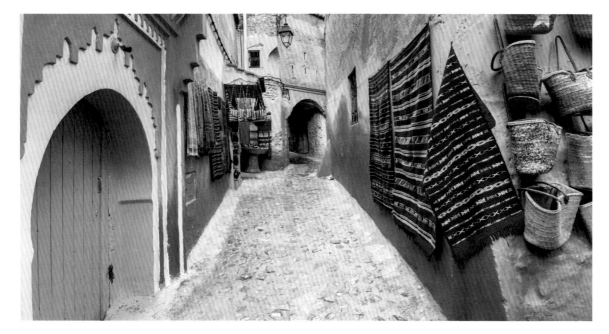

A bowl of bissara

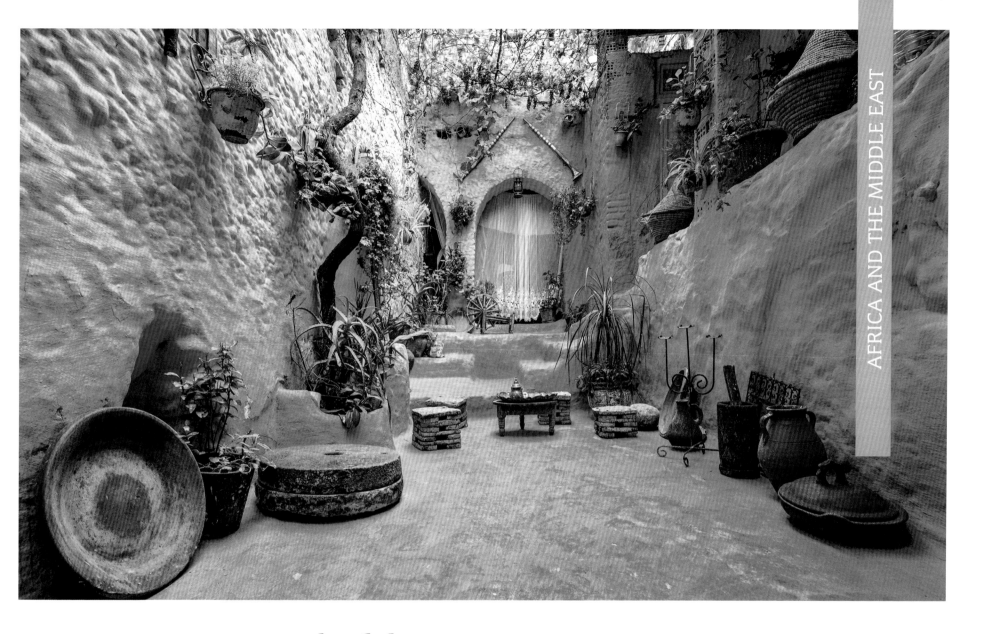

Chefchaouen, Morocco

Perched in the Rif Mountains of northern Morocco, the city of Chefchaouen is small—but it's very, very blue. In fact, it's commonly known as Morocco's blue city, or sometimes its "blue pearl." As for the history of the myriad shades of blue in the architecture, and even the streets, speculation varies wildly; it may date back to the 15th century, though some locals track the tradition to just the past few decades. It's believed to be a reminder of both the color of the sky and of God's power. In any case, Chefchaouen is magically scenic. And there's more to it than just blue, like bissara, for instance, the traditional split pea soup that's quite green—and nowhere near as mysterious.

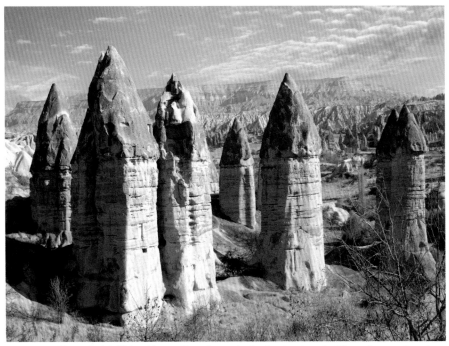

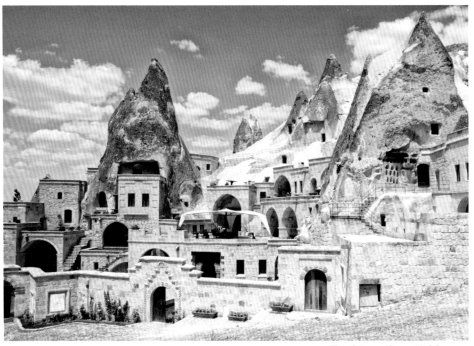

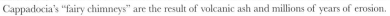
Cappadocia's "fairy chimneys" are the result of volcanic ash and millions of years of erosion.

The Göreme Open Air Museum

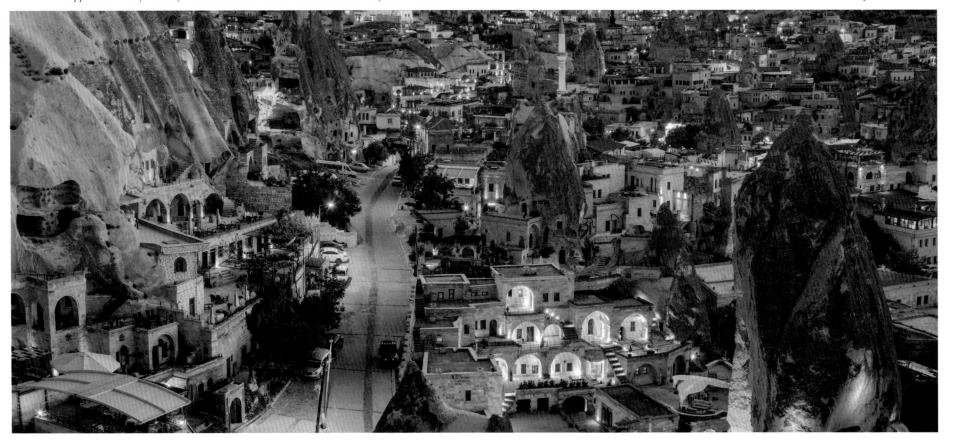

Cappadocia, Turkey

The Cappadocia region of central Turkey is a wonderland of stark and mystifying moonscape topography. Among the area's most surreal geological formations are the towers of soft rock known as "fairy chimneys." Formed by erosion millions of years ago, these whimsical features change color in different kinds of daylight, lending Cappadocia a magical, otherworldly aura. Over the centuries, human hands have carved captivating structures into the landscape, including the Göreme Open-Air Museum, a UNESCO World Heritage site that offers visitors a walk through early Christian history's monastic period. Among the most popular ways to survey Cappadocia's bizarre beauty is via hot-air balloon, with more than 25,000 balloon rides lifting off every year.

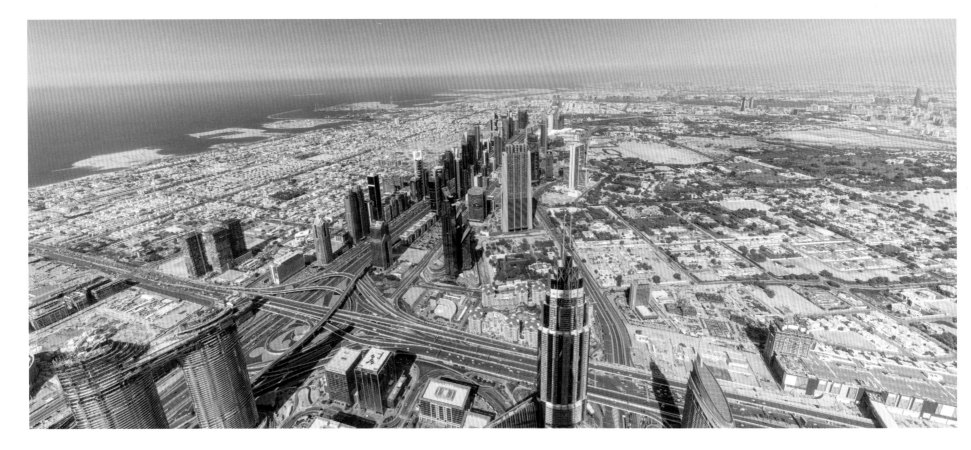

The observation deck of the Burj Khalifa

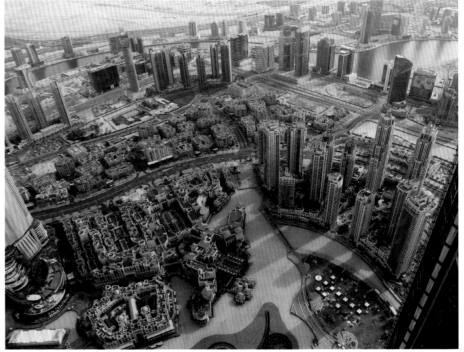

The view of Dubai from the top of the Burj Khalifa

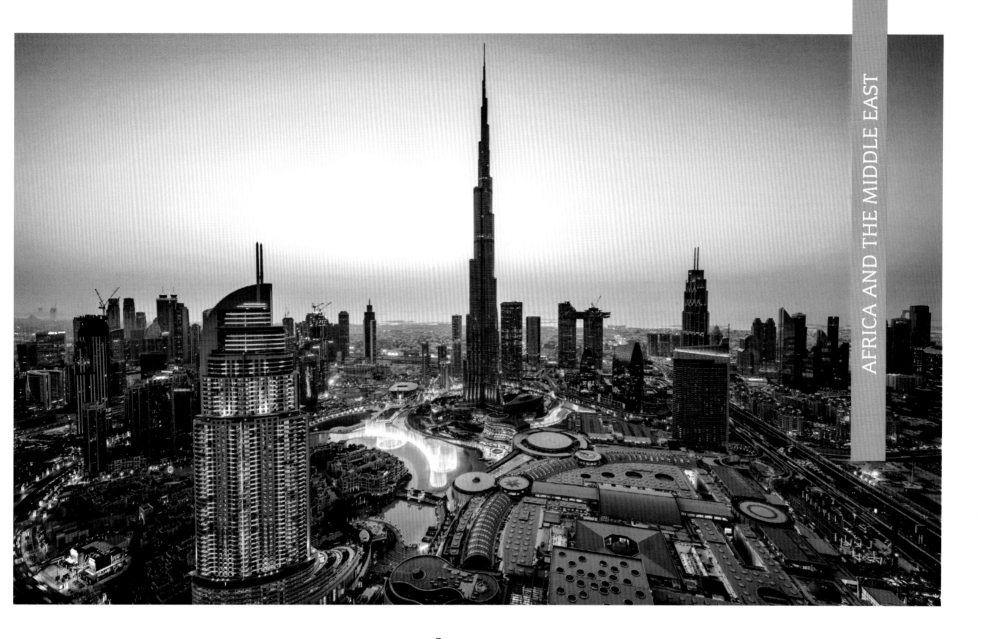

Dubai, UAE

Dubai is a hyper-modern city of more than 3 million people on the southeastern banks of the Persian Gulf—and right in the middle of the Arabian Desert. Over the last several decades, Dubai has been among the world's fastest growing cities, and it's expected to double in population by 2027. In 2019, the Burj Khalifa—a mixed-use 2,716.5-foot-tall skyscraper in the middle of downtown Dubai—was the tallest building in the world, had the highest occupied floor in the world, and boasted the highest outdoor observation deck in the world. In fact, on Uber's 2018 list of the world's most visited attractions, Burj Khalifa came in at #6!

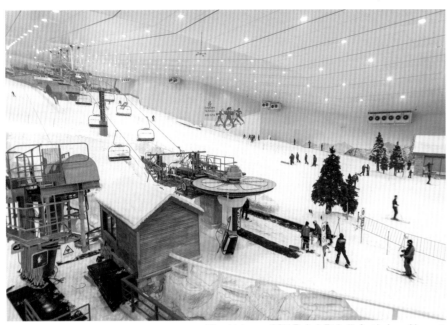
The ski slopes of Ski Dubai, Dubai's first indoor ski resort

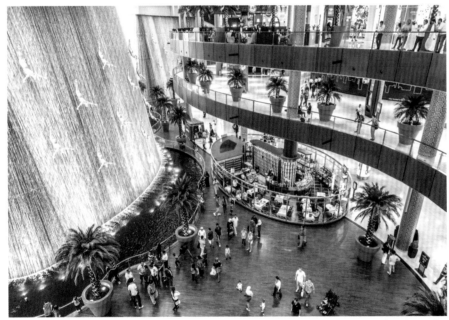
Dubai Mall, one of the world's largest shopping malls,
features its own aquarium, indoor theme park, and even a haunted house.

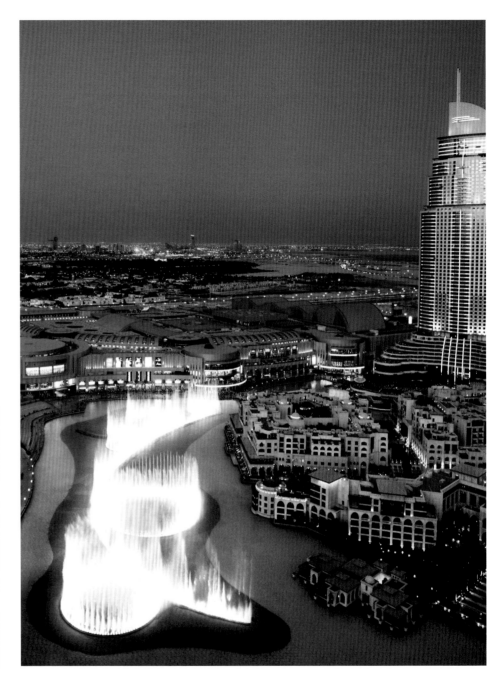

Although Dubai offers views of its cityscape and surroundings from half a mile in the sky, it gets even more superlative closer to sea level. You can join the 100 million annual visitors to Dubai Mall, or marvel at Dubai Fountain, the world's tallest. You can even hit the slopes at the world's third-biggest indoor ski slope. On the Palm Jumeirah—Dubai's giant manmade islands shaped like 17 fern fronds—you can chill out in the company of grouper, jellyfish, and albino alligators at the Lost Chambers Aquarium. It's all so mind-blowing you're bound to get hungry, and when you do, try the spicy chicken or lamb stew known as margoogat or sample some luqaimat, the doughnut-like dumplings topped with sesame seeds and served with date sauce.

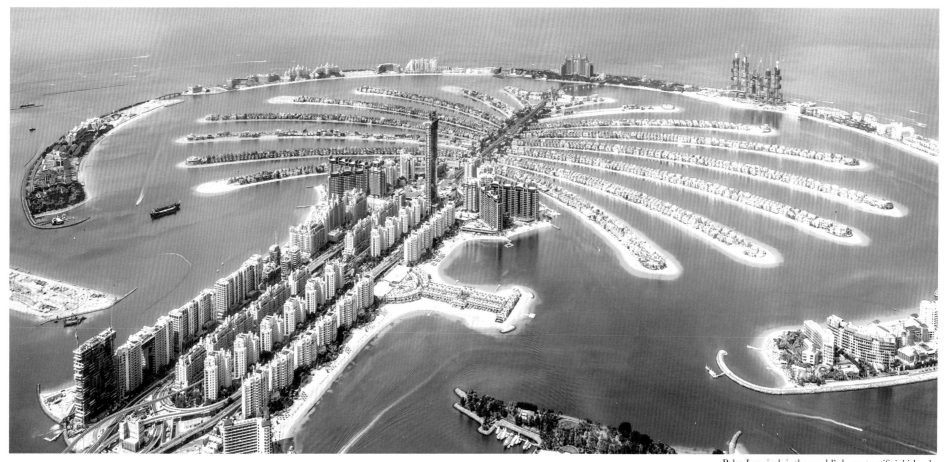
Palm Jumeirah is the world's largest artificial island.

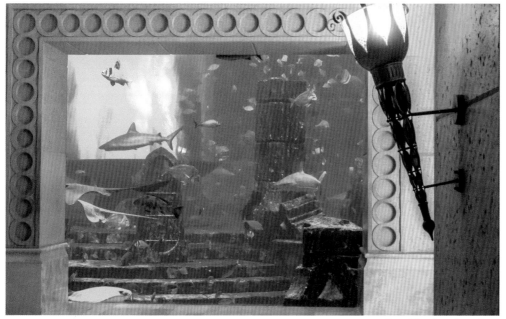
Lost Chambers Aquarium

Luqaimat

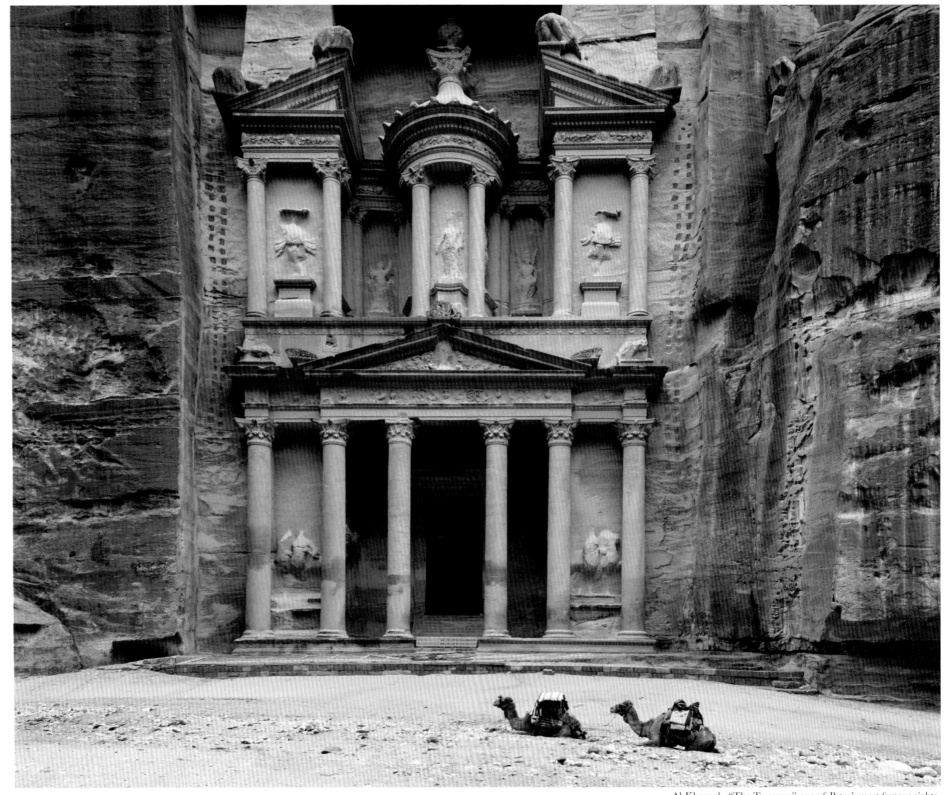

Al-Khazneh, "The Treasury," one of Petra's most famous sights

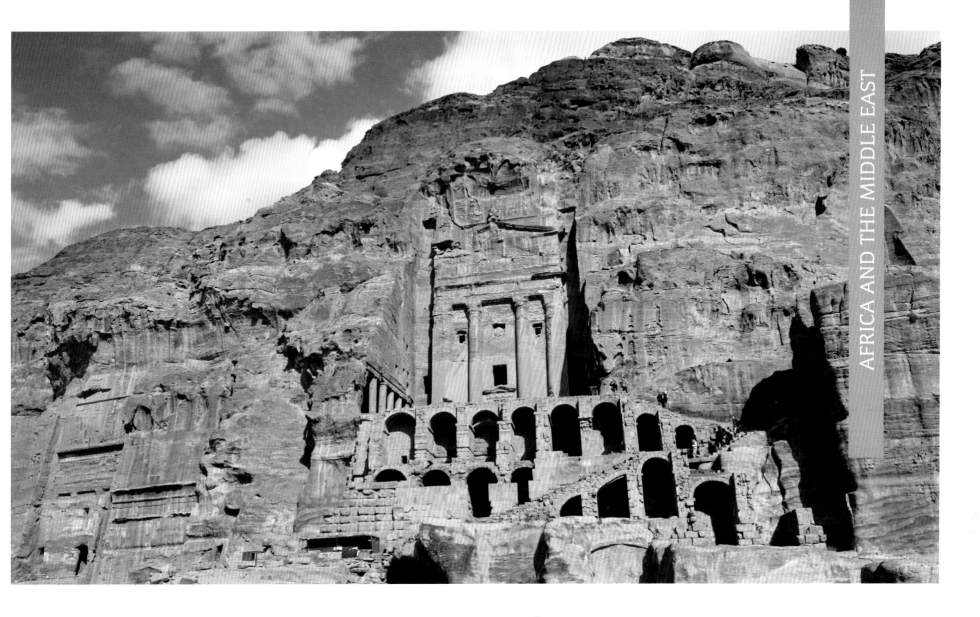

Petra, Jordan

Petra was once the capital city of a nomadic tribe known as the Nabateans; today, this "lost city" is Jordan's most treasured tourist destination. Many of the world-famous ruins at Petra, a UNESCO World Heritage site, were carved into the natural sandstone, including homes, mausoleums, a courthouse, and an amphitheater, not to mention functional features like staircases and irrigation channels. The Treasury, Petra's most famous facade, is intricately decorated with Corinthian columns and was probably completed sometime in the 1st century BC. Petra's largest freestanding building is the 80,000-square-foot structure known as the Great Temple, though debate remains about how it was used by the people who put so much care and expertise into building and decorating it.

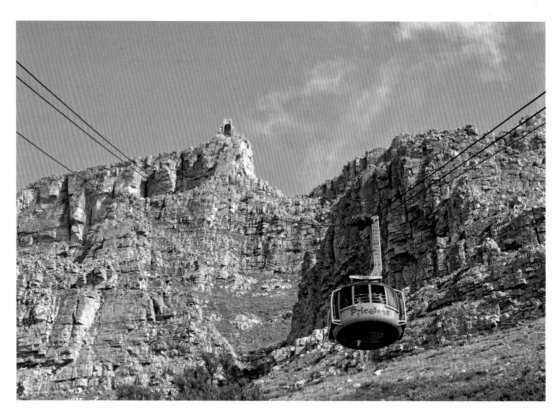

Pincushion flowers, a species of fynbos in the Cape Floral Kingdom

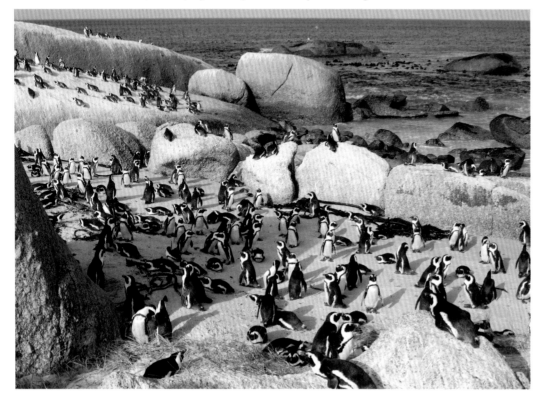

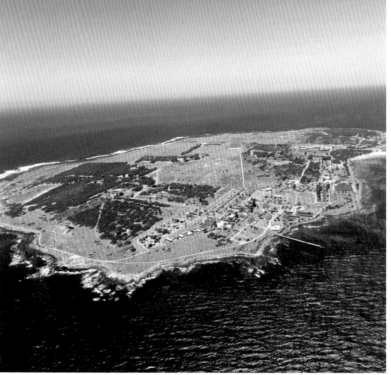
Robben Island

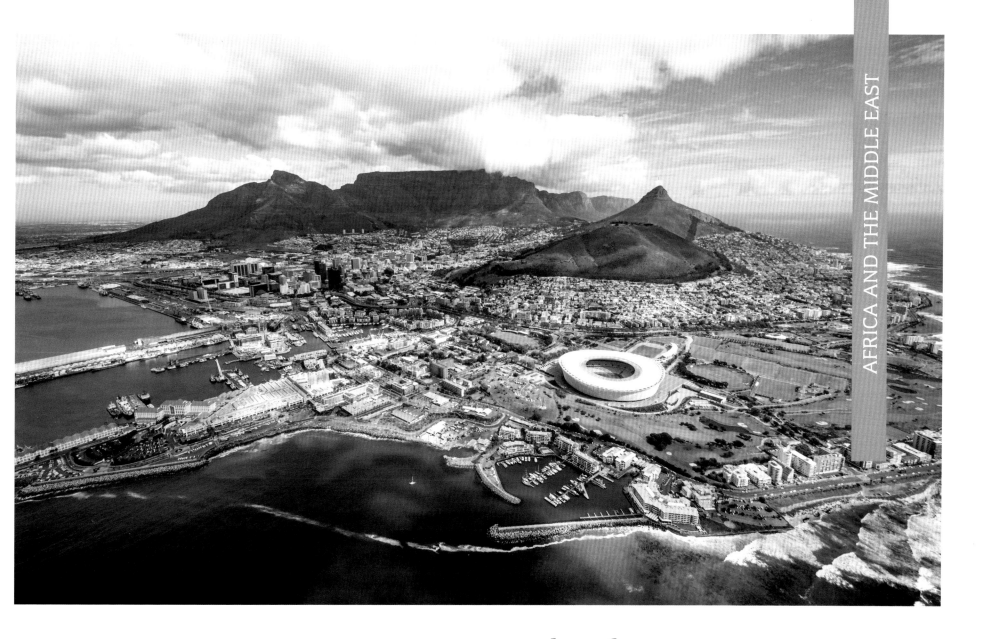

Cape Town, South Africa

In Cape Town, visitors tend to orient themselves around Table Mountain and its attendant national park. It's a sprawling world heritage site that attracts more than 4 million visitors every year, offering splendid views of the surrounding city, hiking, cable car rides, and the Cape Floral Kingdom, with its 9,000 species of the flowery shrubland plant called fynbos. There's even a penguin colony that's home to around 3,000 of the squawking seabirds. History tourists will want to spend some time on Robben Island, the former prison island where Nelson Mandela was held and where the division and triumphs of Cape Town's past are retold by experienced guides, some of whom were imprisoned on the island themselves.

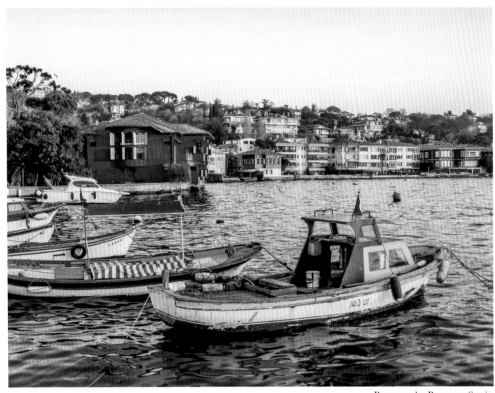

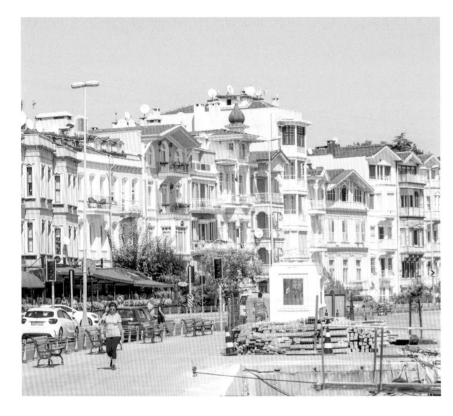

Boats on the Bosporus Strait

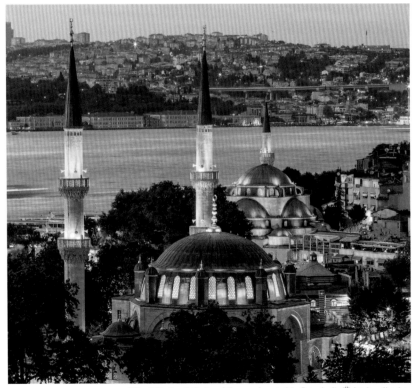

The Mihrimah Sultan Mosque located in Istanbul's Üsküdar district

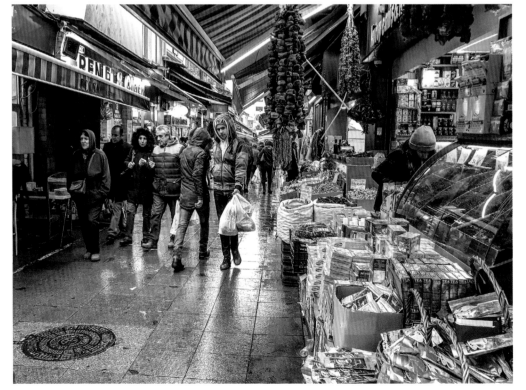

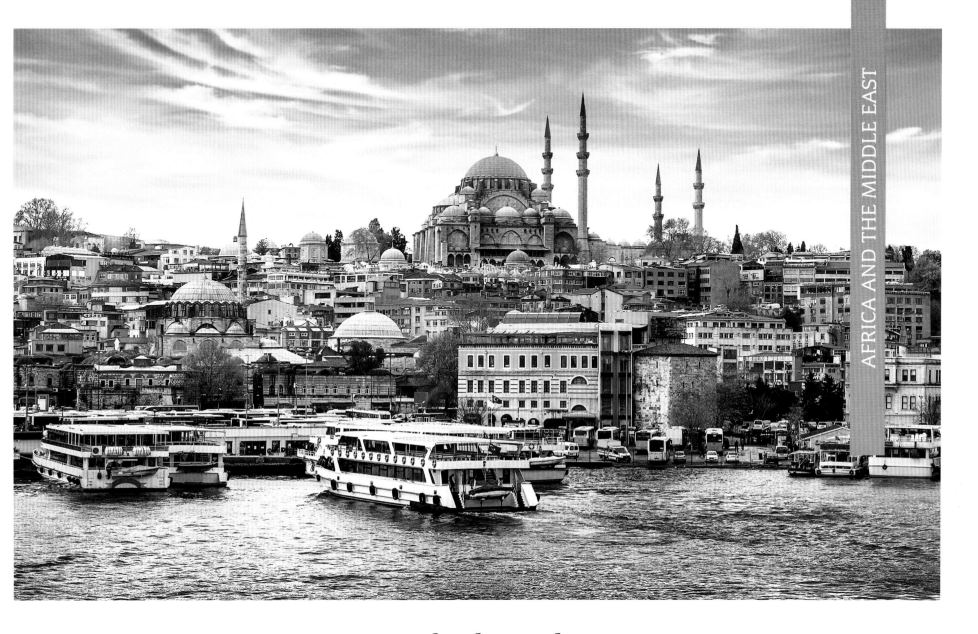

Istanbul, Turkey

Located on the Bosporus strait, and split into two parts by the border between Europe and Asia, Istanbul is truly a gateway to both continents. The population of Istanbul's city proper is just over 15 million, making it the world's fourth largest behind three of China's biggest cities. Istanbul itself has a European and an Asian side; the European side features some of the city's most famous attractions, while the Asian side offers a more relaxed glimpse at how the locals live. Visitors to Asian side are treated to traditional districts like Çengelköy and Bebek, the mosques of Üsküdar, and the cultural and foodie riches of Kadıköy market.

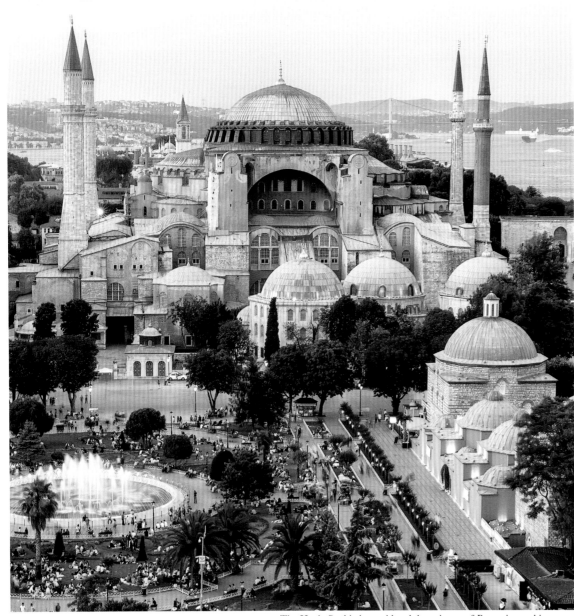

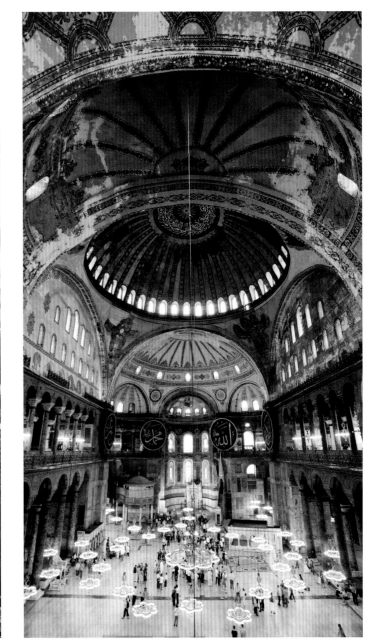

The Hagia Sophia is considered the epitome of Byzantine architecture.

On the European side of Istanbul, travelers can explore iconic landmarks and several of the most beautiful mosques in the world. The Hagia Sophia, which was built as a church and has also served as a mosque and a museum, is probably the famous and most striking of them all. Others, including the Blue Mosque, the Süleymaniye Mosque, and Ortaköy Mosque, feature such highlights as ornate calligraphy and ceramics, tombs full of gorgeous ivory inlays, and neo-Baroque architecture. With its thousands of shops and cafes, the Grand Bazaar is both an important history lesson on Eurasian trade routes and an unforgettable modern shopping experience. Finally, the 9-story Byzantine Galata Tower, with its history as both a lighthouse and a fire tower, dominates the landscape today and provides the best views of the city.

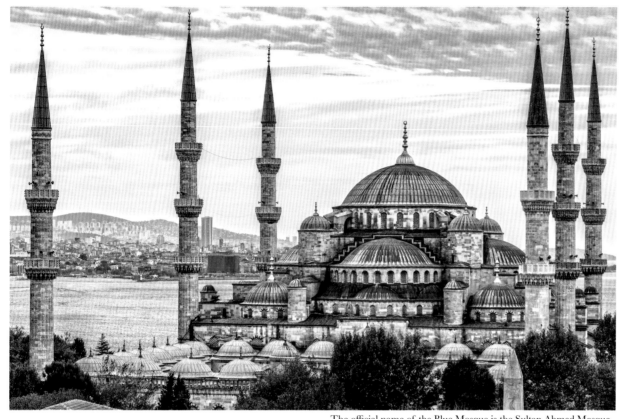

The official name of the Blue Mosque is the Sultan Ahmed Mosque.

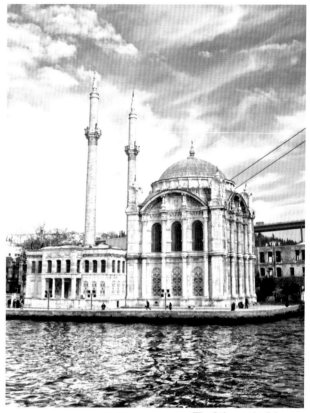

The Süleymaniye Mosque

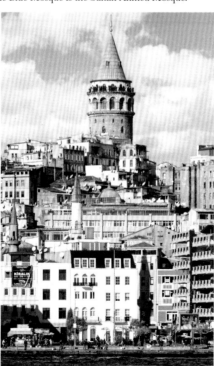

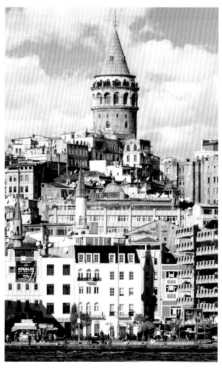

The Ortaköy Mosque

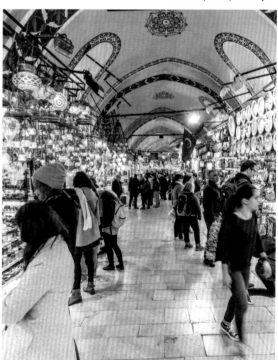

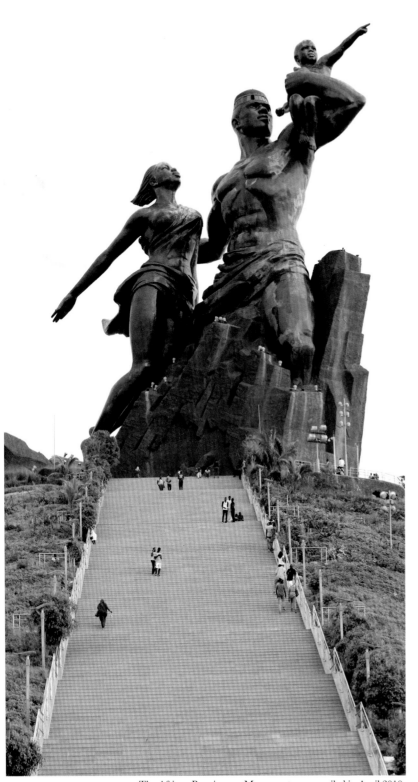

Lake Reta has a salt content of up to 40% in some areas.

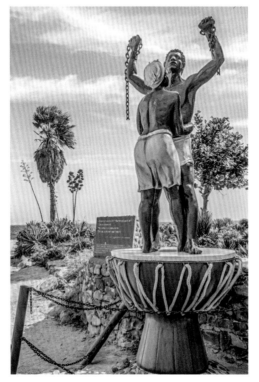

The African Renaissance Monument was unveiled in April 2010 to celebrate Senegal's 50th anniversary of its independence from France.

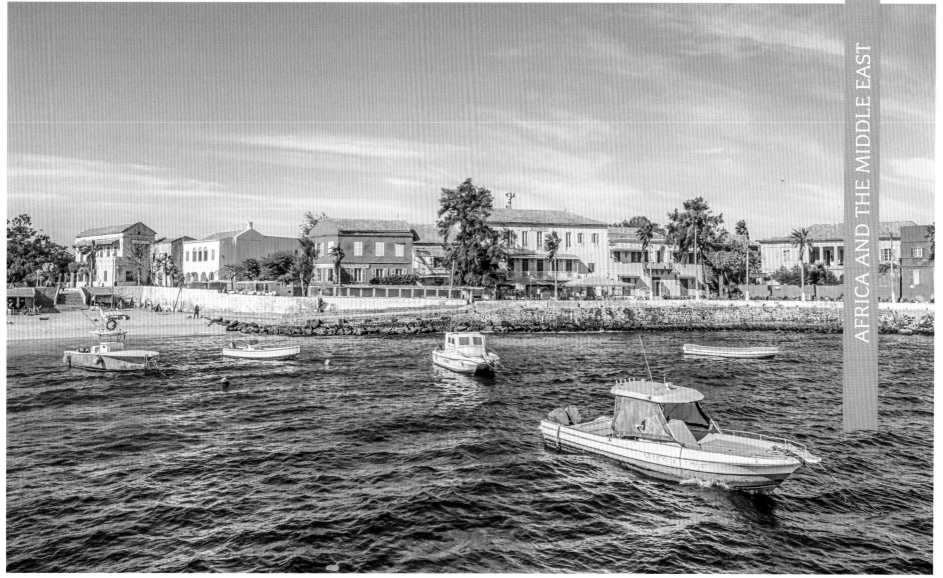

Gorée Island

Dakar, Senegal

Located on the Cap-Vert Peninsula at the westernmost point of Africa, Dakar is both the capital city of Senegal and the nation's largest city. To get a great look at the city, many visitors ascend to the 15th-floor observation windows inside the Monument de la Renaissance Africaine, or African Renaissance Monument, a triumphant-looking 160-foot statue that's Africa's largest. There are some amazing beaches in Dakar, and not far away there's a pink lake that's so saline, it's almost impossible to sink into it. A short ferry ride from the mainland is Gorée Island, one of the 12 inaugural UNESCO World Heritage sites, Senegal's most visited attraction, and one of the world's most significant historical monuments to the slave trade.

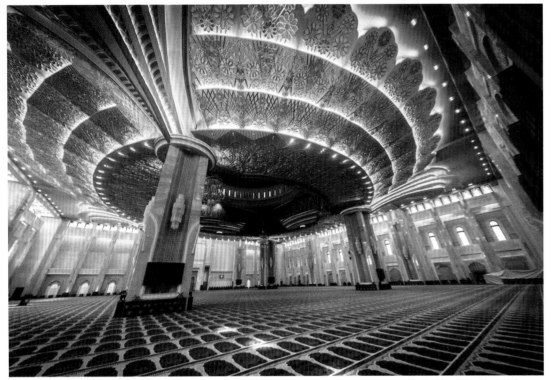

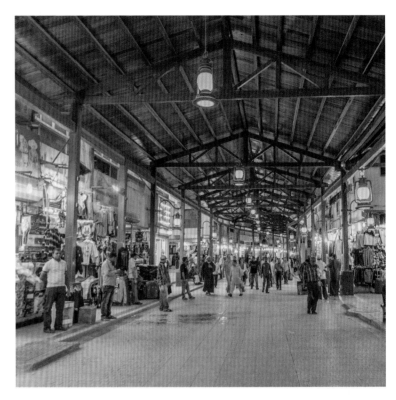

The inside of the Grand Mosque

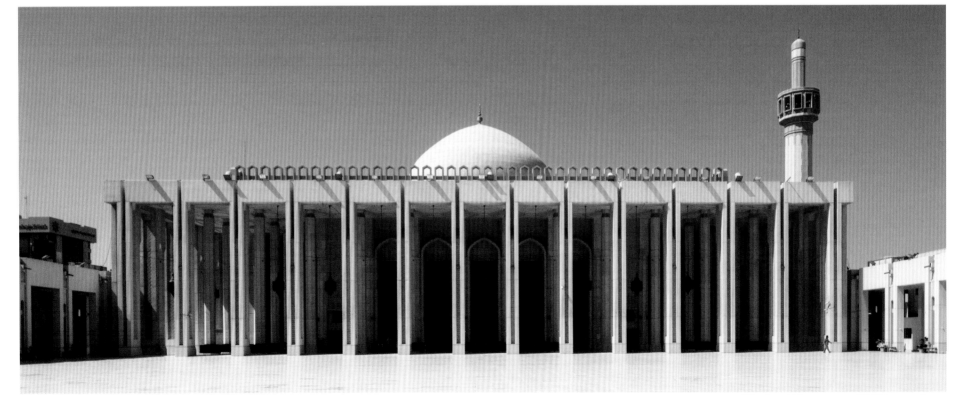

The Grand Mosque spans 480,000 square feet.

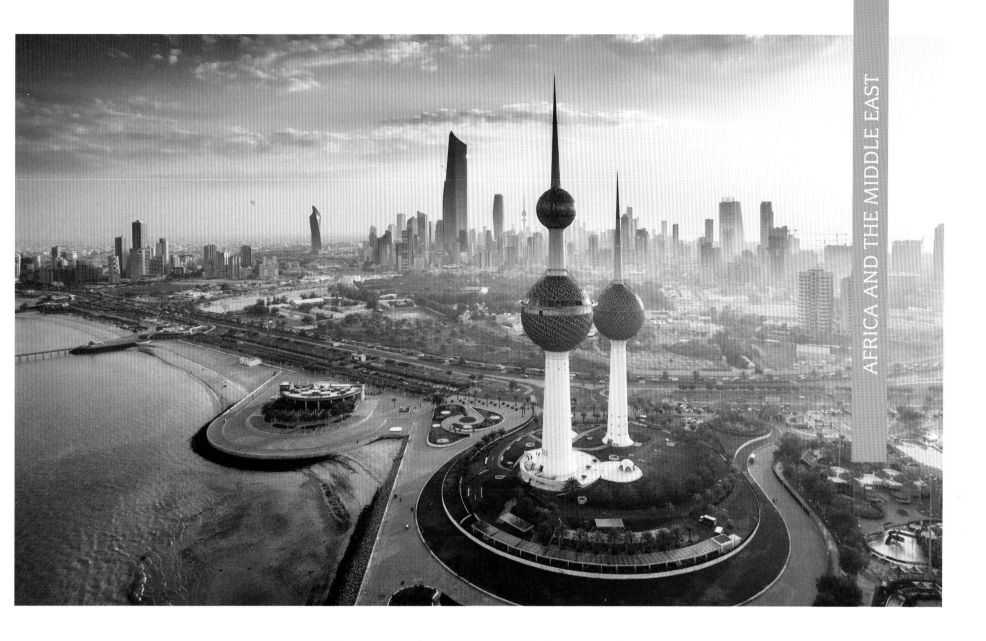

Kuwait City, Kuwait

Kuwait City is a busy modern metropolis, dotted with upscale hotels, modern skyscrapers, and towers of striking design. Three of those towers are among the city's most noted attractions: the triple spindles of Kuwait Towers, which are part million-gallon water tank, part sky-high restaurant, part rotating observation sphere. Back at street-level, visitors should schedule ample time to explore Souq Mubarakiya, a traditional market that's a rich shopping experience in spicy aromas, local souvenirs, and even gold. Kuwaiti and Islamic culture are even more deeply explored at art centers like the Tareq Rajab Museum or religious temples like the $46 million Grand Mosque.

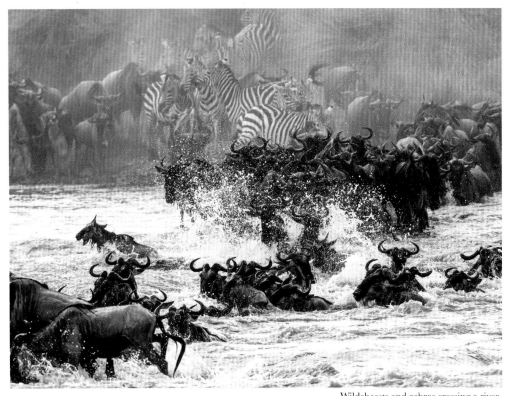

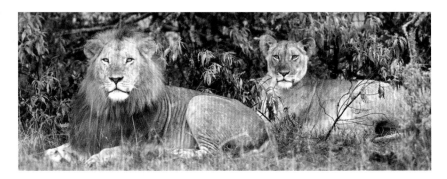

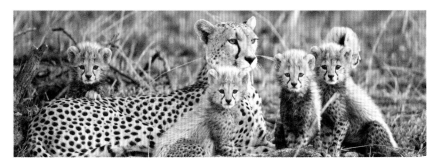

Wildebeests and zebras crossing a river

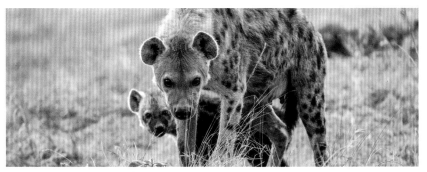

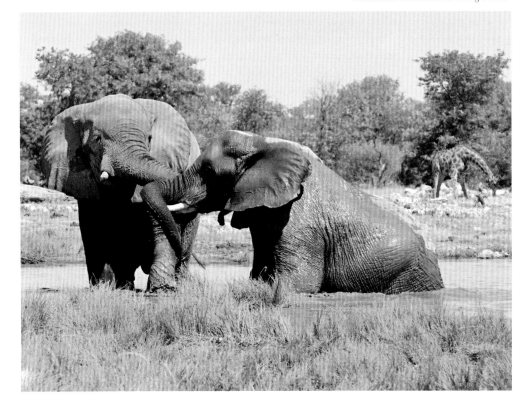

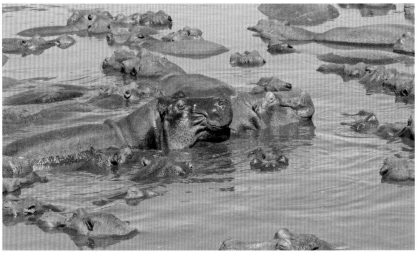

A hippo pool in the Serengeti

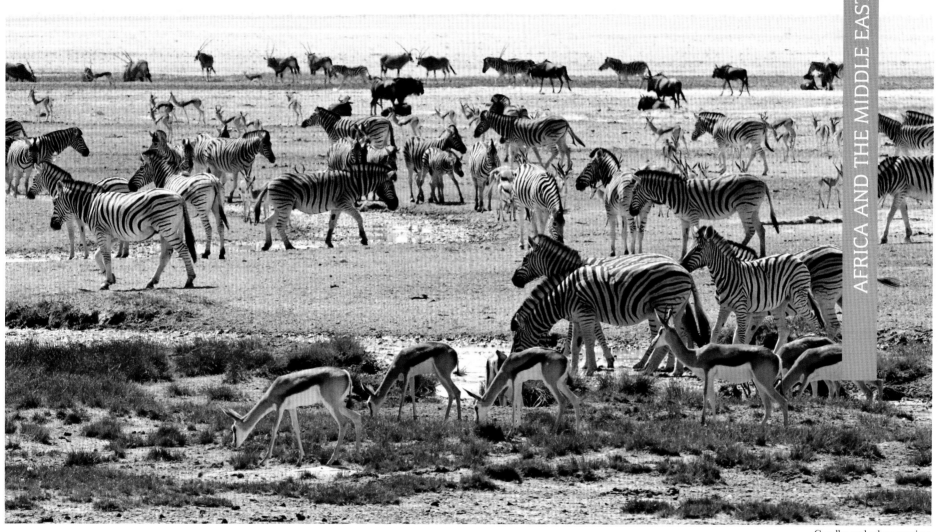

Gazelles and zebras grazing

Serengeti National Park

Serengeti National Park, a 5,700-square-mile area of northern Tanzania, is home to some of the most impressive and important natural phenomena anywhere in Africa or the world. Every year, more than 2 million wildebeests, gazelles, and zebras migrate within the park in search of food and water, with predators including lions, cheetahs, and hyenas hot on their heels. Visitors to the park can witness the great herds as they cross deep muddy rivers between June and October. Also topping list of Serengeti's wildlife highlights are the Retina Hippo Pool, with its 200 lounging and carousing hippopotamus, and Bologonja Springs, where some of Earth's biggest land mammals, like elephants and giraffes, can be found dining on fresh leafy greenery.

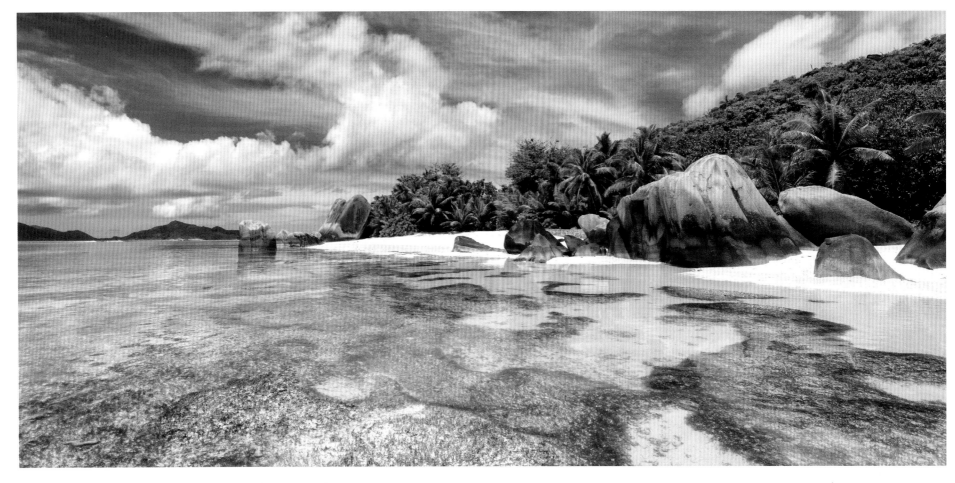

Bird Island is named after the 700,000 pairs of sooty tern birds that nest there each year.

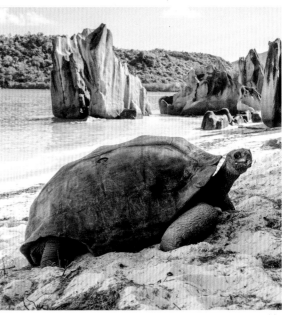

Aldabra giant tortoises can live to be over 200 years old.

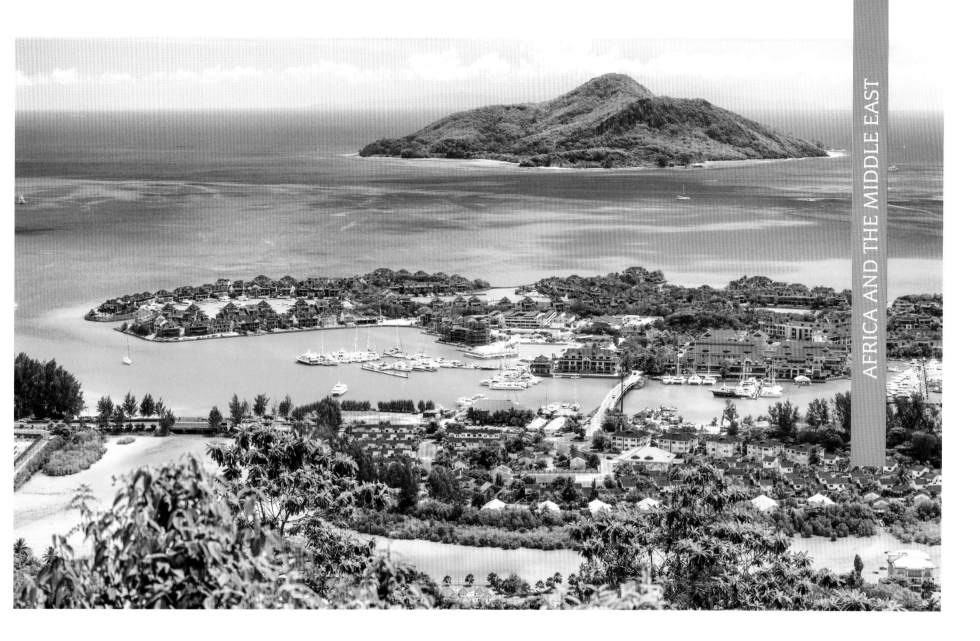

Seychelles

The Seychelles are a 115-island archipelago in the Indian Ocean, about 700 miles northeast of Madagascar. For tropical beaches with crystalline waters protected by massive, shapely boulders, the Seychelles are on top of the list. On Mahé island, which has the nation's only airport, there's Anse Royale, a long, shallow beach that's quite popular. Most photographed is Anse Source d'Argent, with big, multi-hued boulders and a reef just off the water's edge. Then there are the beaches of Praslin island—no less gorgeous but much less crowded. To get even farther out, tourists can take the 30-minute flight to Bird Island Lodge for private chalets, lots and lots of birds, and maybe even an encounter with one of the world's largest tortoises.

The Grand Friday Mosque in Malé

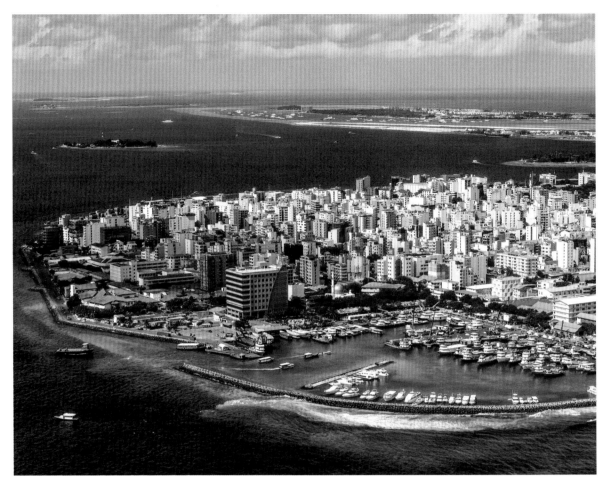

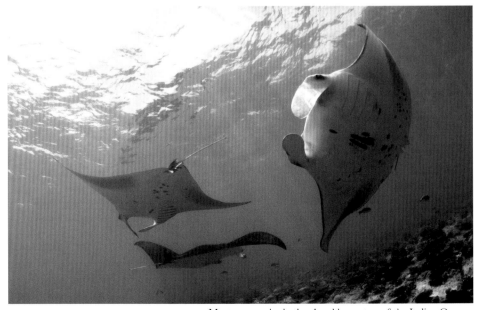
Manta rays swim in the clear blue waters of the Indian Ocean.

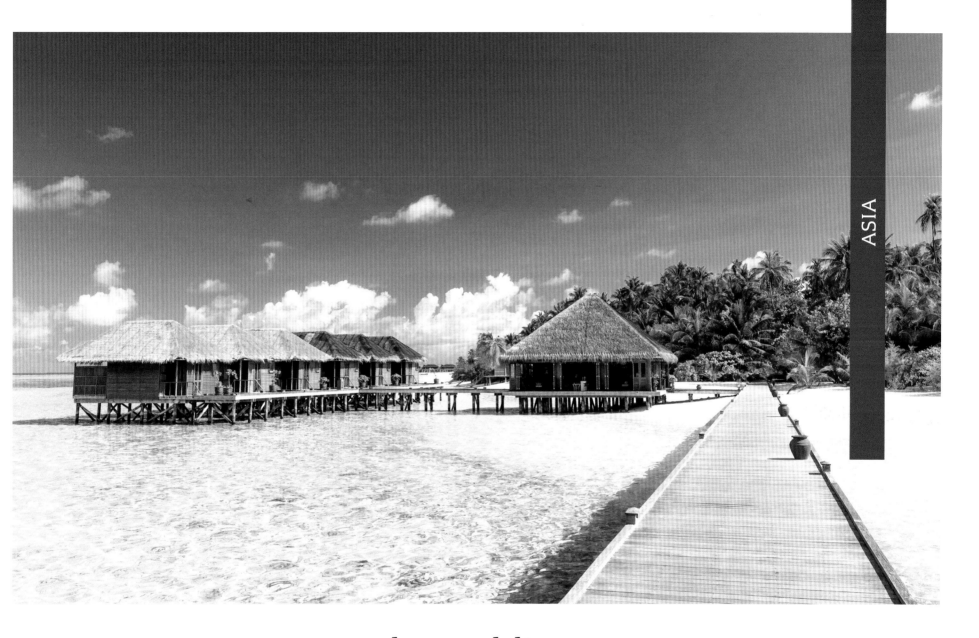

The Maldives

The Republic of Maldives is an Asian nation in the Indian Ocean, a chain of 26 coral atolls that's home to nearly half a million people. For many of the 100,000 yearly visitors, the attraction of the Maldives is mostly in the turquoise blue waters, the endless beaches, and the over-water bungalows offering everything from affordable relaxation to luxurious private pools and top-notch service. Reef snorkeling and scuba diving in the Maldives can bring you face-to-face with moral eels and manta rays. And in Malé, the nation's tightly packed capital, you can explore mosques, markets, and a national museum featuring treasures from the islands' Islamic history.

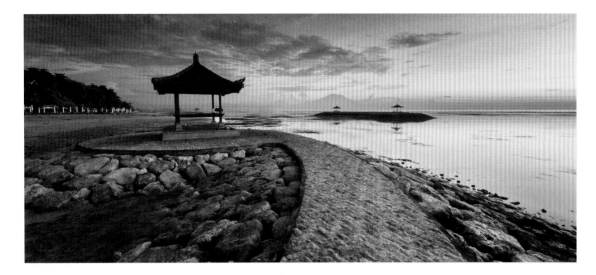

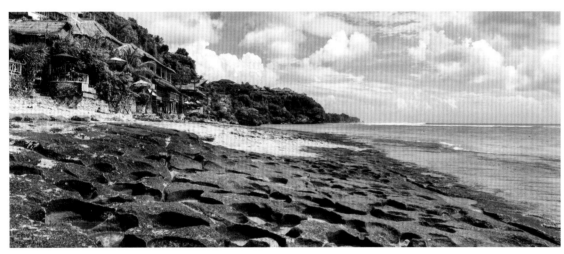

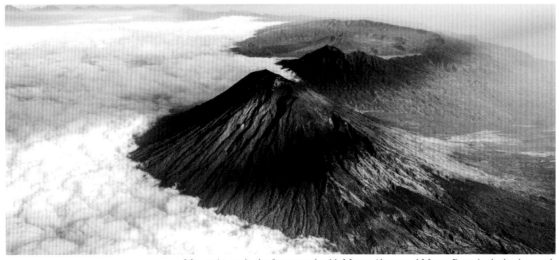

Mount Agung in the foreground, with Mount Abang and Mount Batur in the background

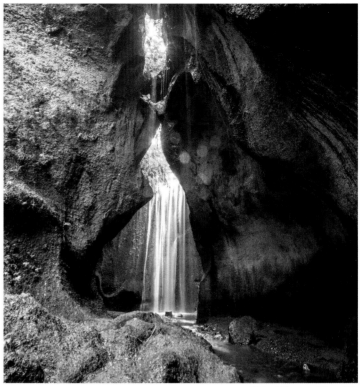

Tukad Cepung Waterfall

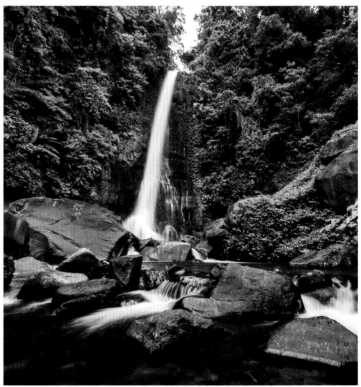

Gitgit Waterfall

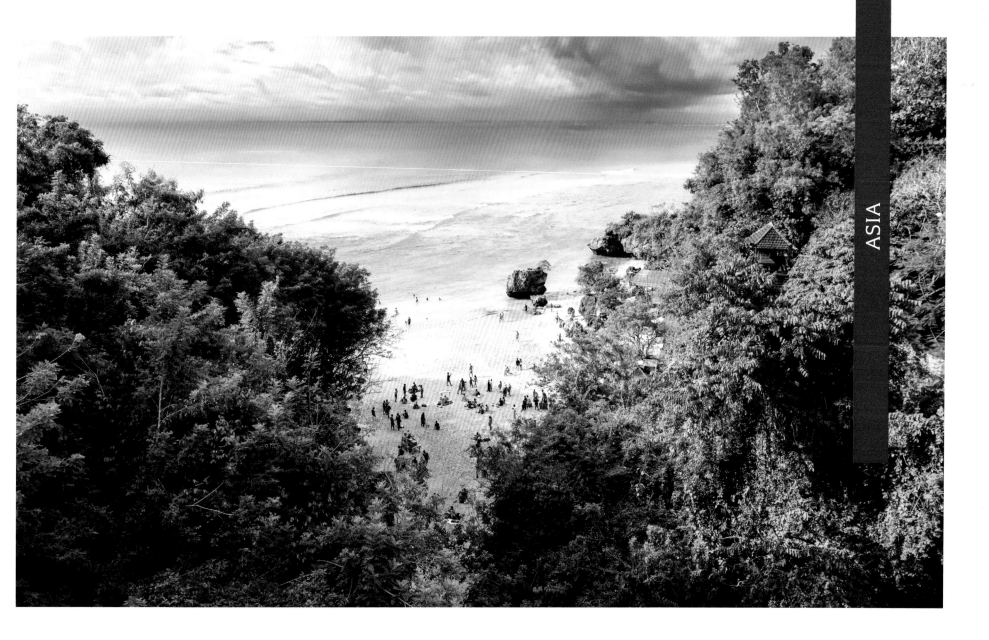

Bali, Indonesia

The Indonesian island of Bali isn't quite as big as the U.S. state of Delaware, but it's one of the world's most popular tourist destinations, welcoming millions of visitors every year. Both mountainous and tropical, Bali has more than its share of world-class beaches, like picturesque Padang Padang, laid-back Sanur, and secluded Bingin. The forests of the island hide scores of bewitching waterfalls, with names like Tukad Cepung and Gitgit. For more rugged ecotourists, there's no shortage of challenging hikes, some of which feature encounters with active volcanoes like Mount Batur and Mount Agung.

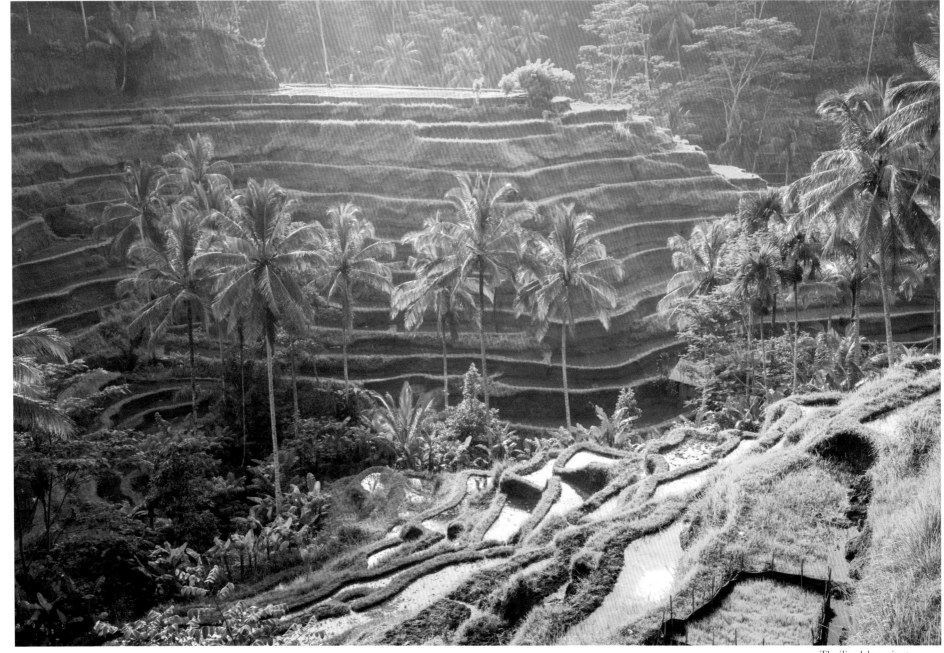

The Tegalalang rice terraces

The cultural side of Bali is just as stunning as its natural charms. The rice terraces of Tegalalang are serpentine works of agricultural beauty, and they're a perfect illustration of the Balinese philosophy of Tri Hita Karana: harmony with nature, with other humans, and with God. On the slopes of Mount Agung, there's Pura Besakih, which is one of the island's most important Hindu temples. Another must-see is Balinese traditional dance, with its dazzling costuming, intricate choreography, and accompaniment by gamelan orchestra. Catch a performance in the town of Ubud, which is also the place to sample highlights of Balinese cuisine, including babi guling and bebek goreng, also known as roasted suckling pig and crispy fried duck.

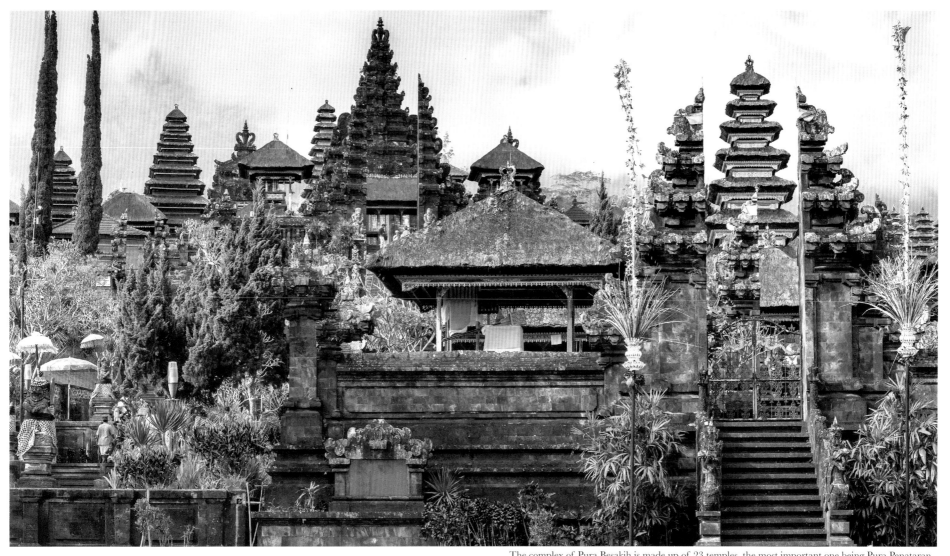

The complex of Pura Besakih is made up of 23 temples, the most important one being Pura Penataran.

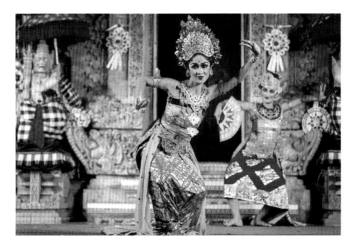

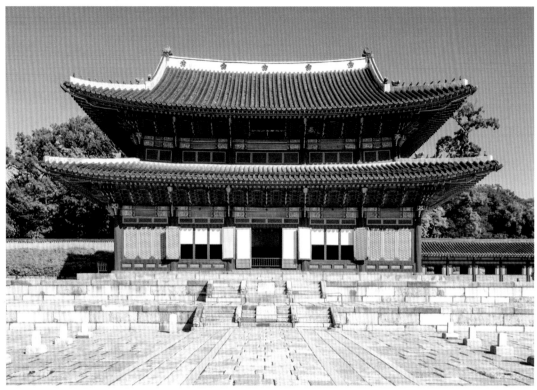

Geunjeongjeon, the main throne hall of Gyeongbokgung

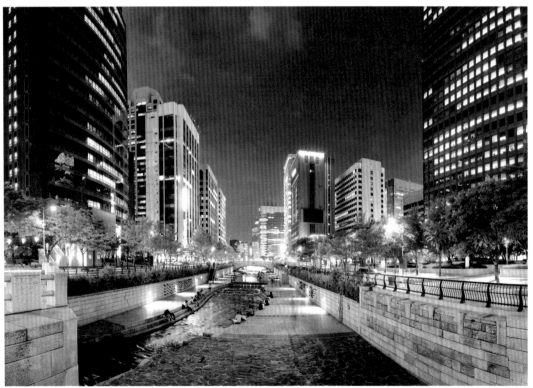

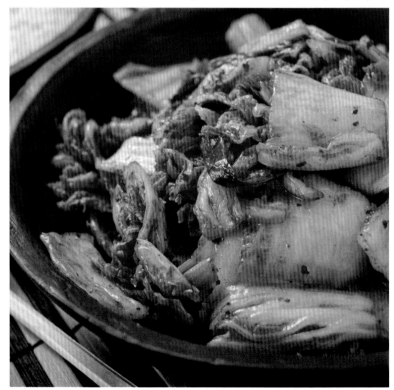

Kimchi is one of the most ubiquitous dishes in South Korea and is typically made with cabbage or other vegetables and garlic, ginger, and various spices.

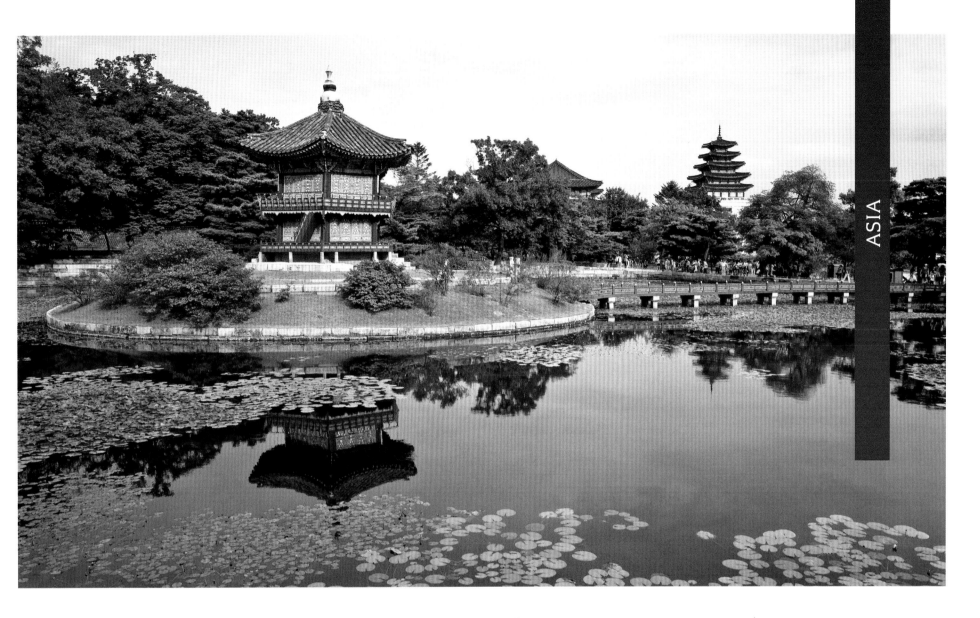

Seoul, South Korea

Seoul, South Korea, has around 2 million more people than New York City, but its population is packed into about 75 fewer square miles—that's a densely inhabited city! And Seoul is teeming with tourist enticements as well. It's rich in palaces, including Gyeongbokgung, with its 600-year history of grandeur, destruction, and rebuilding, and the stunning Changdeokgung, a UNESCO-listed edifice that's probably Seoul's most beautiful. Free museums dedicated to art, history, agriculture, and more will wear out your feet, after which you can rest them in the cooling waters of an artificial urban stream called Cheonggyecheon. Further afield, you can visit an abandoned theme park called Yongma Land or even a museum dedicated to the cabbage dish kimchi. Few may realize that Seoul Special City is the Korean capital's official name, but visitors quickly find out how fitting a name that is.

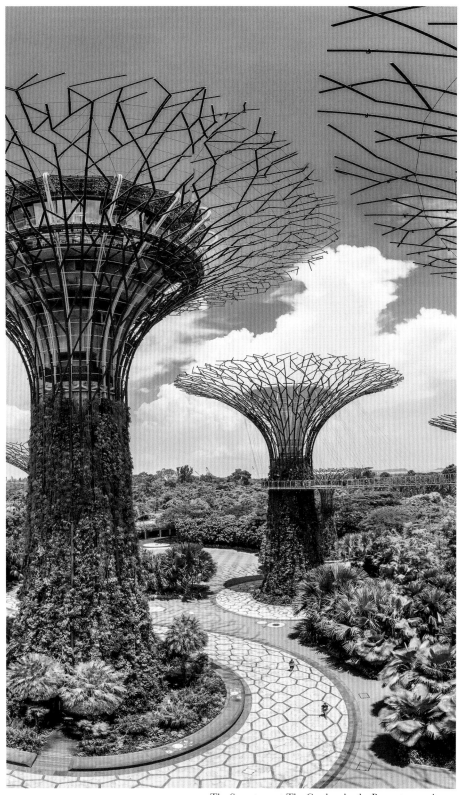

The Supertrees at The Gardens by the Bay nature park are actually vertical gardens, and they can be as tall as 160 feet.

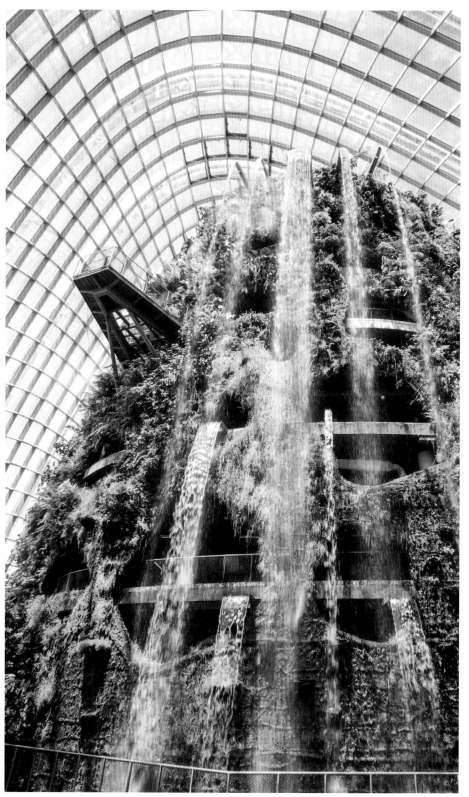

The Cloud Forest is home to one of the world's tallest indoor waterfalls.

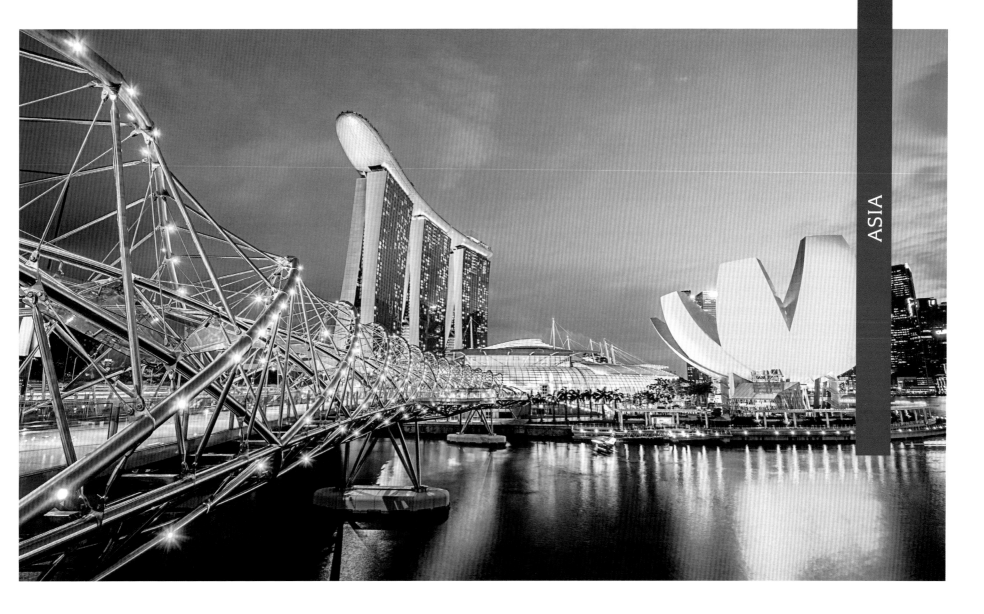

Singapore

With annual tourists numbering more than 15 million in recent years, the Southeast Asian city-state of Singapore is one of the five most-visited metropolises on the planet. It's a study in stark contrasts, where high-rise buildings sit adjacent to jungles and Hindu temples overlook busy Chinatown streets. In and around the downtown core are some of Singapore's unmissable highlights. Gardens by the Bay is an enormous and hyper-modern nature park featuring 16-story Supertrees connected by a futuristic Skyway. The park's Cloud Forest is a tropical highland landscape enclosed in a 115-foot-tall domed structure. At Marina Bay Waterfront Promenade, there are Vegas-sized light and water shows and a Helix Bridge that offers amazing photo ops of the burgeoning Singapore skyline.

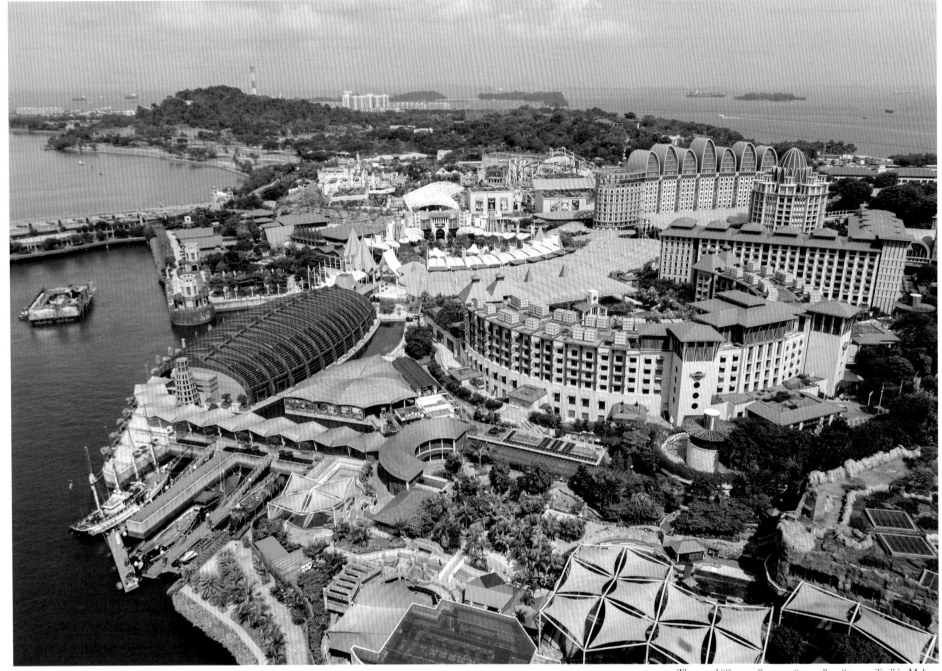

The word "Sentosa" means "peace" or "tranquility" in Malay.

There's so much to do and see in Singapore, it's easy to get overwhelmed. Sentosa Island is among the area's most exciting resort attractions, colorfully described as Las Vegas in a forest on a beach. One of the world's great zoos is here, too: the $9-million Singapore Zoo, a leader in naturalistic, open zoological exhibits. For special topics in natural wonders, try the National Orchid Garden or Jurong Bird Park. And don't forget to eat hawker street food at one of Singapore's many delightful food courts. The local delicacies include chili crab, sambal stingray, and a vegetarian dish called yong tau fu.

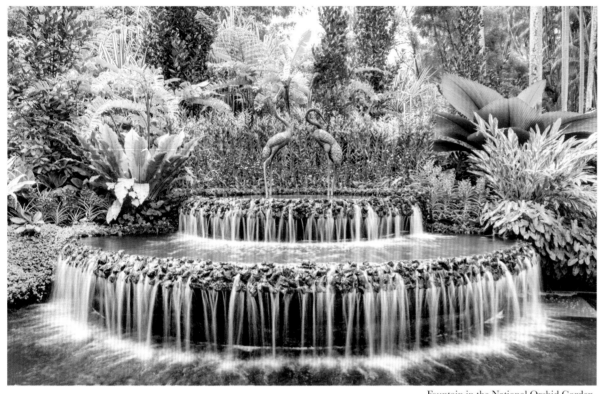

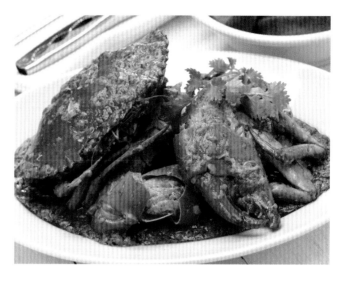

Fountain in the National Orchid Garden

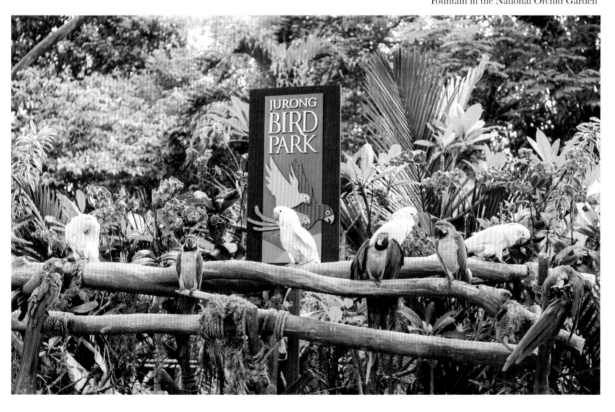

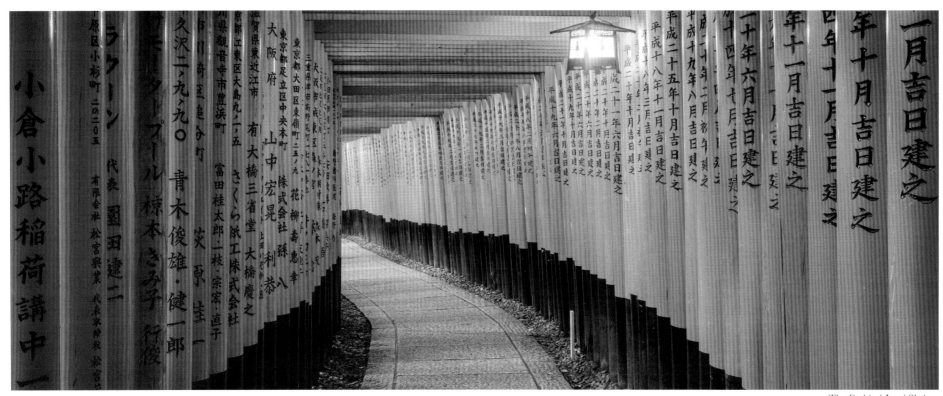

The Fushimi-Inari Shrine

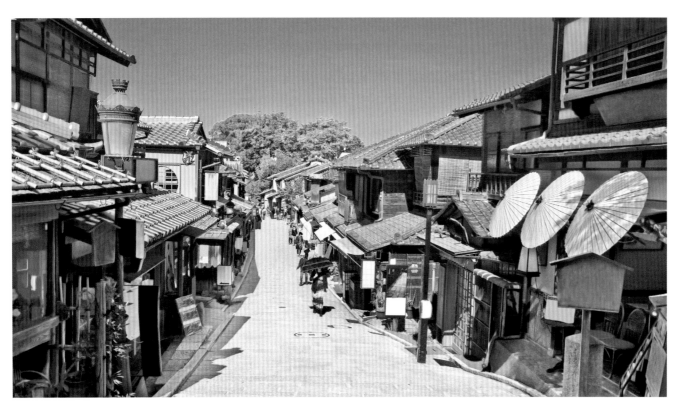

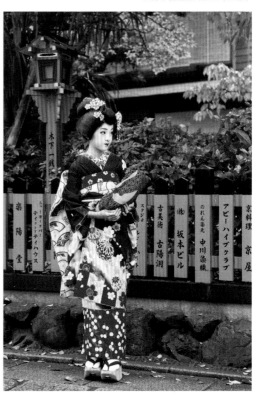

122

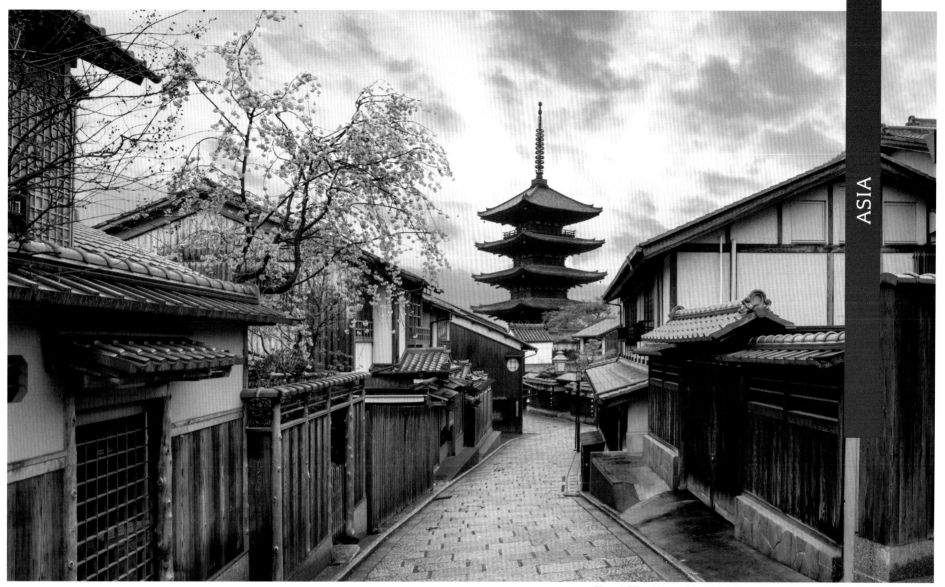

Kyoto's Higashiyama District is full of beautiful architecture, temples, and history.

Kyoto, Japan

Kyoto reigned as the capital city of Japan for more than a thousand years. Today, it's a time-capsule that preserves the aura of ancient Japan better than anywhere else. For visitors, Kyoto presents a huge collection of exquisite and stately castles, temples, palaces, and shrines, including the Fushimi-Inari Shrine, built in 711, dedicated to a Shinto agriculture goddess, and featuring thousands of traditional Japanese torii arches in bright orange. In the Gion district of Kyoto, 17th-century Japan survives in teahouses and restaurants. This geisha district of the city also features a street called Shimbashi, which some have called "the most beautiful street in Asia."

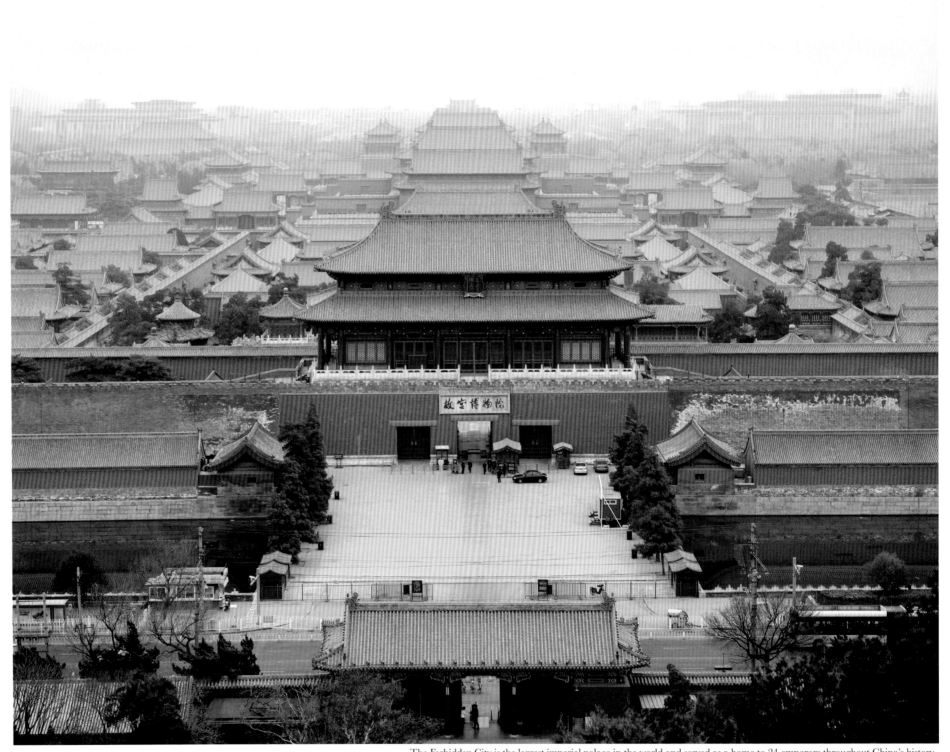

The Forbidden City is the largest imperial palace in the world and served as a home to 24 emperors throughout China's history.

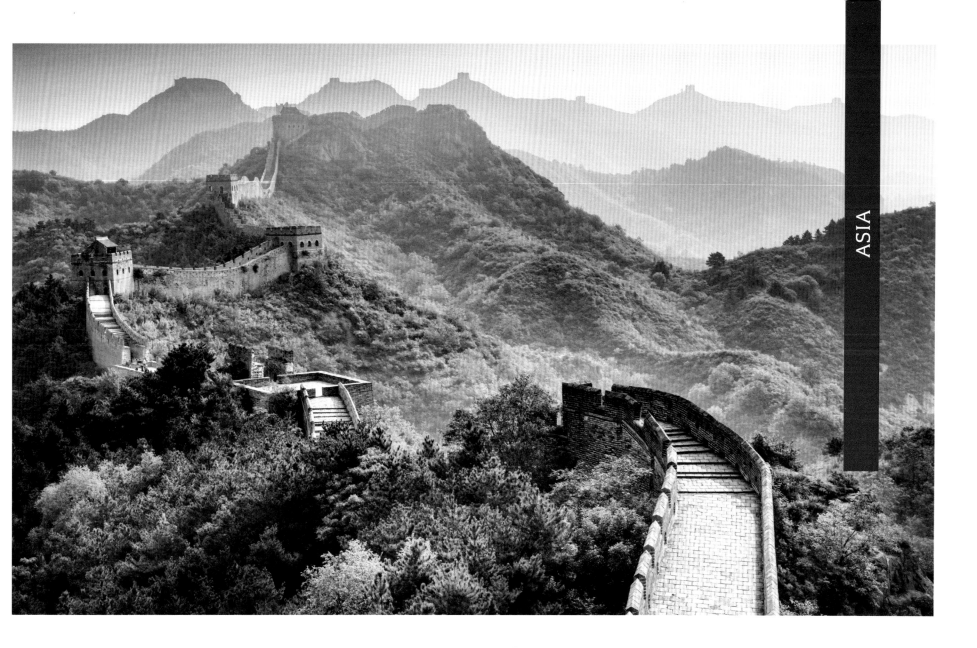

Beijing, China

Beijing, the sprawling and ancient capital city of China, is where more than 21 million people make their homes. About 140 million Chinese tourists visit the city every year, not to mention the 4.4 million international travelers who visit Beijing annually. And it's no wonder: Beijing can boast some of China's most renowned attractions. First, and most obvious, are Beijing's 356 miles of the Great Wall of China, most of which were built during the Ming Dynasty. Next up is the Imperial Palace, sometimes referred to as the Forbidden City. It's an overwhelming historical complex of nearly 8 million square feet, with ornate corner towers, 33-foot walls, and a moat half as wide as a football field.

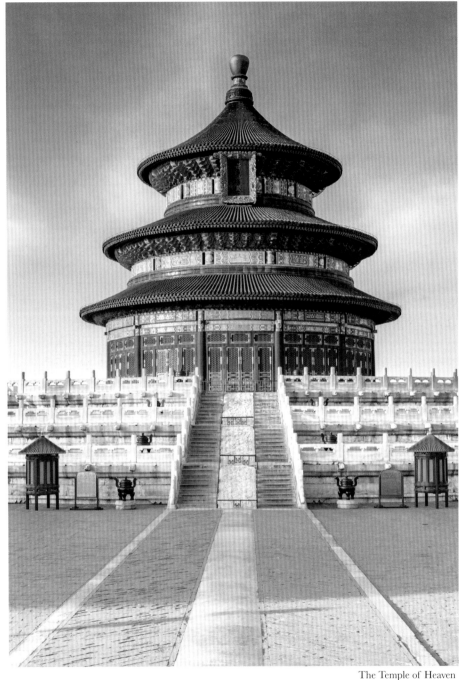

The Temple of Heaven

Fayuan Temple is one of Beijing's oldest temples.

For a city of such size and history, you'd expect that the list of Beijing "must sees" is long—and it really, really is! You could spend weeks exploring nothing but temples, like the 600-year-old Temple of Heaven or the even older Fayuan, or Source of Law Temple, which dates back to 645 AD. A visit to Beijing can also bring art lovers to the steps of the National Museum of China, the second most visited art museum on Earth after the Louvre in Paris. And don't leave China before you sample Peking roast duck, which tops many a Beijing "must eat" list.

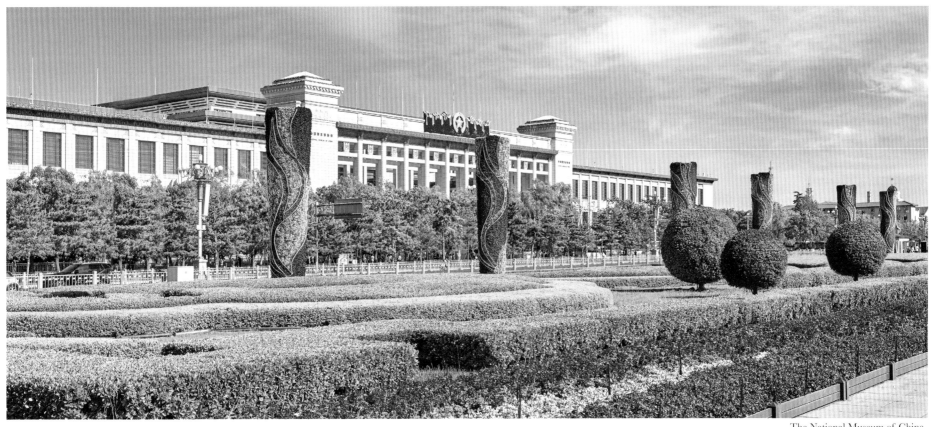

The National Museum of China

The National Museum of China has a permanent collection of more that 1 million items from China's history.

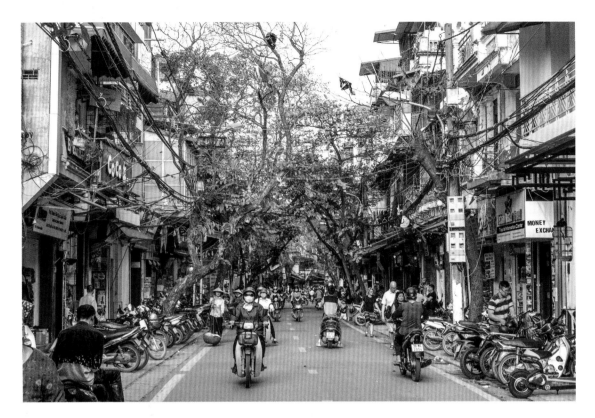

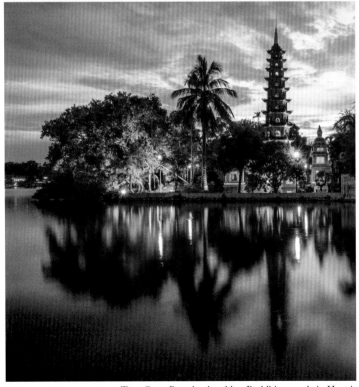

Tran Quoc Pagoda, the oldest Buddhist temple in Hanoi

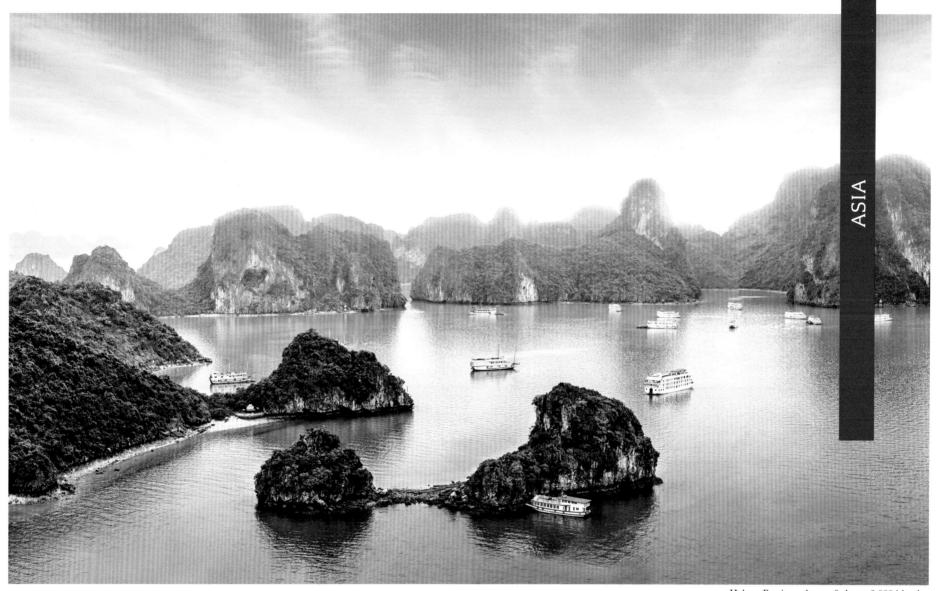

Halong Bay is made up of almost 2,000 islands.

Hanoi, Vietnam

In Hanoi, the capital of Vietnam, there are just over 8 million residents—and there are more than 5 million scooters or motorbikes! They're considered part of the city's buzzing personality. Also integral to Hanoi is the Old Quarter, a traditional city core once closed off behind massive gates and now a great place for exploring and getting lost among the cathedrals, pagodas, cafes, and food vendors. And speaking of food, Hanoi's street fare is ranked right up there with the best in Asia; barbecue stands and noodle shops are just two of the can't-miss options. Hanoi is blessed with natural wonders, too, including tranquil Hoan Kiem Lake and the dramatic limestone islands of UNESCO-listed Halong Bay.

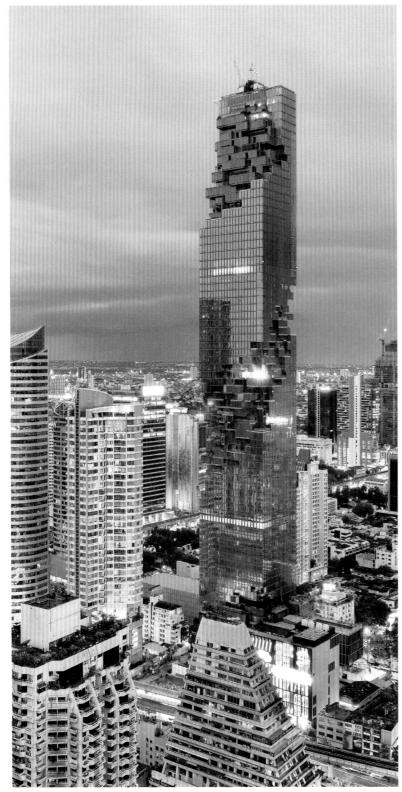

The MahaNakhon tower is the tallest building in Thailand.

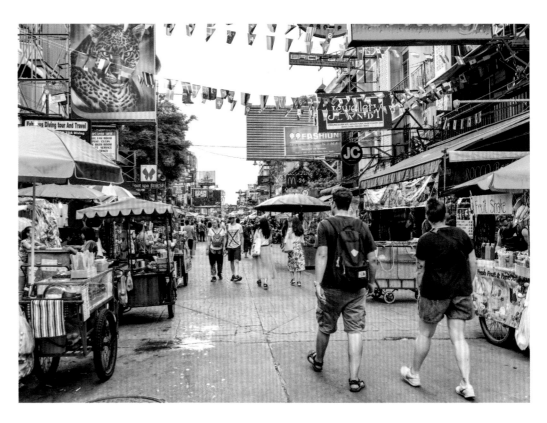

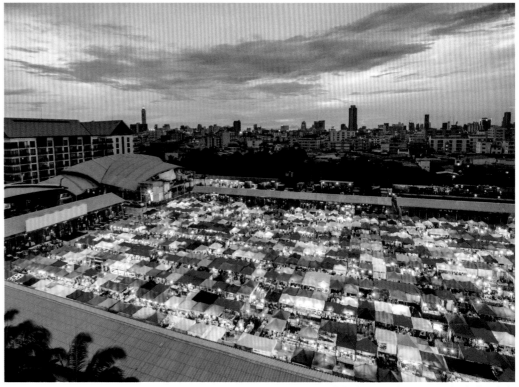

Colorful tents of a street market in Bangkok

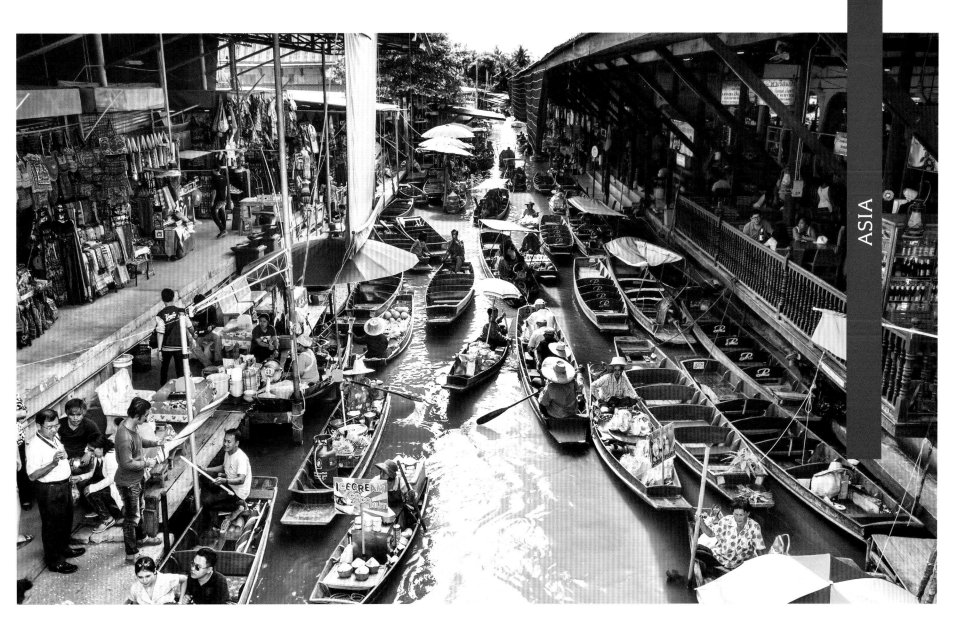

Bangkok, Thailand

In 2018, Bangkok, Thailand, celebrated its third year in a row as the top international destination in the world. In securing its coveted spot, Bangkok welcomed more than 20 million visitors. It's a teeming metropolis and can tend to overwhelm, especially in busy market districts like Khao San Road, the Damnoen Saduak Floating Market, or the Chatuchak Market, the largest in the world, featuring approximately 15,000 stalls. Bangkok is also home to brilliant and strange postmodern architecture, like the pixelated, 1,000-foot-tall MahaNakhon tower; a mixed-use triple tower that looks like an elephant and called The Elephant Building; and the quirky and aptly named Robot Building.

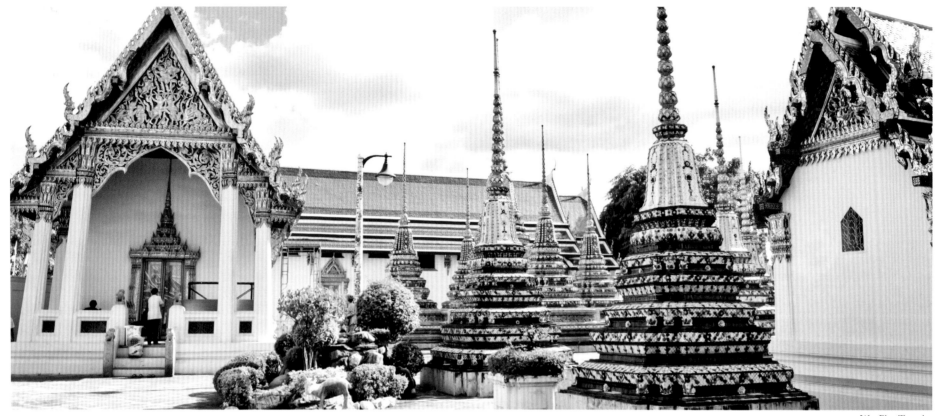
Wat Pho Temple

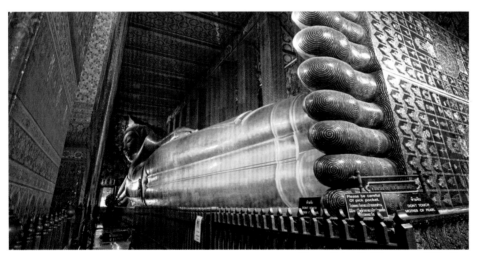
The reclining Buddha statue of Wat Pho

Bangkok is also quite rich in historical and cultural attractions. Perhaps most famous is the 16th-century Buddhist temple called Wat Pho, which houses both enormous, spindly pagodas and the Reclining Buddha, a 150-foot statue that's among Thailand's biggest buddhas. You can dive into history at palace sites like Wang Na and the royal compound called the Grand Palace. And street food is a must in Bangkok, with endless options including pad thai; the oyster omelette known as hoy tod; and som tam, a papaya salad made with fish sauce and garlic.

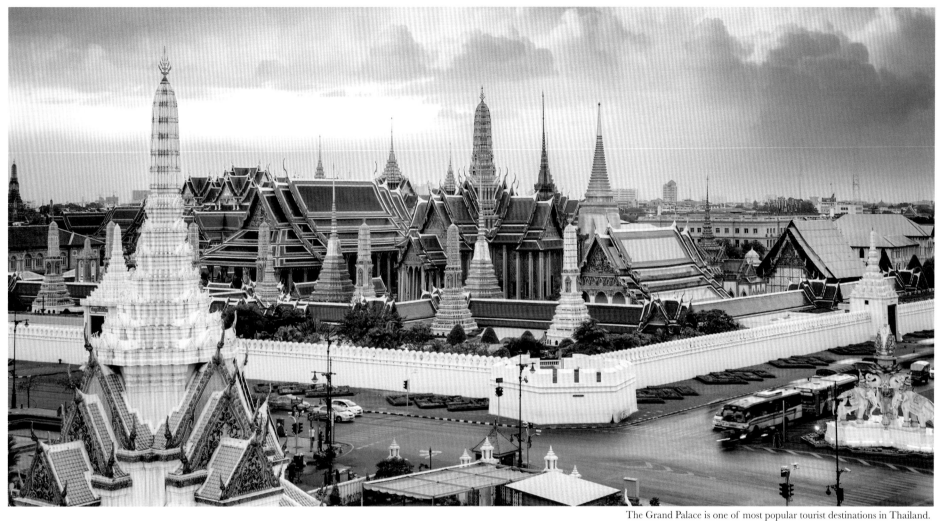

The Grand Palace is one of most popular tourist destinations in Thailand.

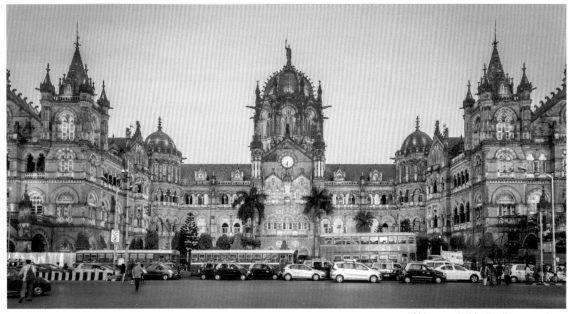

Chhatrapati Shivaji railway terminus

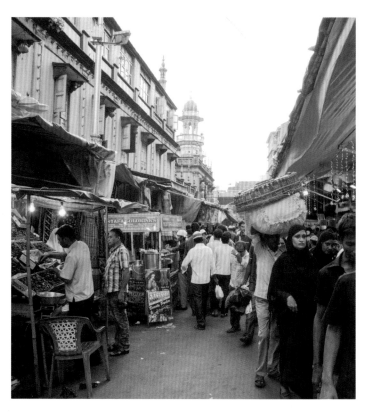

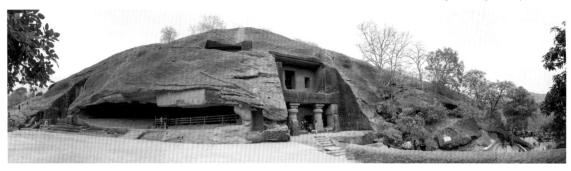

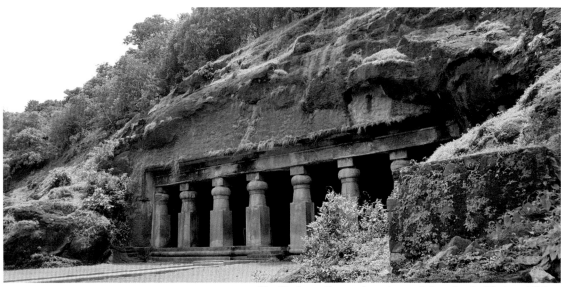

The Elephanta Caves and temples are dedicated to the Hindu god Shiva.

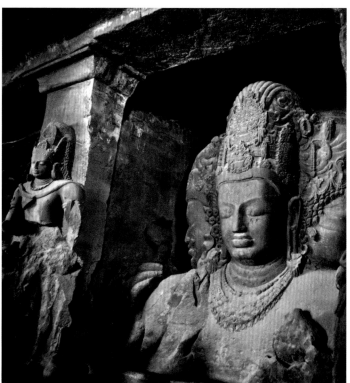

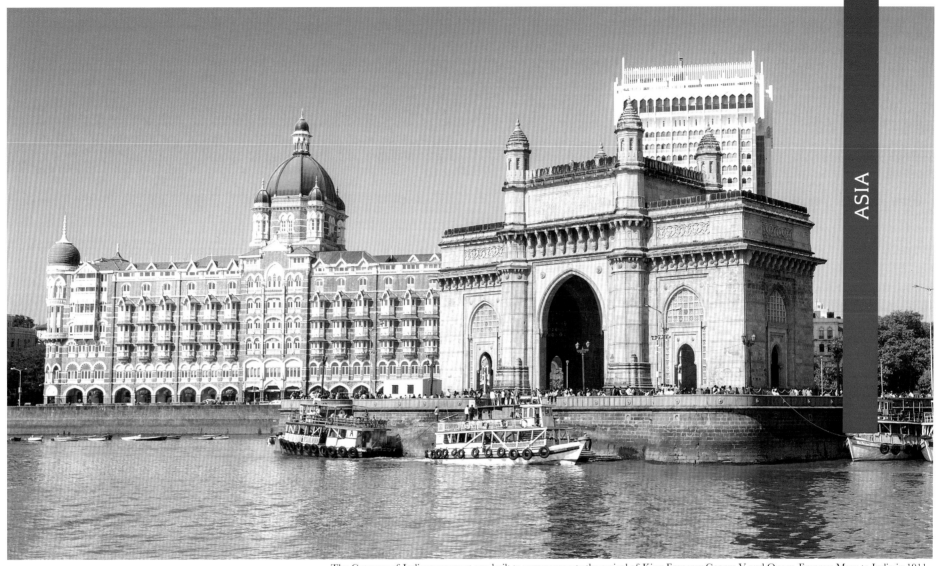

The Gateway of India monument was built to commemorate the arrival of King-Emperor George V and Queen-Empress Mary to India in 1911.

Mumbai, India

Mumbai, formerly known as Bombay, is India's largest city. It's the nation's financial and fashion center, and it's home to Bollywood, India's prolific film industry. The list of cultural treasures and historic landmarks in gigantic Mumbai is never-ending, including architectural monuments like the Gateway of India, the Chhatrapati Shivaji railway terminus, and the Taj Mahal Palace Hotel. Sanjay Gandhi National Park is the largest on Earth located entirely within any city, and Chor Bazaar is an intoxicating 150-year-old flea market. For an edifying daytrip into history, explore the Elephanta Caves, located on an island about 6 miles from the Mumbai mainland. This UNESCO World Heritage site features intricately carved Hindu and Buddhist sculptures around 1,500 years old.

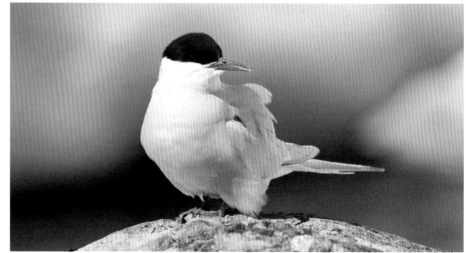

An Antarctic tern

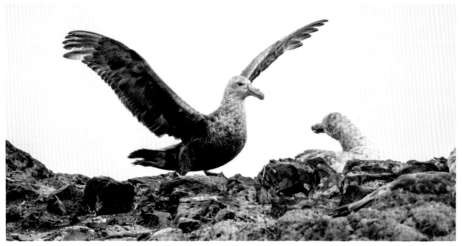

A giant petrel

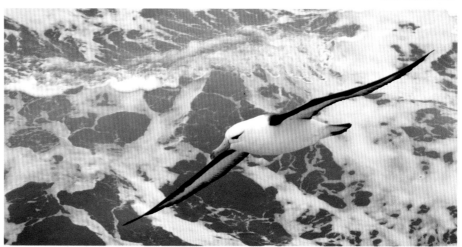

An albatross

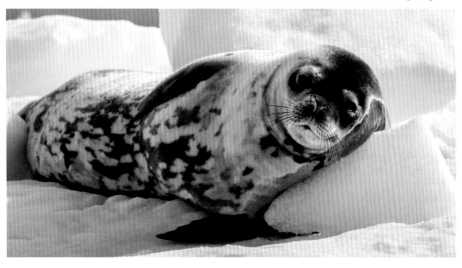

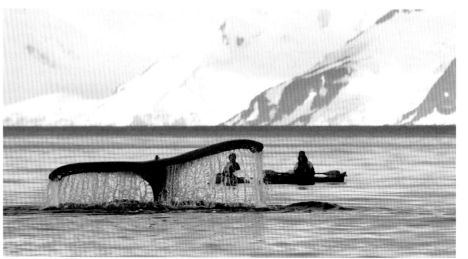

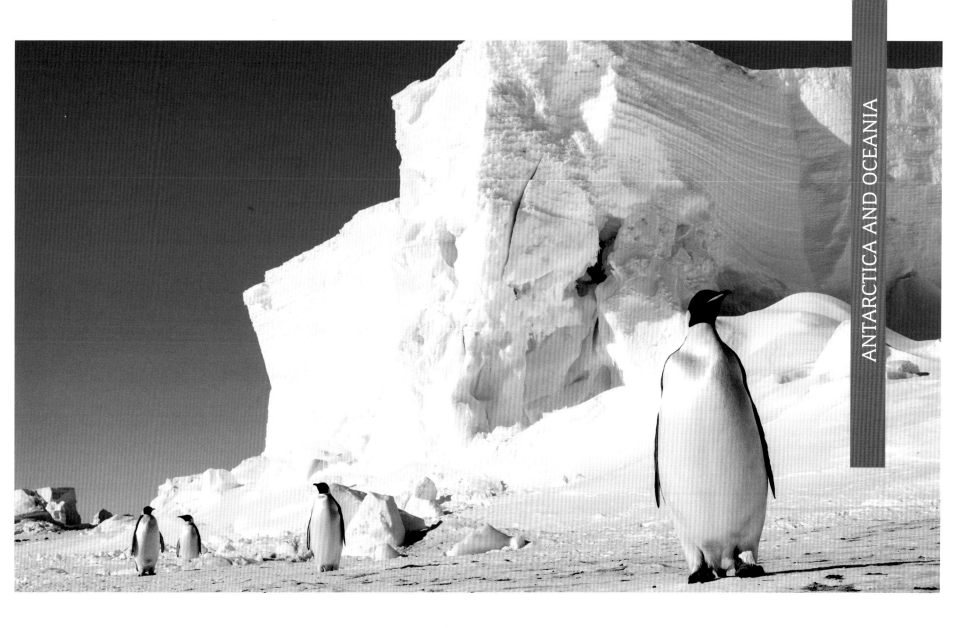

Antarctica

The bottom of the world has come a really long way, considering its new status as a dream destination for globetrotters. Though Antarctica tourism began only in the 1960s, the frozen continent now receives more than 40,000 annual visitors. Every trip to frigid and wild Antarctica is more expedition than vacation, and inflatable zodiac boats get most people from their cruise ship to shore—like the shores of Deception Island, a scientific outpost and former sealing station built on an active volcano and featuring hot spring baths. Though it's possible to spend time with terns, petrels, albatross, and six different kinds of seal and penguin, whale watching is probably Antarctica's top wildlife attraction, done best aboard kayaks with rocky coasts, glaciers and snow-capped peaks in the distance.

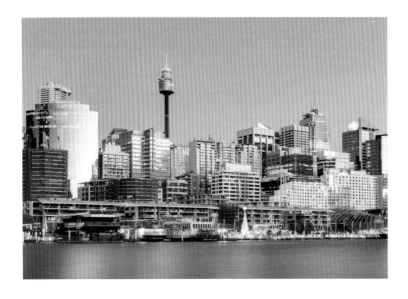

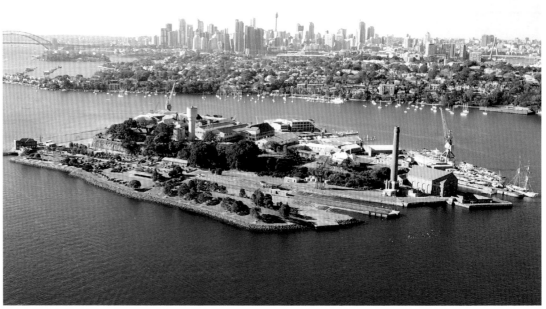

Lotus leaves at the Royal Botanical Garden

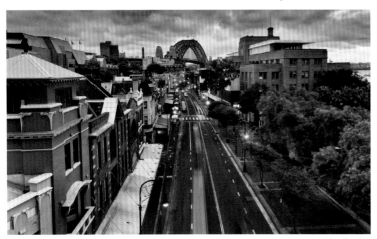

The Rocks

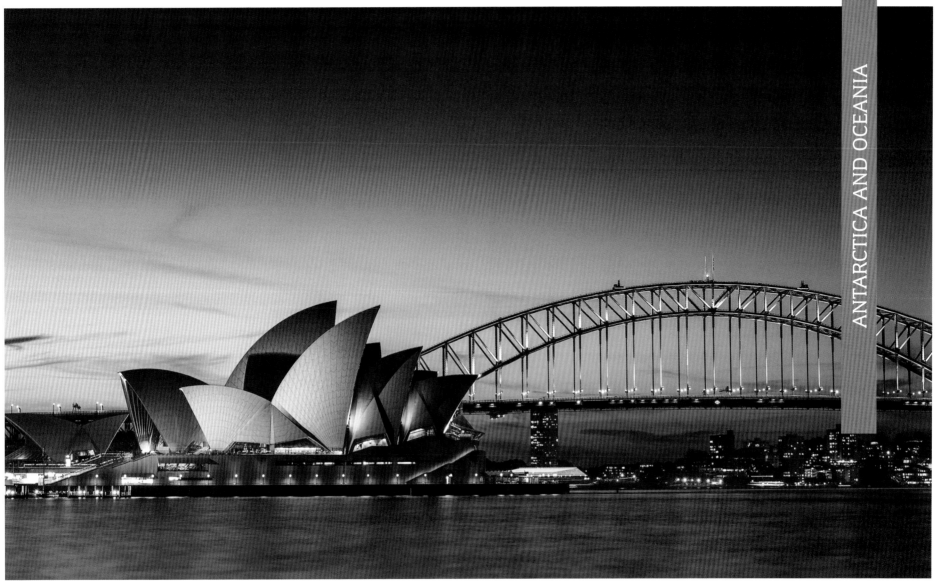

More than 1 million tiles cover the roof of the Sydney Opera House.

Sydney, Australia

The scalloped, sail-shaped roof sections of the grand opera house on the harbour are what most people first envision when they think of Sydney, Australia. And right there on Sydney Harbour are the scenic climb up Sydney Harbour Bridge, the Australian history experience of Cockatoo Island, and some of the most splendid beaches on the whole continent. Sydney's harbour highlights extend to Darling Harbour, with its walkable stores, restaurants, zoo, aquarium, and museums. Other local landmarks include the 1,000-foot-tall Sydney Tower Eye and the peaceful Royal Botanic Garden. A bit further from the beaten path is The Rocks, a former convict district that's now a cobbled-street time capsule, brimming with local flavor.

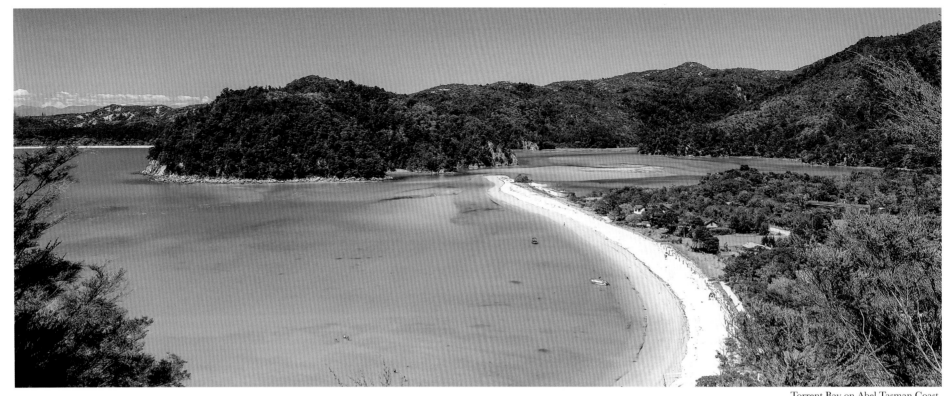

Torrent Bay on Abel Tasman Coast

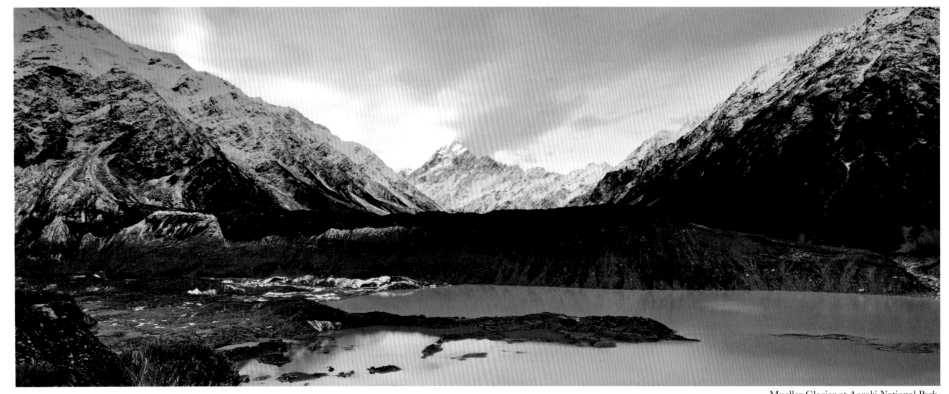

Mueller Glacier at Aoraki National Park

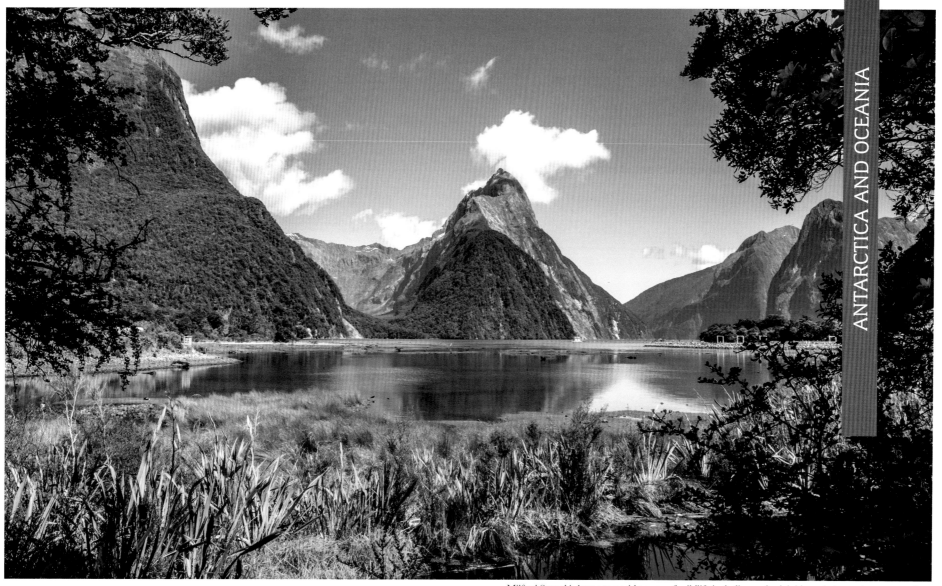

Milford Sound is home to a wide array of wildlife including seals, dolphins, whales, and even penguins.

South Island, New Zealand

New Zealand's South Island was famed for its fairy-tale landscapes long before director Peter Jackson's *Lord of the Rings* fantasy film series boosted many of its locations to legend status. In fact, the Te Wahipounamu area in the island's extreme southwest corner has been a World Heritage site since 1990, and it incorporates no fewer than four national parks. One of those, Fiordland National Park, features Milford Sound, a stunning fiord with sheer 4,000-foot rock faces, dramatic peaks and waterfalls, and even a floating underwater observatory. Elsewhere, there's the hiking and snorkeling

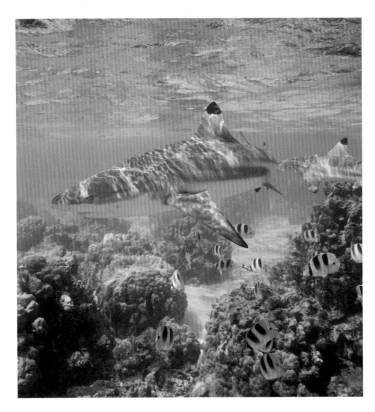

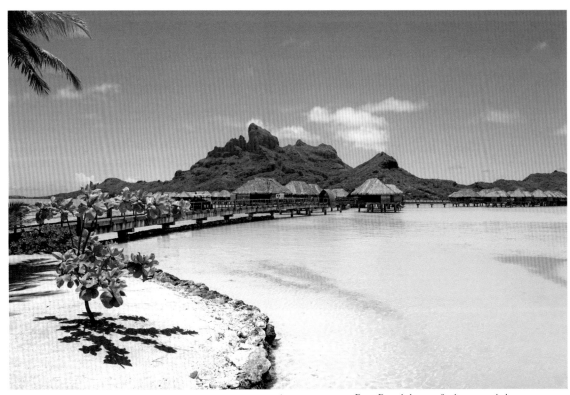

Bora Bora is known for its romantic luxury resorts.

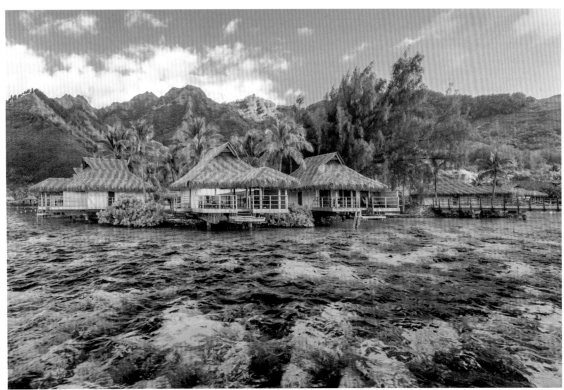

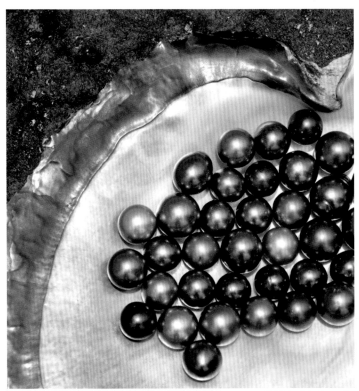

Tahitian black pearls

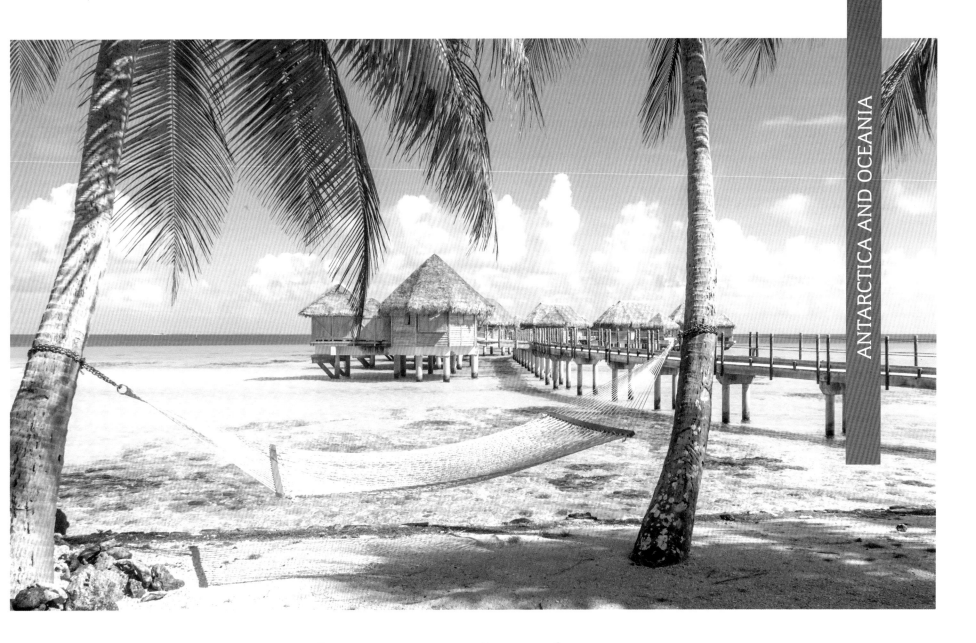

Tahiti, French Polynesia

Just thinking the word "Tahiti" itself conjures up images of aquamarine waters, palm-lined beaches, and blue lagoon bungalow bliss. The largest island in French Polynesia, Tahiti is also the most frequently visited isle in the archipelago. For overwater huts, the islands of Bora Bora and Moorea can't be beat. On Tahiti Nui, rainforests just inland give way to waterfalls and rockpools. And on Huahine, snorkeling with reef sharks can be enjoyed at a natural lagoon aquarium. There are even museums dedicated to the islands' rare black pearls and to painter Paul Gaugin, whose time in Tahiti resulted in several of his most famed canvasses.

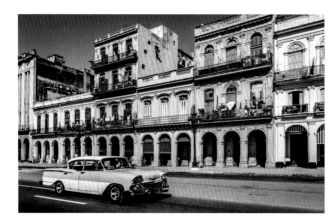
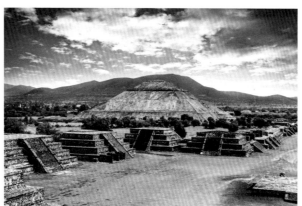
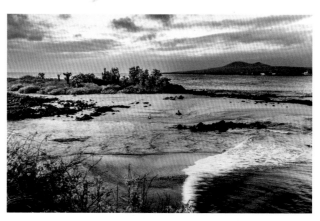
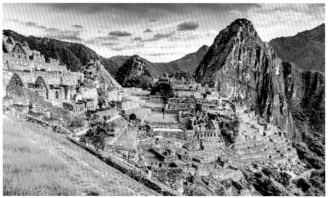
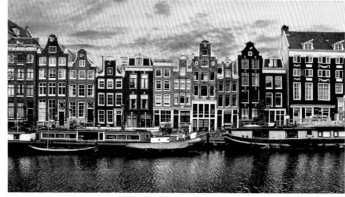
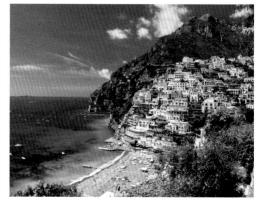
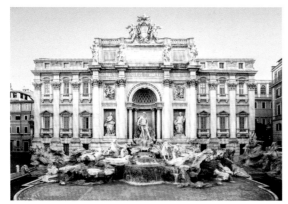
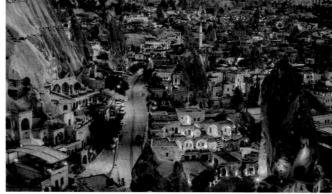
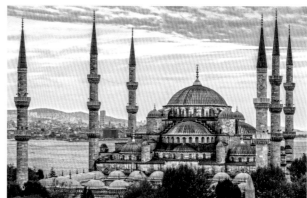
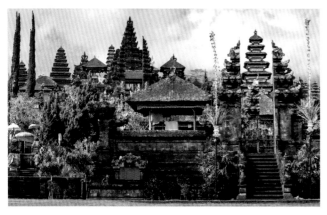
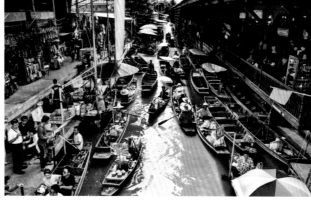
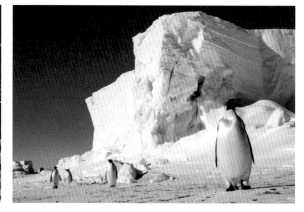